Perdition

Two dedications:

To brave Clare, with love and admiration.

To the Jews of Hungary
who were murdered by the Nazis at Auschwitz.

Perdition

a play in two acts

by Jim Allen

Ithaca Press
London & Atlantic Highlands
1987

Jerusalem Studies Series No 13

First published in 1987
in collaboration with
Jerusalem & Peace Services, sole licencees for the production of *Perdition* in the UK

Ithaca Press
13 Southwark Street London SE1 1RQ
&
171 Atlantic Highlands NJ 07716

Typeset by EMS Photosetters, Rochford, Essex

Printed and bound in England by
Robert Hartnoll Ltd Bodmin

ISBN 0 86372 099 4 cased
ISBN 0 86372 100 1 paperback

British Library Cataloguing in Publication Data

 Allen, Jim, *1926 -*
 Perdition : a play in two acts. ——
 (Jerusalem studies series; 13).
 I. Title II. Series
 822'.914 PR6051.L5388

Library of Congress Cataloguing In Publication Data

Allen, Jim, *1926 -*
 Perdition : a play in two acts
 (Jerusalem studies series; 13)
 Bibliography : P
 I. Title II. Series
 PR6051.L5388 P4 1987 822'.914 87-3349

 ISBN 0-86372-099-4
 ISBN 0-86372-100-1 Pbk

Contents

Publisher's Note The contributions by Lenni Brenner and by Akiva Orr are provided to give bibliographical background to material not easily accessible. These writers are critics of Zionism in at least some of its aspects and this is represented by placing their work in the first part of the book.

Bibliography

Reuben Ainsztein: *The Warsaw Ghetto Revolt*
Pier Anger: *With Raoul Wallenberg in Budapest*
Hannah Arendt: *Eichmann in Jerusalem*
John Bierman: *Righteous Gentile*
Blatt, Davis, and Kleinbaum (Eds.): *Dissent and Ideology in Israel*
Lenni Brenner: *Zionism in the age of the Dictators*
Noam Chomsky: *The Fateful Triangle*
Lucy Dawidowicz: (ed): *A Holocaust Reader*
Lucy Dawidowicz: *The War against the Jews 1933–45*
Isaac Deutscher: *The Non-Jewish Jew*
Amos Elon: *The Israelis*
Martin Gilbert: *Auschwitz and the Allies*
Nahum Goldmann: *Jewish heroism in Seige*
Gideon Hausner: *Justice in Jerusalem*
Ben Hecht: *Perfidy*
Theodor Herzl: *The Jewish State*
Raul Hilberg: *The Destruction of the European Jews*
Walter Laqueur: *The Terrible Secret*
Abram Leon: *The Jewish question*
Eugene Levai: *Black Book on the martyrdom of Hungarian Jewry*
Barnett Litvinoff (Ed.): *The Letters and Papers of Chaim Weizmann*
A. Morse: *While six million died*
M J Nurenberger: *The Scared and the Doomed*
Akiva Orr: *The unJewish State*
Natalie Rein: *Daughters of Rachel: Women in Israel*
Jacob Robinson: *And the crooked shall be made straight*
Maxime Rodinson: *Cult, ghetto, and state*
Hannah Senesh: *Her life and Diaries*
Rab Moshe Shonfeld: *The Holocaust Victims Accuse*
Isaiah Trunk: *Judenrat*
Rudolf Verba: *I Cannot Forgive*
Nathan Weinstock: *Zionism: False Messiah*
Alex Weissber: *Desperate Mission*
Marion Woolfson: *Prophets in Babylon*
David Wymann: *The Abandonment of the Jews*

Author's Note

Perdition is a play which shows how some Zionist leaders collaborated with the Nazis during and before the Second World War. The characters on the stage of this play are all fictions and no resemblance to any person living or dead is intended. Jacob Szamosi and his diaries are also fictions.

Events, personalities and their statements referred to in the evidence of witnesses are to be found in the published sources given in the bibliography. The interpretation of these by the action of the play I believe in good faith to be justified.

The time of the play in July 1967. The scene is the High Court of Justice in London.

The Company

SCOTT	Gabriel Byrne
GREEN	Judith Sharp
LAWSON	Ian Flintoff
MIKLOS YARON	Ralph Nossek
RUTH KAPLAN	Caroline Gruber
VANDOR	Zibigniew Sieciechowicz
KARPIN	John Gabriel
ORZECH	Dennis Clinton
MIRIAM MOSER	Ania Marson
MEMBERS OF THE JURY	The Audience

The part of the JUDGE was played by Dennis Clinton

Design	Eileen Diss
Stage Management	Liz Ainley
Costume Design & Wardrobe	Lindy Hemming & Jenny Cook
Asst. Costume Design	Bob Starrett
Sound	Chris Shult
Lighting	Lenny Tucker
Director	Ken Loach

This is the revised text of the play not first performed at the Royal Court Theatre Upstairs on 22nd January 1987.

Act One

The Prosecution

The time is July 1967. The scene is an ante-room in the High Court of Justice in London. GREEN, junior counsel for the defence, is going through the morning papers. She is a neat woman of about 30, with shrewd eyes. ALEC SCOTT enters, gowned and wigged and carrying a bulging briefcase. He is a man in his forties. There is a quality of toughness about him. He looks jaded. GREEN looks up, smiling.

GREEN: Morning.

SCOTT: Some sod wrote on the back of my car last night.

He drops his briefcase on the desk.

GREEN: What did it say?

SCOTT: 'Anti-Semitic bastard'.

GREEN laughs and SCOTT flops in the chair.

SCOTT: So I left it at home this morning and used the public transport — which is not very reliable.

As SCOTT searches for something in his briefcase:

GREEN: Are they still queueing outside the court?

SCOTT: I'm surprised they aren't selling tickets.

GREEN: Seen the papers this morning?

SCOTT: Anything remotely interesting in them?

GREEN: There is a piece in the *Telegraph* and another mention (*She reads*) 'Hungarian Tragedy' . . . 'War Crimes Trial' . . . 'Did Doctor Yaron collaborate with the Nazis?'

SCOTT: (*He takes the paper, glances at it, shakes his head and puts it down*) There could be a retrial. If Jenkins considers that coercion was a factor, he could overrule the jury — that's if they go in our favour — and give directions which might lead to an appeal.
I seen they mention he has three children.

GREEN: Mmm.

SCOTT: Had you been in his place, would you have taken that train?

1

GREEN: (*Smiling*) Objection. Irrelevant and immaterial.

SCOTT: I think I would. (*He jabs his finger at her*) And so would you.

GREEN: That isn't the issue.

SCOTT: Of course not.

GREEN: What about the thousands he left behind?

SCOTT: You really hate him, don't you?

GREEN: Yes.

Pause. SCOTT *slowly nods his head in agreement.*

GREEN: (*Heatedly*) Do you know what they called the survivors when they landed in Israel after the war?

SCOTT: Soap.

GREEN: *Sabon.* That is how native-born Israelis referred to the Jews of the Diaspora. Soap. Cowards who allowed themselves to be slaughtered like cockroaches and turned into soap.

SCOTT: And he is to be blamed?

GREEN: Partly.

SCOTT: Only partly?

GREEN: There were others.

SCOTT: By the way, did you hear the radio this morning? People are dancing the Hora on the streets of Tel Aviv, celebrating the Israeli victory over the Arabs.

GREEN *smiles.*

SCOTT: Not soap any more? You've matured.

GREEN: We don't get kicked around.

SCOTT: (*Slyly*) And perhaps without men like Doctor Yaron, there may not have been a Jewish state, then you would have nothing to celebrate? (*Smiling at* GREEN's *unease*) I'm trying to understand some of the things that went into the making of him.

GREEN: (*Pointing to the documents*) Why bother? It's all here.

SCOTT: That's only the scaffolding.

Enter the defendant RUTH KAPLAN. *She is a quiet, attractive woman in her late twenties.* SCOTT *hurries out. As the rest take their places:*

GREEN: Nervous?

RUTH: A little.

GREEN: Don't be. Everything is going fine.

RUTH: You don't think there'll be any more adjournments?

GREEN: Shouldn't be. Not unless something unforeseen crops up, which is highly unlikely at this stage. Don't worry!

RUTH: When will I be called?

GREEN: Not until after lunch. Come on, I'll take you.

2

The lights cross-fade to a montage of photographs from the Jewish ghettos of the Second World War.

Music. Then:

ASSOCIATE OF THE COURT: *(V.O.)* . . . In the case of Doctor Miklos Yaron *v.* Ruth Kaplan.

LAWSON: My Lord, I appear for the Plaintiff who claims that the defendant, Ruth Kaplan, did falsely and maliciously write and publish a pamphlet entitled *I Accuse*. On page 14 of the said pamphlet are the following words which form the substance of the alleged libel:

'I accuse certain Jewish leaders of collaborating with the Nazis in 1944. Among them was Doctor Yaron. He knew what was happening in the extermination camps, and bought his own life and the lives of others with the price of silence.'

. . . To this charge, the defendant has entered a plea of justification, and it is your task, members of the jury, to say whether this justification has been proved.

The lights cross-fade to the courtroom. SCOTT *and* GREEN *appear for the defence,* LAWSON *for the plaintiff.*
LAWSON *is on his feet and* DOCTOR YARON, *a tall, distinguished man, is the witness box.*

LAWSON: Your name is Doctor Miklos Yaron, and you live at 64 Brantwood Terrace, Maida Vale?

YARON: *(His voice is clear and calm. But beneath it there is fear and tension)* Yes.

LAWSON: When did you come to this country?

YARON: I came here in February 1951.

LAWSON: From Israel?

YARON: Yes.

LAWSON: Where were you born?

YARON: Hungary. A place called Varad, near the Hungarian/Romanian border.

JUDGE: How do you spell that?

YARON: V–A–R–A–D.

LAWSON: What year was that?

YARON: 1903.

LAWSON: Can you tell the court something of your family background?

YARON: My father was an accountant. He worked for an oil company. My mother was Polish, and I had two sisters.

LAWSON: What became of your family, Dr Yaron?

YARON: When I was 15 my parents separated. She came from a strict Orthodox Jewish family, and my father had become a convert to Zionism. This she could not accept.

3

LAWSON: You received your medical education at Budapest University?

YARON: That is correct.

LAWSON: And did you practise there?

YARON: Yes, I specialized in gynaecology.

LAWSON: Was that until the war started in 1939?

YARON: Yes.

LAWSON: But you were in Switzerland when the war started, were you not?

YARON: I was attending a Zionist congress there.

LAWSON: And when the news came through, did you return to Budapest?

YARON: Not immediately. I was concerned about my mother and two sisters who were then living in Lodz.

LAWSON: You visited them?

YARON: Yes. I tried to persuade them to leave Poland.

LAWSON: And did they?

YARON: No.

LAWSON: Will you tell the court what happened to them?

Pause.

YARON: They died in Treblinka.

LAWSON: So it was only after a trip to Poland that you returned to your wife and children in Budapest?

YARON: Yes.

LAWSON *picks up the pamphlet, studies it, and puts it down.*

LAWSON: Miss Kaplan accuses you of collaborating with the Nazis.

YARON *nods.*

LAWSON: How do you respond to that?

YARON *shrugs.*

LAWSON: Is there any truth at all in that suggestion?

YARON: Absolutely none.

LAWSON: You dispute the authenticity of the missing notebook which Miss Kaplan brought back with her from Budapest, and which now forms part of the Szamosi Diaries?

YARON: No.

LAWSON: Who was Jacob Szamosi?

YARON: He was a Hungarian Jew who lived in Budapest.

LAWSON: Did you ever meet him?

YARON: No.

LAWSON: You never saw him?

4

YARON: I never knew he existed until the Diaries were discovered.

LAWSON: When was that?

YARON: Eleven years ago. 1956.

LAWSON: The year of the Hungarian uprising?

YARON: Yes.

LAWSON: And of course you will have read those Diaries?

YARON: Many times. The original is at the Jewish Historical Institute in Budapest and we have a copy here in London.

LAWSON: Would you describe them to the court?

YARON: They were written in the Hebrew language, and describe in detail the appalling conditions experienced by the Jews of Budapest during the war. A remarkable chronicle, written in children's notebooks and smuggled out of the ghetto.

LAWSON: What happened to Jacob Szamosi?

YARON: It's difficult to say exactly when, but it is almost certain that Szamosi, his wife and three children perished at Auschwitz extermination camp, some time in June 1944.

Pause.

LAWSON: Turning to Miss Kaplan — perhaps you could tell the court how you first came to meet her.

YARON: I have been involved with the National Jewish Library of Judaism here in London for some years. I offer advice. I help with translations. I travel abroad on behalf of the Library examining documents and manuscripts.

Two years ago Miss Kaplan came to me with a letter of recommendation from an old colleague of mine, who teaches at the University of Jerusalem.

LAWSON: In other words, she came to you looking for a job?

YARON: Yes.

I persuaded the Library Committee to offer her a position as researcher. But that wasn't too difficult. Miss Kaplan is highly qualified.

LAWSON: How did you get on with her?

YARON: Very well.

LAWSON: You had a good working relationship?

YARON: At the time I thought we did.

LAWSON: How did she come to be in Budapest?

YARON: In November 1965 we attended the International Oriental Congress in Moscow on behalf of the Library.

LAWSON: Whose idea was that?

YARON: Mine.

5

I also asked her if she would call into Budapest on her way home, and microfilm the Kaufmann Collection for the Library.

LAWSON: Is that when she discovered the missing notebook?

YARON: Yes.

LAWSON: But when did she first show it to you?

YARON: There was a small Hanukkah party at the Library. Miss Kaplan asked if she could speak to me privately. She said: 'Your past has caught up with you.'

Then she handed me the notebook. Told me it was part of the Szamosi Diaries, and that my name was mentioned. Then she repeated what she had said.

LAWSON: About your past catching up with you?

YARON: Yes. But I did not understand, until she opened the page and then I read it. (*Pause*) I couldn't believe my eyes.

LAWSON: You are speaking now of the entry on page 18 where Szamosi refers to seeing you with a member of the Eichmann SS?

YARON: Yes. But that I could explain. Every day we met with the SS. We had to. It was the *way* he wrote it. The underlying assumption. (*He shrugs*) A person you have never met puts your name in a notebook. Twenty-three years later you read it and there is nothing you can do about it. How can you question the dead?

LAWSON: What happened next?

YARON: The following morning I informed each member of the committee, and a meeting was arranged for January 3rd.

LAWSON: And what happened at that meeting?

YARON: Miss Kaplan asked that the notebook be published, immediately.

RUTH *shakes her head.*

GREEN *scribbles a note and passes it to* SCOTT.

LAWSON: Did you oppose it?

YARON: Yes.

LAWSON: On what grounds?

YARON: Because of the damage it could do to my name and my reputation.

LAWSON: Was it your intention to try and suppress the notebook?

YARON: No. Of course not.

LAWSON: Then what was your intention?

YARON: To delay publication until I could find witnesses who knew me in that period and who would testify.

LAWSON: And did the committee agree to this?

YARON: Of course.

6

LAWSON: What about Miss Kaplan?

YARON: No. Her mind was already made up. She got angry and began to shout. Said we were all Zionists. There was a big row, then she resigned and walked out.

LAWSON: And then six months later this pamphlet appeared.

YARON: Yes.

LAWSON: And it was then that you decided to seek legal advice?

YARON: Yes, but it was too late. The damage had already been done.

LAWSON: In what way?

YARON: Copies were sent to various Jewish organizations both here and abroad and it was reviewed in left-wing newspapers.

LAWSON: And what effect did it have upon your personal life?

YARON: Not only my life; it touched the lives of my family. I started getting phone calls and letters. In the Jewish community I became a pariah.

LAWSON: Would I be right in suggesting that the term Zionist is a code word for Jew?

JUDGE: Mr Lawson, there are many Jewish people who would not subscribe to that definition.

LAWSON: I withdraw the question.

YARON: (*He turns to the* JUDGE) May I say something.

JUDGE: Yes, Doctor Yaron.

YARON: It is true that not every Jew will identify with Zionism. But among non-Jews there is this belief. And this . . . intertwining of Jew and Zionist is common in nearly all anti-Semitic literature.

SCOTT *smiles.*

JUDGE: I am sure you are quite right, Doctor Yaron. But I fail to see how the defendant can be held responsible for the way others may seek to use and interpret her pamphlet.

LAWSON: I'd like to turn now to events in Budapest. How did you come to be a member of the Jewish Council in Budapest?

YARON: The *Judenrat* . . .

JUDGE: May I suggest that we use the word Council, Doctor Yaron?

YARON: Yes.

The JUDGE *nods and sits back.*

LAWSON: You were saying how you became a member.

YARON: The Council was mainly composed of pre-war leaders of the Jewish community.

LAWSON: And what was its function?

YARON: Before the coming of the Nazis?

7

LAWSON: Yes. What was its traditional function?

YARON: We looked after the welfare of our people. We helped the sick, fed the hungry and educated the children.

LAWSON: And what happened after the Nazis took over in March 1944.

YARON: All that changed. First thing that happened was that we were summoned to attend a meeting at the Hotel Majestic, addressed by Eichmann. He told us that we would have to form a central committee which would have total jurisdiction over all the Jews in Hungary, and that this Central Jewish Council would have to carry out German instructions. He said that nothing would happen to them providing that they worked hard and co-operated.

LAWSON: And what were your feelings about that?

YARON: (*He smiles*) Whatever we felt inside we hid. My feelings? (*He shrugs*) I went there with my suitcase packed, not knowing what would happen. But after Eichmann spoke, most of the others felt a sense of relief. They felt that by making themselves useful and carrying out German orders, they could buy time.

LAWSON: So you went away and formed a Central Council?

YARON: Yes. We submitted a list of names to Eichmann which he approved. Then we sent out a letter to each president of the Jewish communities in Hungary, saying that henceforth they would obey all instructions coming from the Council in Budapest. I remember at the time I was critical of this move to centralize our activities. I thought that we should wait and see what the Nazis had in store for us first, but I had to go along with the rest.

LAWSON: What would have happened had you just refused to serve on the Council?

YARON: I could have been executed.

LAWSON: Is that the only reason you remained a leader?

YARON: No, I felt it was my duty to stay and help set up some sort of administrative machinery which would serve the needs of the population. At the time, we had over 200,000 Jews living in Budapest, and I could not desert them.

LAWSON: But your efforts were not confined to administration, were they, Doctor Yaron?

YARON: No.

LAWSON: Were you not a member of a rescue committee?

YARON: Yes. The Zionist Rescue Committee was formed because we felt that the Jewish Council was not active enough. I was a member of both. We brought Jews in from Poland.

LAWSON: And hid them in Hungary?

YARON: Some we managed to get to Palestine via Romania.

LAWSON: And if you had been caught it could have cost you your life?

YARON: (*He nods and shrugs*) Yes.

LAWSON: Then the Zionists were very much involved with the Resistance in Hungary?

YARON: Of course. Many were tortured and died at Auschwitz. Our Zionist youth forged papers and acted as couriers. We urged diplomats from neutral countries to open up their buildings to Jews.

LAWSON: Can you say how many Jewish lives were saved by your actions?

YARON: I don't know.

LAWSON: Thousands?

YARON: Yes.

LAWSON: Ten of thousands?

YARON: Probably.

LAWSON: Yet Miss Kaplan accuses you of collaboration?

YARON: There was a Resistance and I was part of it.

LAWSON: Is there anything else you would like to tell the court about the Resistance?

YARON: There was the 18,000 we saved from Auschwitz.

LAWSON: Eighteen thousand?

YARON: They were scheduled for deportation. The Rescue Committee bargained with Eichmann and they were sent to labour camps in Austria.

LAWSON: Did any of them survive the war?

YARON: Over 70 per cent.

LAWSON: Thank you Doctor Yaron.

SCOTT *rises.*

SCOTT: Does Hebrew scripture teach that exile in the Diaspora was a punishment for Jewish sinfulness?

YARON: Yes.

SCOTT: Divinely decreed by God as a punishment for their transgressions against His law?

YARON: Yes.

SCOTT: And how long have the Jews held to this belief?

YARON: (*He shrugs*) Two thousand years.

SCOTT: And what year did Zionism first appear on the scene?

YARON: Zionism as a political movement was created by Theodore Herzl in 1897.

SCOTT: Seventy years ago.

YARON: Yes.

SCOTT: And would you agree that most of those early Zionists were atheists and non-believers?

YARON: Yes.

SCOTT: They rejected all religious concepts?

YARON: Yes.

SCOTT: Would you say that they were nationalists who directed all their efforts to the settlement of Jews in Palestine?

YARON: Yes.

SCOTT: Well, how did the rabbis take it? This sudden rupture with the Jewish religious tradition?

YARON: There was conflict.

SCOTT: Between the dictates of political Zionism and Divine Law?

YARON: Yes, but over the years agreement was reached.

SCOTT: A sort of pact?

YARON: Their aims became complementary.

SCOTT: Is it fair to suggest that the rulers of the new state of Israel avoided dividing the Jewish community by offering the religious element concessions on things like education and dietary laws, etc?

YARON: Yes.

SCOTT: Was this because without the stamp of biblical approval, Zionism could never have legitimized its claims to Palestine?

YARON: I would have thought that the holocaust and the murder of over six million Jews were sufficient grounds to underpin Zionist claims on Palestine.

SCOTT: Perhaps, so, Doctor Yaron. But the point I am trying to make is that Zionism annexed the Jewish religious tradition.

(*Pause. He shuffles papers*) Now let us move on. When you and your colleagues met Eichmann in March 1944 at the Hotel Majestic, how did he treat you? Was he polite, courteous, dismissive, arrogant?

YARON: Courteous.

SCOTT: Friendly?

YARON: Courteous.

SCOTT: And did you know at the time that five million Jews had already been exterminated?

YARON: It's difficult to remember what we knew at that moment.

SCOTT: Did you know that five million Jews had already been exterminated?

YARON: We knew something about the camps, yes.

SCOTT: Thank you. Did you also know of the role Eichmann had played in the liquidation process?

YARON: Yes.

SCOTT: That he was the Technician. The man whose bands of killers roamed Europe seizing Jews and arranging their transport to the death camps?

YARON: Yes.

SCOTT: Then how did you feel when this vulture suddenly appeared spreading and flapping his wings in Hungary, the last place and refuge of one million Jews? Didn't that tell you something?

YARON: We feared the worst.

SCOTT: Yet agreed to carry out his orders.

YARON: At first we hoped that we could negotiate with him and save all the Jews in Hungary.

SCOTT: It is right, isn't it, that Eichmann arrived in Budapest on March 19th, 1944?

YARON: Yes.

SCOTT: And that shortly after his arrival, all Jewish shops, stores and warehouses were closed down, and perishable goods auctioned off to non-Jewish enterprises?

YARON: Yes.

SCOTT: Bank accounts were closed. Personal property seized: cars, radios, books, etc. On March 29th, ten days later, all Jews above the age of 6 were compelled to wear the Jewish star?

YARON: Yes.

SCOTT: And the Council issued an order preventing all Jews from leaving or entering Budapest without its permission?

YARON: Yes.

SCOTT: Hungary was divided into six different zones, and in each zone the Jewish population was crowded into makeshift ghettos, and all this happened with the full co-operation of the Jewish Council?

YARON: Yes.

SCOTT: Surely it must have been obvious that the physical isolation, the round-up and the ghettoization of the Jewish people could only mean that the next step was deportation? *(Pause)* Does the name Rudolph Kastner mean anything to you?

YARON: Yes.

SCOTT: Was he a former president of the Zionist Organization in Budapest?

YARON: Yes.

SCOTT: How long had you known him?

YARON: A long time. Many years.

SCOTT: In fact, you were both active together in the Zionist movement before the war, and during the Nazi occupation.

YARON: Yes.

SCOTT *picks up a paper from his desk.*

SCOTT: I have here a *statement* made by your friend Kastner. It is, I suggest, conclusive evidence that as far as the Jewish leadership in Hungary was concerned, the future of Hungarian Jewry had already been decided. *(He reads)*

'In Budapest we had a unique opportunity to follow the fate of European Jewry. We had seen how they had been disappearing one after the other from the map of Europe. At the moment of the occupation of Hungary, the number of dead Jews amounted to over five million. We knew very well about the work of the *Einsatzgruppen*. We knew more than was necessary about Auschwitz and the other extermination camps.'

(He puts the statement down)

Would you say that that is a fair assessment of how you all felt at the time?

YARON: Yes, more or less.

SCOTT: Privileged information, Doctor Yaron?

YARON: Sorry?

SCOTT: Did your Jewish people realize the immediate and mortal danger they were in?

YARON: Many refugees from the East were hiding in Budapest. They must have known what to expect.

SCOTT: And in the provinces? In those isolated scattered communities. Did they know what to expect?

YARON: They must have had some idea.

SCOTT: And so they just sat at home waiting for it to happen? *(Pause)* What would you say was Eichmann's biggest problem?

YARON: I don't know what you mean.

SCOTT: He came to help murder one million Jews, and his reputation had preceded him. Do you agree that in order to successfully carry out his killing operation, he first had to dispel the fears of his victims? To hoodwink them?

YARON: I suppose so.

SCOTT: Do you agree, Doctor Yaron?

YARON: Yes.

SCOTT: And what better way of achieving this than by enlisting the support of Jewish leaders like yourself and Doctor Rudolph Kastner?

YARON: *(Angrily)* That is a lie! *(Restraining himself)* It was not like that.

SCOTT: You carried out his orders. You did everything Eichmann asked of you.

YARON: We had no choice. But we did not support him, not in

the way you mean.

SCOTT: You knew Eichmann was an expert. You knew he had studied Hebrew and was the Nazis' specialist on Zionism. He knew that Jews lived in close-knit communities, and did what their Elders, their leaders, told them. What was the first instruction Eichmann gave you at that meeting in the Hotel Majestic?

YARON *looks blank.*

You've already referred to it. Was it to inform the leaders of every Jewish community in Hungary that henceforth they were to carry out the orders of the Central Jewish Council in Budapest?

YARON: Yes.

SCOTT *turns and goes over to the desk. He sorts through the documents and* GREEN *hands him a sheet of paper. He turns and confronts* YARON.

SCOTT: In fact, I have here the actual manifesto. (*He reads:*)

'The Central Jewish Council has been granted the right of absolute disposal over all Jewish manpower. You, women and girls, men and boys, are all executors of the instructions issued by the Central Council. You must realize that every decision, however momentous it may be, is the outcome of official intervention and the existence of the community as a whole depends on such instructions being fully observed.'

He drops the paper on the desk.

'The right of absolute disposal'. Now, why do you think Eichmann gave such powers to the Council?

YARON: Whatever the reason, we were in no position to argue.

SCOTT: But you were in a position to co-operate?

YARON: We had to.

SCOTT: I suggest, Doctor Yaron, that the very first step along the road which led to the destruction of Hungarian Jewry was when you put your names to that manifesto.

YARON: It was the only valid response.

SCOTT: Would you agree that Eichmann's priority . . . was the need to prevent panic and resistance? To avoid another Warsaw uprising?

YARON: Looking back — yes. But at the time there was little else we could do.

SCOTT: You could have told them the truth. Told them the facts about Auschwitz. About the five million dead. You could have told them to flee, to resist. To run for their lives.

YARON: There was nowhere for them to go. Where could they have fled to?

SCOTT: But you yourself fled, Doctor Yaron. You, Kastner and the others. You got away all right.

Pause. YARON *shakes his head.*

YARON: You see things as they are now, here in this courtroom. In the abstract. You have the law to protect you. You sleep safe in your bed. You don't have to wear a star. You know nothing of the terrible burden. You have no conception. You should go down on your knees and thank God that you didn't have to experience what we went through.

SCOTT: Doctor Yaron, the accusations and the indictment come from your own people. From men like Szamosi, Rabbi Michael Dov-Ber Weissmandel, and Rudolph Verba . . . does that last name mean anything to you? Verba? Doctor Rudolph Verba?

It clearly does, and YARON *looks and says nothing.*

SCOTT: Perhaps if I were to refresh your memory. In April 1944 Rudolph Verba was one of two men who escaped from Auschwitz and warned Jewish leaders in Hungary that evacuation meant death. His warnings were ignored. Seventeen years later, in February 1961, Doctor Verba's memoirs were published in the Daily Herald. May I quote them to you?

He picks up a paper and reads:

'I am a Jew . . . In spite of that — indeed, because of that — I accuse certain Jewish leaders of one of the most ghastly deeds of the war. This small group of quislings knew what was happening to their brethren in Hitler's gas chambers, and bought their own lives with the price of silence.

'I was able to give Hungary's Zionist leaders three weeks' notice that Eichmann planned to send one million Jews to his gas chambers. Kastner went to Eichmann and told him: "I know of your plans, spare some Jews of my choice and I shall keep quiet." Eichmann not only agreed, but dressed Kastner up in SS uniform and took him to Belsen to trace some of his friends.'

SCOTT *drops the paper on the desk and looks up at* YARON.

SCOTT: Is this true, Doctor Yaron?

YARON: *(Stiffly)* Kastner never dressed in SS uniform.

SCOTT: Were you given three weeks' notice of Eichmann's plans to send one million Jews to the gas chambers?

Long pause.

YARON: We were given an eye-witness account of the killings and atrocities committed at Auschwitz, but there was no actual evidence of that happening in Hungary.

SCOTT: You thought you were safe?

YARON: From extermination, yes.

SCOTT: Yet Kastner himself testified during a libel case in 1953, that at the end of April, the Nazis informed him that they had decided on the total deportation of Hungary's Jews?

YARON: *(After a slight pause)* I knew nothing about that.

14

SCOTT: All right. Let us take it in stages. Rudolph Verba and Alfred Wetzler escaped from Auschwitz on April 7 1944. Both had been prisoners there for two years and knew every aspect of the killing operations. Is that correct?

YARON: Yes.

SCOTT: Was their main concern to publicise what was happening at Auschwitz, and in particular to warn the Hungarian Jews?

YARON: Yes.

SCOTT: Did they write a report stating in detail what they had both seen and experienced?

YARON: Yes.

SCOTT: Did you see the report?

YARON: Yes.

SCOTT: Who showed it to you?

YARON: Kastner.

SCOTT: Will you please tell the court how Kastner came to get hold of the report?

YARON: After their escape, Verba and Wetzler made their way into Slovakia. On April 25, they met a leading Zionist in Zilina and told him their story. It was there that they wrote their report.

SCOTT: And then?

YARON: Copies were made and smuggled to the West. One copy was translated into Hungarian, and the Zionist in Zilina promised to deliver it to Doctor Kastner.

SCOTT: And did he?

YARON: Yes. Three days later, on April 28, Kastner visited Zilina, picked up the report, and returned with it to Budapest.

SCOTT: To show to you and the other Jewish leaders?

YARON: Yes.

SCOTT: And you had no doubt at all in your mind that the report was authentic?

YARON: Absolutely none.

SCOTT: So what did your meeting decide?

YARON: Our decision was to negotiate secretly with Eichmann and the SS.

SCOTT: And not to publish the report?

YARON: No.

SCOTT: Nor to urge the Jews to resist deportation?

YARON: We hoped that our negotiations would help to avert the deportations.

Pause.

SCOTT: Tell us about these 'negotiations', Doctor Yaron.

YARON: On April 25 . . .

SCOTT: The same day that Verba and Wetzler were writing their report?

YARON: Yes. Joel Brand, a leading member of the Zionist Rescue Committee, was summoned to a meeting with Eichmann.

SCOTT: Where was this?

YARON: At the SS Headquarters in Budapest. Eichmann offered to sell Jews. Goods for blood. One million Jews. To negotiate the proposals with the Allies and the Jewish Agency, he said that Brand would be permitted to leave Hungary as an emissary.

SCOTT: And did he?

YARON: Yes. He arrived in Istanbul on the 19 of May.

SCOTT: And then what happened?

YARON: He went to Syria to meet Moshe Shertok, Head of the Agency's Political Department. But then the British arrested him and he was taken to Egypt where he was imprisoned.

SCOTT: Can you tell the court why he was arrested?

YARON: (*Shrugs*) Perhaps because they saw him as an emissary from the Germans . . . I don't know why. But he was held in a Cairo prison for four and a half months.

SCOTT: What sort of goods did Eichmann ask for as ransom?

YARON: Food. Tea, coffee, soap. Ten thousand trucks for use on the Eastern Front.

SCOTT: And how did the Allies respond to this offer?

YARON: They rejected the proposals.

SCOTT: Did that surprise you? Did you seriously believe that one month before the Normandy invasion, the Allies would be prepared to move one million Jews across Europe, tying up transport and shipping, and then send material goods back into Germany? Thousands of trucks, which would be used to aid the German war effort?

YARON: It was a period without precedent. We hoped that if we could get the Allies to negotiate and keep talking, it would help keep Jews alive in the camps.

SCOTT: When did the mass deportations to Auschwitz begin?

YARON: May 15.

SCOTT: And within the space of five weeks nearly half a million had been exterminated.

YARON: Yes.

SCOTT: Then clearly, Doctor Yaron, the Jews were not being kept alive in the camps, were they? While you conducted your secret negotiations with the Nazis, they were being shipped off in sealed trains; shot, gassed, and incinerated.

Pause. He picks up the pamphlet.

16

SCOTT: In her pamphlet, *I Accuse*, Miss Kaplan quotes an interview which Eichmann gave to a Dutch journalist.

YARON: *(With sarcasm)* The Eichmann Confessions.

SCOTT: Published in *Life* magazine.

YARON: *(With a mocking laugh)* Here is a Jew believing in Eichmann!

SCOTT: *(Factually)* In 1955 while in hiding in Argentina, Eichmann was interviewed by former SS man, Willem Sassen. What later became known as the Sassen Documents was published in the German magazine, *Der Stern*, in July 1960, and in *Life* magazine in December. Seventy pages written by Eichmann upon which the interview was based, was accepted as evidence at the Eichmann trial. The extract which Miss Kaplan quotes in her pamphlet, does seem to confirm the accusations made by Rudolph Verba. If I might remind the court:

SCOTT *opens the pamphlet and finds the page he is looking for.*

SCOTT: *(Reading)* 'I now concentrated on negotiations with the Jewish political officials in Budapest. Among them, Doctor Rudolph Kastner, authorised representative of the Zionist movement. This Doctor Kastner was a young man about my age, an ice-cold lawyer and a fanatical Zionist. He agreed to help keep the Jews from resisting deportation and even keep order in the collection camps, if I would close my eyes and let a few hundred or a few thousand young Jews emigrate illegally to Palestine. It was a good bargain. For keeping order in the camps the price was not too high for me. We trusted each other perfectly. I believe that Kastner would have sacrificed a thousand or a hundred thousand of his blood to achieve his political goal. "You can have the others," he would say, "but let me have this group here". And because Kastner rendered us great service by helping to keep the deportation camps peaceful, I would let his group escape. After all, I was not concerned with small groups of a thousand or so Jews. That was the gentleman's agreement I had with Kastner.'

Pause. SCOTT *and* YARON *stare into one another, then* SCOTT *opens the pamphlet on the desk and turns to the jury. (Audience):*

SCOTT: After the war Kastner went to Israel where he became Editor of an Hungarian language newspaper. In 1953, an Israeli citizen, Greenwald, accused him of collaborating with the Nazis, and because Kastner was a highly placed Zionist, the government prosecuted Greenwald for libel. The Jerusalem court found Greenwald innocent and ruled that Kastner did collaborate. The government filed an appeal, and on January 17, 1958, the Supreme Court, by a majority of three to two found that what Kastner did was morally justifiable. The Jerusalem court's verdict was reversed.

Pause.

17

SCOTT: We have established that the deportations began in May 1944.

YARON: Yes.

SCOTT: The last year of the war in Europe. One month before the allied armies landed in France. (YARON *nods his head slowly*) And during that period, 12,000 a day were being sent to Auschwitz. Numb, confused, lied to, they marched in columns and piled onto trains while their leaders stood back with folded arms and let it happen. This also we have established.

YARON: We did protest.

SCOTT *angrily snatches up a slip of paper.*

SCOTT: Petition to Interior Minister Jaroszi:
'We emphatically declare that we do not seek this audience to lodge complaints about the merits of the measures adopted, but merely ask that they be carried out in a humane spirit.' This was your protest?

YARON: (*Evasively*) What I meant was . . . we still thought rescue was possible.

SCOTT: For you, yes.

YARON: And for others.

SCOTT: But the trains were already taking them off to Auschwitz! Why didn't you warn them?

YARON: (*Weaker*) What good would it have done?

SCOTT: It would have saved thousands of Jewish lives.

YARON: Not necessarily.

SCOTT: (*After a slight pause*) Why do you say that?

YARON: They had guns, we didn't. They were armed and trained.

SCOTT: Eichmann thought differently.

YARON: We had nothing.

SCOTT *puts down the slip of paper and takes up the pamphlet. He thumbs through it and finds the page he is looking for.*

SCOTT: Allow me to read you something else Eichmann said in his Confessions: 'We wanted Hungary combed with a tremendous thoroughness before the Jews could really wake up to our plan and organise Partisan resistance.'

He throws the pamphlet down and stares disdainfully at YARON.

SCOTT: Had not the Jews of Europe, abandoned by its leadership already distinguished themselves by acts of resistance against the Nazis?

YARON: Yes. But they were not abandoned.

SCOTT: Were they not active in the Partisan movements?

YARON: Yes.

SCOTT: Even in the concentration camps, had there not been uprisings and revolts?

YARON: Yes.

SCOTT: (*Incredulously*) Then why did you not issue a proclamation calling upon the inhabitants of the Ghettoes to resist?

Pause. YARON *stands in silence.*

SCOTT: How many SS men did Eichmann have at his disposal?

YARON: I don't know.

SCOTT: One hundred and fifty.

YARON: Assisted by the Hungarian Fascist Police.

SCOTT: Five thousand, Doctor Yaron. (*In disbelief*) One hundred and fifty SS and five thousand Hungarian gendarmes against a million Jews. Is it not obvious, that had the Jews refused to board the trains Eichmann could not have coped, simply because he did not have the manpower, and was afraid of another Warsaw uprising?

YARON: (*Hesitates, then*): You refuse to understand.

SCOTT: Then tell us. Perhaps it will help us to understand how he was able to deport half a million Jews in two months, given the situation which I have just described.

YARON: What you have just described has nothing to do with what it was really like.

SCOTT: What was the routine before every killing operation?

YARON: How do you mean? I don't understand.

SCOTT: The victims, men, women and children marked for destruction, had to be isolated and targeted, right?

YARON: (*Warily*) Yes.

SCOTT: A crucial stage in the liquidation process.

YARON *nods, still not sure.*

SCOTT: Why then, when the SS followed this routine of differentiating between Jew and Gentile by compelling all Jews over a certain age to wear the six-pointed Star of David, did the Jewish Council not resist?

YARON: How could we? Each day there were more and more prohibitive decrees and regulations.

SCOTT: In fact, when the Germans first decided that the stars should be sold at 3 *pengoes* each, you agreed, and then when this order was cancelled, you published a warning, did you not? (*He picks up paper*)

'It is incumbent upon everyone concerned to supply himself with a star of the prescribed dimensions until a standard model has been issued.'

SCOTT *puts down the paper and takes up another.*

On the same day that this warning was published, were there not angry scenes and demonstrations outside the Council headquarters in Sip Street?

YARON: There were often scenes. People were always protesting and complaining.

SCOTT: Yes, but on this particular occasion, speeches were made calling upon the Jewish Council to resist. Isn't that so, Doctor Yaron?

YARON: Not to my knowledge.

SCOTT: Were not police called in to protect the building and maintain order in the surrounding streets?

He looks across at YARON, *inviting comment.* YARON *stares back at him.*

SCOTT: In an attempt to calm and soothe the Jewish population, did the Council then publish the following article?

'Work and do not be downhearted. Let every Jewish co-religionist, whether rich or poor, consider it his duty to devote his entire energy to any task that he may be called upon to do. We emphasize the absolute necessity for every instruction, regulation, order or command emanating from the competent Authorities to be observed immediately and in full without any complaint or objection whatsoever.'

Could Eichmann himself have asked for more?

He drops the papers onto the desk, looks at his notes and continues.

On April 20, the Council was summoned to a meeting in the Jewish Theological Institute where they were instructed to provide the SS with large-scale maps showing the exact location of all provincial Jewish communities, schools, buildings and institutes, etc. Yes? Seven days later the final round-up began. Branded with the Star of David, herded in ghettos, factories, brick kilns and open fields, the Jews of Hungary were assembled like meat on the hoof waiting to be slaughtered.

That is how the Jewish leadership reacted, Doctor Yaron, isn't it? By flopping down on all fours. Grovelling, servile, obedient?

YARON: We were forced to become obedient! We had no choice. But all the time we schemed, manoeuvred and plotted to help and support our people . . .

We lived a day-to-day existence, bargaining and hoping to delay the process of extermination.

SCOTT: By stifling every voice of criticism?

YARON: Suddenly we were thrown into a cage with this monster Eichmann. How do you deal with it? It was like trying to keep an animal at bay. By appeasement. By feeding him scraps. By cunning, lying, bribery and corruption. The Nazis made speeches

full of promises which we wanted to believe because the alternative was too terrible to contemplate . . .

SCOTT: But you knew, Doctor Yaron! You already knew! Three-quarters of the Jews in Europe were already dead!

YARON: Always you think that you will be the exception. To begin with, their demands were for material things. Blankets and bedding which we took from the Jewish hospital. Eating utensils, furniture, money, apartments. Then stupid, ridiculous things like scent, eau de cologne, women's lingerie . . . even pianos.

SCOTT: Then life itself.

YARON: (*Withdrawing*) You cannot judge me in retrospect, Mr Scott, because you weren't there.

SCOTT *nods his agreement.*

SCOTT: Of course the act of collaboration did not happen all at once, as the defence will show. Its roots lay in the pre-war efforts of some Zionists to effect an alliance with the Nazis.

LAWSON: (*Angrily*) My Lord, is the defence then saying that Zionism helped Hitler to destroy the Jews?

SCOTT: (*At* LAWSON) No, my Lord, our contention is that before the Final Solution, the Nazis wanted the Jews out of Europe and the Zionist leaders were only too happy to oblige — providing they went to Palestine. Thus, in form, if not in essence, the interests of Zionism and Nazism coincided. Once the extermination programme began, it then became a salvaging operation: the salvation of the 'best biological material'. The 'prominents', the pioneers and the Zionist youth who would help build the Jewish homeland in Palestine. The fact is, Doctor Yaron, your daily contacts with Eichmann and the SS, the step-by-step compliance and co-operation with the German and Hungarian fascists led ultimately to out-and-out collaboration until, in the end, the Jewish Council became a cat's-paw in the hands of Eichmann.

Isn't it true that without your collaboration his task would have been impossible?

No more questions, my Lord.

SCOTT *walks to his desk and sits down.* LAWSON *rises.*

LAWSON: Doctor Yaron. Was it the aim and object of the Jewish Council in Budapest to assist the Nazis in the extermination of the Jews?

YARON: Of course not.

LAWSON: Are you surprised that some Jews like Szamosi for example, were critical of the role played by the Council?

YARON: No. We were 'visible'. People saw us talking with the Nazis and having meetings with them.

LAWSON: It may help the jury if you could explain briefly what the situation was in Hungary prior to the Nazi occupation.

YARON: Hungary was Germany's ally during the war. It was really a satellite relationship. The Regent of Hungary was Admiral Horthy, a sick old man in his seventies. At that time Hungary was the only country in Europe with its Jewish population still intact, and Hitler was demanding that the Jews there be included in the Final Solution. Although anti-Semitic laws had been introduced, the Hungarian government, afraid of Allied retribution, had refused to take part in the extermination programme. They argued that the Jews should be used as forced labour, but allowed to live. Then, on March 15, 1944, Hitler gave Horthy an ultimatum: a choice between German military occupation or a German-approved government — which in reality amounted to the same thing. Horthy chose the latter and four days later the new German Minister for Hungary, Doctor Edmund Veesenmayer, arrived in Budapest.

LAWSON: Thank you. Now can we go back to the work of this Rescue Committee. On April 25, when Joel Brand reported to the Committee Eichmann's offer to spare one million Jews in exchange for a cargo of goods, how did you and the others react?

YARON: With absolute horror. We couldn't believe it. For a long time we said nothing. We just sat and stared at one another.

LAWSON: You were naturally suspicious?

YARON: Of course. But he had dangled a carrot. He said that although the deportations would have to continue, he would stop the killings for two weeks to allow Brand time enough to start the negotiations.

LAWSON: So even though Jews were still being transported to Auschwitz, you had reason to hope that they would remain alive?

YARON: Yes.

LAWSON: Are you saying that you trusted Eichmann?

YARON: No. But we were grasping at straws. We hoped that by entering into this arrangement, we could perhaps slow down the extermination of Hungarian Jews.

LAWSON: And while Joel Brand was out of the country, what were you doing?

YARON: I went with Kastner and SS Colonel Becher to Switzerland to try to obtain funds for the rescue.

LAWSON: Did you meet with any success?

YARON: Not on that occasion, no.

LAWSON: So you returned to Budapest?

YARON: Yes.

LAWSON: Was that the end of the negotiations?

YARON: No. Kastner and I kept the talks going with Eichmann,

while Sally Meyer conducted the negotiations with Colonel Becher in Switzerland.

LAWSON: But what were you left to bargain with?

YARON: We had nothing. Bluff, promises, the offer of bribes we could never deliver. Anything to keep the talks going in the hope that we could save Jewish lives.

LAWSON: And how successful were you?

YARON: At the end of June a train left Budapest for Bergen-Belsen with 7,000 Jews on board. On August 21st as a gesture of goodwill, the Nazis allowed 318 of those to go to Switzerland and a further transport of 1,300 arrived on December 5th.

LAWSON: It is suggested by the defence that the Jewish leaders were standing back with arms folded. In actual fact, you were doing everything humanly possible to save your people?

YARON: Yes.

LAWSON: Did you feel betrayed by the attitude of the world outside?

Pause.

YARON: Betrayed? That is perhaps a strong word. Many Allied lives were being lost, and the first priority was to smash Hitler and end the war. What were the lives of a few more Jews? By that time we had already lost five million.

LAWSON: Well, did you at any time feel that Jewish lives were expendable?

YARON: In war, Mr Lawson, all lives are expendable. We were the victims. We feared death and thought rescue possible. We were wrong. It didn't happen. What else can one say?

LAWSON: Thank you, Doctor Yaron.

A light picks out a photo from the montage.
Music. Then:

LAWSON: Call Laszlo Vandor.

VANDOR *is roughly the same age as YARON. Confident and sure of himself. A man used to taking decisions.*

LAWSON: Your name is Laszlo Vandor?

VANDOR: Yes.

LAWSON: Where do you live, Mr Vandor?

VANDOR: Budapest.

LAWSON: You are a government employee, I believe?

VANDOR: Yes. I work with the Department of Trade. A director.

LAWSON: Do you know the plaintiff, Doctor Yaron?

VANDOR: We were both members of the Jewish Council in Budapest during the war.

23

LAWSON: Miss Kaplan has accused him of collaborating with the Nazis.

VANDOR *smiles.*

LAWSON: What do you think of that?

VANDOR: (*Simply*) I say it is a lie.

LAWSON: Is there any truth at all in the allegation?

VANDOR: None at all. Doctor Yaron took great personal risks. He did more than any of us to help the Jews in the provinces.

LAWSON: Can you give the court an example?

VANDOR: Jews were only allowed to travel if they had a special permit. This prevented them from escaping from the provinces when deportations started. The Council decided to issue its own travel permits, and it was Doctor Yaron who not only organized the distribution of these permits, but actually took them himself.

LAWSON: What do you think would have happened to him had he been caught?

VANDOR: I know what would have happened. He would have been shot. Or deported.

LAWSON: Together with his family?

VANDOR: Yes.

LAWSON: Thank you, Mr Vandor. SCOTT *rises.*

SCOTT: Are you a Zionist, Mr Vandor?

VANDOR: (*He smiles*) In Hungary . . . ?

SCOTT: Are you a Zionist?

VANDOR: No.

SCOTT: Do you belong to the Hungarian Communist Party?

VANDOR: Yes.

SCOTT: Were you a member of the party during the war?

VANDOR: No. I joined after the war. 1949.

SCOTT: Doctor Yaron is a Zionist. Given the relationship existing between Communist countries and Israel, can I ask why you, a Communist, should choose to come forward as a witness for the plaintiff?

VANDOR: I came because Doctor Yaron is accused of collaborating with the Nazis. That is not true. I was there. I saw with my own eyes.

SCOTT: Were you involved with the Rescue Committee?

VANDOR: I was very young at the time.

SCOTT: Were you involved?

VANDOR: Yes. But not to the same extent that he was.

SCOTT: Why did Eichmann choose to negotiate with the Rescue Committee? Why not the Jewish Council?

VANDOR: Because the Council was without any real influence.

SCOTT: Outside of Hungary?

VANDOR: Yes. It did not have official backing from the world Zionist movement in the way that Kastner and his group had.

SCOTT: Or access to the funds controlled by Meyer in Switzerland?

VANDOR: Yes.

SCOTT: Along with the international connections in Washington, London and Jerusalem?

VANDOR: Yes.

SCOTT: But the Zionist group led by Kastner, Brand and Doctor Yaron did?

VANDOR: Why else would Eichmann single out the Zionists when it came to serious bargaining?

SCOTT: Was there a difference in Eichmann's attitude towards the Zionists, as opposed to the Jewish Council?

VANDOR: All the time. He had contempt for the Council.

SCOTT: And the Zionists?

VANDOR: He treated them with more respect. They were given privileges. Often they would conduct their meetings in coffee houses.

SCOTT: Where?

VANDOR: In coffee houses.

SCOTT: One last question. Were you a passenger on the rescue train that left Budapest and arrived in Switzerland on December 6th?

VANDOR: Yes.

SCOTT: Did Doctor Yaron arrange for your passage?

VANDOR: Yes.

SCOTT: Then I suggest that you owe him your life, Mr Vandor. No further questions.

LAWSON: Thank you, Mr Vandor. Call Stanley Karpin, please.

SCOTT *sits down leaving* VANDOR *looking angry. A photo on the montage. The sound of engines shunting. Then:*

KARPIN *enters the court and goes into the witness box. He takes the oath. He is an alert 66-year-old, relaxed and self-assured.*

LAWSON: Is your name Stanley Karpin, and do you live at Meadowcroft Lodge, Brighton?

KARPIN: Yes.

LAWSON: Have you an occupation, Mr Karpin?

KARPIN: Retired. I was a Labour member of parliament from 1945 until 1959.

LAWSON: You also served on the Board of Deputies for British Jews, did you not?

KARPIN: I did.

LAWSON: And were you also a member of the Executive of the World Zionist Organization?

KARPIN: Yes.

LAWSON: How well did you know Doctor Yaron?

KARPIN: I first met him in 1939 at the Zionist Congress in Switzerland.

LAWSON: Do you regard him as a friend?

KARPIN: Yes.

LAWSON: And how would you describe his character?

Pause.

KARPIN: Highly intelligent. Honest, and in my opinion totally incorruptible. Although he has been active in the Zionist movement for many years, he was always more of an academic than a political activist. He had no time for intrigue. If he had a weakness, then I would say it was an excess of generosity. He values personal relationships, and can easily be taken advantage of.

LAWSON: From your knowledge of him, can you conceive that he would have collaborated with the Nazis to save his own skin?

LAWSON: Absolutely not. He would have given his life.

LAWSON *picks up the pamphlet.*

LAWSON: Have you read this pamphlet?

KARPIN: Yes.

LAWSON: And what do you think of it?

KARPIN: (*He smiles and shrugs*) It is the type of thing the Soviet press occasionally produces. An inventory of lies and half-truths arranged to accommodate Miss Kaplan's obvious hostility to Zionism, which she seems at times to equate with Fascism, forgetting that the one was occupied with the extermination of the other. For her to repeat the myth of Nazi–Zionist collaboration is not only a libel against Doctor Yaron, it is a libel against the six million Jewish dead.

LAWSON: Was it right for Doctor Yaron and other Jewish community leaders to co-operate with the Nazis?

KARPIN: In my opinion, given the situation in which they found themselves, they had no other alternative. Jewish lives had to be saved.

LAWSON: You would not see it as collaboration?

KARPIN: Of course not. Someone had to negotiate with the Nazis, and as I understand it, the sole purpose of the negotiations was to save Jewish lives.

You see, nowadays people tend to forget just how alone and isolated the Jews of Europe were. One cannot judge the actions of Doctor Yaron or any other Jewish leader in Occupied Europe without taking into consideration the Allies' refusal to mount any kind of rescue operation.

LAWSON: You say the Allied refusal?

KARPIN: (*Firmly*) There is no other way to put it. Like their refusal to bomb the railway lines leading into Auschwitz, for example. Or the time when the Swedish government offered to save the lives of 20,000 Jewish children and America blocked it.

LAWSON: When was that?

KARPIN: Early 1943. I remember I was at a meeting when word came through that the Swedes were ready to accept these children, providing Germany agreed and Britain and America shared the cost of transport and food. We were all for it, but the American State Department's attitude was negative.

LAWSON: In what way?

KARPIN: They started dragging their feet. Internal memos flying backwards and forwards. One memo stated that approval should be withheld until President Roosevelt had decided from which fund the payment for the children should be made. That sort of thing. In the end the rescue mission was abandoned.

LAWSON: And 20,000 Jewish children perished?

KARPIN: I would imagine so.

LAWSON: How would you explain the State Department's behaviour?

KARPIN: I personally attribute it to the presence of anti-Semitic influences at work within the State Department itself.

I mean, you had men like Assistant Secretary of State Breckinridge Long, who when he was ambassador to Italy in 1933 sent a report to Roosevelt praising the Fascist regime and saying what a great leader Mussolini was. Seven years later, Roosevelt makes him assistant Secretary of State, make of that what you will.

LAWSON: And you are saying, then, that the way the Allies ignored the fate of the Jews influenced the conduct and behaviour of Jewish leaders in the occupied countries?

KARPIN: Of course. They were left to their own devices.

LAWSON: Thank you, Mr Karpin.

LAWSON *returns to his desk and* SCOTT *rises.*

SCOTT: If what you say is true about the fate of these Jewish children . . .

KARPIN: It is a fact. It happened.

SCOTT: Then the question arises: why did not the American Jewish Congress intervene?

KARPIN: (*He smiles*) That is a question you should put to them.

SCOTT: I'm asking you, Mr Karpin.

KARPIN *stiffens*.

SCOTT: Were you not on the Executive of the World Zionist Organization at the time of these negotiations?

KARPIN: Yes.

SCOTT: And were you personally involved in the talks at this end in London?

KARPIN: Yes.

SCOTT: Then I suggest that you are in a position to answer my question. What was the name of the leader of the American Jewish Congress in 1943.

KARPIN: Rabbi Stephen Wise.

SCOTT: And is it correct that he was on first-name terms with President Roosevelt? That whenever he wrote to him, he referred to him as 'Dear Boss'?

KARPIN: (*Uncomfortably*) I believe so.

SCOTT: Is it true that as early as August 1942 a representative of the Zionist Congress in Switzerland sent two cables, one to the British section of the World Jewish Congress here in London and one to Rabbi Wise in New York . . .

KARPIN: Yes.

SCOTT: . . . confirming Hitler's plan to exterminate every Jew in Europe?

KARPIN: Yes.

SCOTT: Will you please tell the court what happened to those cables.

KARPIN: The cable sent to Wise was suppressed by the State Department. He only found out about it when we sent a copy to New York.

SCOTT: So what did he do then?

KARPIN: He went to see the Under-Secretary of State, Sumner Welles, and complained.

SCOTT: And the cable was then released?

KARPIN: No. Welles asked him not to make public the contents until it had been confirmed.

SCOTT: And did the Rabbi Wise agree to this?

KARPIN: Yes.

Pause.

SCOTT: Let me get this straight, and because the jury may find this hard to believe. This was August 1942. Had not the Nazis already embarked on their programme of 'resettlement'? Jews were being deported from Poland, France and elsewhere. Only

28

one month before, 380,000 Jews were shipped out of the Warsaw ghetto. Is that correct?

KARPIN: Yes.

SCOTT: And presumably reports were coming in from other sources confirming Hitler's decision to liquidate all Jews?

KARPIN: Yes.

SCOTT: Given this amount of intelligence, would you say, then, that Rabbi Wise must have known what the cable said was true?

KARPIN: I would think so. (*Seeing the look on* SCOTT*'s face*) Yes.

SCOTT: And yet he agreed to remain silent. The head of five million American Jews.

KARPIN: I personally would have shouted it from the rooftops, but the situation in America was different. Wise was persuaded that the only salvation for the Jews was an Allied victory, and that any outcry or rescue attempt would jeopardize the war effort.

SCOTT: Correct me if I'm wrong, Mr Karpin. But did you not in your earlier testimony accuse the Allies of refusing to mount any kind of rescue operation?

KARPIN: (*Tightlipped*) Yes.

SCOTT: Then are you not being a little selective in your criticism? Here we have the Rabbi Stephen Wise, leader of five million American Jews, not only agreeing to remain silent but also acting as an accomplice of those very same anti-Semitic influences at work within the State Department, that you condemn.

KARPIN: It is of course possible that he failed to grasp the significance of what was happening around him.

SCOTT *smiles, shakes his head and takes a slip of paper out of his pocket.*

SCOTT: He knew exactly what was going on around him. He was part of the cover-up. On 24 November, 88 days after receiving the cable, the State Department released him from his promise to keep silent, and on 2 December, Wise wrote to President Roosevelt: 'Dear Boss, I have had cables and underground advice for some months telling of these things. I succeeded, together with the heads of other Jewish organisations, in keeping them out of the press'.

Pause. SCOTT *drops the slip of paper on the desk.*

Now let us come nearer home. Counsel for the plaintiff has repeatedly suggested that Miss Kaplan's accusation against Doctor Yaron is linked with her criticism of Zionism, and you, Mr Karpin, have agreed with that.

KARPIN: (*Firmly*) Yes.

GREEN *hands* SCOTT *a newspaper which he holds up.*

SCOTT: I have here a copy of the London *Times* dated June 6

1961. It contains a letter written by Rabbi Solomon Shonfeld. (*As* KARPIN *nods*) You know him?

KARPIN: Yes.

SCOTT: And would you say he is an honourable and responsible man?

KARPIN: (*He hesitates*) He is a sincere man, yes. But he is also an anti-Zionist.

SCOTT: There is a distinction? (KARPIN *looks and says nothing*) What role did he play during the holocaust?

KARPIN: He was chairman of the British Rescue Committee set up by the Chief Rabbi.

SCOTT: You're no doubt aware that during the Eichmann trial a year earlier, criticism was raised about the British government's unwillingness to act in defence of the Jews?

KARPIN: Yes.

SCOTT: The charge was that H.M. Government was indifferent to the effort made by the British Zionists who sought to help the victims. Doctor Shonfeld writes:

'My experience in July 1942–43 was wholly in favour of British readiness to help, openly, constructively and totally, and that this readiness met with opposition from Zionist leaders who insisted on rescue to Palestine as the only acceptable form of help.'

As a leading Zionist yourself during that period, how did you respond to this?

KARPIN: I disapproved.

SCOTT: Of what?

KARPIN: Of the line taken at that time.

SCOTT: Did you ever express your disapproval?

KARPIN: Privately, yes.

SCOTT: But not publicly?

KARPIN: (*Pause*) No.

SCOTT: Why not

KARPIN: At the time our main priority was in building a Jewish homeland in Palestine.

SCOTT: What did that have to do with it? Here were people in fear of their lives.

KARPIN: Yes, but the feeling was that had these refugees found sanctuary in countries other than Palestine, there would have been no Jewish state.

SCOTT: Then what you are saying is that the holocaust Jews who were being daily massacred were expendable.

KARPIN: You are putting words into my mouth. I am not saying that.

SCOTT: Then why did you disapprove?

(KARPIN *thinks*)

KARPIN: The argument was that escape was no answer. That in the long term, the permanent solution to the Jewish problem lay in the creation of a National Home in Palestine and objectively I saw the logic in this. But subjectively, the price was too high.

SCOTT: Jewish people were dying horribly, and Zionist leaders preferred that it remain so rather than accept resettlement elsewhere.

KARPIN: I find that a rather brutal over-simplification.

SCOTT: Then how otherwise do you interpret it? You see, the position was, wasn't it, that the Zionists needed something to bargain with, and had the refugee problem been divorced from Palestine, international pressure and sympathy for a Jewish state would have evaporated. *Pause.* SCOTT *drops The Times on his desk.*

Can you cast your mind back to Germany 1938?

KARPIN: That depends.

SCOTT: *Kristallnacht.*

KARPIN: The night of broken glass.

SCOTT: Precisely.

KARPIN: A night not likely to be forgotten.

SCOTT: It was November, wasn't it?

KARPIN: Yes.

SCOTT: One hundred and ninety-five synagogues went up in flames; 10,000 shops looted and destroyed; 21,000 Jews hauled off to the concentration camps; the streets of Germany littered with broken glass. The terror against the Jews had started, and did not this country offer immediate asylum to thousands of Jewish children?

KARPIN: A noble gesture.

SCOTT: Not according to David Ben-Gurion, prime minister of Israel until four years ago. Were you present at a meeting on December 7, only one month after *Kristallnacht*, when Ben-Gurion spoke to Labour Zionists?

KARPIN: Yes, I was.

SCOTT: Do you remember what he said?

KARPIN: Not his precise words. SCOTT *opens the pamphlet 'I Accuse'.*

SCOTT: Allow me to remind you. (*He reads*)

'If I knew it was possible to save *all* the children in Germany by bringing them over to England, and only half of them by transporting them to Israel, then I would opt for the second

31

alternative. For we must weigh not only the lives of these children, but also the history of the people of Israel.'

. . . Continuing his theme of sacrificing Jewish refugees for the future glory of Israel, Ben-Gurion, son of the lion, then addressed a warning to the Zionist Executive on December 17th:

'If the Jews will have to choose between the refugees, saving Jews from concentration camps and assisting a national museum in Palestine, mercy will have the upper hand and the whole energy of the people will be channelled into saving Jews from various countries. Zionism will be struck off the agenda, not only in world public opinion, in Britain and the United States, but elsewhere in Jewish public opinion. If we allow a separation between the refugee problem and the Palestinian problem, we are risking the existence of Zionism.'

Pause. SCOTT *turns and faces the jury (audience). Then he looks back at* KARPIN.

SCOTT: Don't you find the moral implications of all this frightening, Mr Karpin?

KARPIN: You are quoting one man.

SCOTT: (*Shaking his head*) I am quoting David Ben-Gurion. The founding father of Israel. (*Throwing the paper on the desk*)

They even named a mountain after him.

I have no more questions.

LAWSON: Thank you, Mr Karpin.

SCOTT *slumps in his chair.*

Stiff and angry, KARPIN *is leaving the witness box when the lights fade.*

Act Two

The Defence

Darkness. The harsh sound of a Nazi marching song. It gives way to one of the songs of the ghetto, as a photograph is illuminated. Then cross-fade to the courtroom.

SCOTT: Please state your name and address.

RUTH: Ruth Kaplan. 67 Broomfield Crescent, Clapham.

SCOTT: What is your occupation?

RUTH: Journalist. Freelance.

SCOTT: You were born in Palestine, March 3 1937?

RUTH: Yes.

SCOTT: Where did your parents come from?

RUTH: Germany. They arrived in Palestine in 1934.

SCOTT: And where were you educated, Miss Kaplan?

RUTH: After leaving school in Nazareth, I enrolled as a student at the Hebrew University of Jerusalem, where I studied philosophy and Arabic. After I received my BA, I worked for a time at the *Encyclopaedia Judaica*, then went into teaching.

SCOTT: When did you come to England?

RUTH: I came here in December 1964.

SCOTT: For what purpose?

RUTH: *(Slight pause)* In Israel my options were limited.

SCOTT: In terms of employment?

RUTH: Yes.

SCOTT: But you had a university degree.

RUTH: And because I was a pacifist and active in the civil rights movement, I was dismissed from my job as a teacher.

JUDGE: Is there no provision in Israeli law for a person wishing to register as a conscientious objector, Miss Kaplan?

RUTH: The Declaration of Independence guarantees freedom of conscience, but it has no legal standing in law. Refusal to accept

33

the Draft as I did, on the grounds of conscience, is not recognized.

JUDGE: Thank you, Miss Kaplan.

SCOTT: When you arrived in England in December 1964, did you bring with you a letter of recommendation from a colleague of Yaron's who teaches at the University of Jerusalem?

RUTH: From Moshe Gorgeon, yes.

SCOTT: Which you took to Doctor Yaron?

RUTH: Yes.

SCOTT: And he then found you a job at the National Jewish Library of Judaism as a researcher and translator?

RUTH: Yes. I became his assistant.

SCOTT: And did you get on well together?

RUTH: I think so. Yes, he was kind and considerate.

SCOTT: Did you like and respect him?

RUTH: Yes.

SCOTT: What are your feelings for him now?

RUTH: (*Pause*) I feel sorry for him.

SCOTT: Why?

RUTH: Perhaps sorry is the wrong word.

SCOTT: Compassion.

RUTH: (*Slight pause*) I believe that he acted out of a sense of deep conviction, and that the policies which led him into betraying the Jews were formulated by others.

SCOTT: Who?

RUTH: Zionist leaders. Men like Chaim Weizmann, Sharett, Ben-Gurion, and especially Yitzhak Grunbaum, who as head of the Rescue Committee in Europe was Doctor Yaron's immediate superior. These people knew what was happening in Hungary, yet for six weeks after the deportations began, they did not publish one single word of warning.

SCOTT: Why not?

RUTH: Because their primary aim was the creation of the state of Israel after the war, and all their policies and thinking were geared to this one single objective. Everything else was secondary.

SCOTT: But how would suppression of this information help them achieve this objective?

RUTH: There were several reasons. The reluctance of the Allies to mount any rescue attempts. The fear that news of further massacres might persuade other countries to open doors to Jewish refugees, and the idea, publicly stated, that the spilling of Jewish blood would strengthen their demand for a Jewish state after the war.

34

SCOTT: Are you suggesting that the Zionist leaders actually welcomed the holocaust?

RUTH: No, I'm not saying that. It would be monstrous even to think that. But as I say, their goal was the creation of the Jewish Homeland, and to achieve this they were prepared if necessary to sacrifice the Jews of the Diaspora.

Take Grunbaum, for example, who argued against using money from the Jewish Appeal Fund for any rescue operation. He thought that buying up Arab land was more important than saving Jewish lives.

SCOTT: Did he actually say that?

RUTH: In 1943 at a meeting in Tel Aviv.

SCOTT: While the mass extermination of the Jews was going on in Europe?

RUTH: Yes.

SCOTT: And just remind us, he was the head of the Rescue Committee?

RUTH: Yes. After the war he became a cabinet minister in the Israeli government.

Pause. SCOTT *looks as if he is finding it hard to digest.*

SCOTT: It's almost as if you are saying that Doctor Yaron was himself in some way an innocent victim.

RUTH: (*Firmly*) No.

SCOTT: Or that he was carrying out orders.

RUTH: I am saying that what he did flowed logically from the Zionist policy of making deals with the Nazis both before and during World War Two, and that to him this act of collaboration was justified in terms of building the Jewish Homeland.

Pause. Again a look of bewilderment appears on SCOTT's *face.*

SCOTT: Miss Kaplan, you are telling us something which perhaps the jury finds difficult to grasp or even to understand . . .

RUTH: (*Smiling*) I realize that.

SCOTT: Can you tell us why collaboration with the Nazis should flow logically from the politics and the doctrine of Zionism?

RUTH: Well . . .

LAWSON *rises as if to object, then sits down again.*

RUTH: Well . . . political Zionism teaches that it is futile to resist anti-Semitism. That wherever Jews live an exile existence outside Israel they will meet it. That the only way a Jew can combat anti-Semitism is by escaping from it. By building the Jewish Homeland.

And Jews who sought to eradicate anti-Semitism by struggling against it, by fusing and adapting themselves to the countries they lived in, they were denounced as self-haters, neurotics, and

parasites feeding on the host nation. And I suppose that from a Zionist point of view this was understandable, without anti-Semitism there would be no Zionism. Why emigrate to Palestine when you are doing all right in New York, Berlin or London? This was the feeling of the great majority of Jewish people who rejected Zionism before the war. Then Hitler arrived to confirm the Zionist rationale that assimilation wouldn't work, and the Zionist Federation in Germany, who represented five per cent of organized Jews offered to cooperate with the Nazis.

SCOTT: What about the remaining ninety five per cent?

RUTH: They belonged to the Central Association of German Citizens of Jewish Faith, and because they were pledged to fighting anti-Semitism, the Zionists were more fitted to adapt to the policies of the Nazi regime. My parents came from Berlin and brought with them to Israel Zionist publications: books, newspapers, etc. I remember the jubilation of one particular writer, Joachim Prinz, a rabbi from Berlin, who later became president of the American Jewish Congress. In 1934 after Hitler had come to power, Prinz wrote about how from every hiding place the Jews are being pulled out, and that this does not make us unhappy. That in this we see the fulfilment of our dreams . . . I think this more or less sums up the Zionist attitude at that time.

SCOTT: But surely the warning signs were already there?

RUTH: Yes.

SCOTT: Did the Zionists ever fight Hitler?

RUTH: Many did, as individuals, yes, but not the leadership. Instead, they tried to set up a special relationship with him.

SCOTT: Even though world Jewry was opposed to fascism?

RUTH: Yes. In 1933 the Zionist Federation submitted a memorandum to the Nazi party offering to cooperate and criticising Jews abroad who were attempting to boycott the regime. When Jewish workers went out on the streets joining forces with the German working class to fight the Brownshirts, most of the Zionist leaders waved olive-branches and condemned all anti-Nazi activity.

SCOTT: They were seeking an accommodation with them. Is that what you are saying?

RUTH: Absolutely. They entered into secret negotiations with the Nazis, arguing that they too believed in racial exclusiveness. Prinz also said: 'A state which is constructed on the principle of the purity of nation and race can only have respect for those Jews who see themselves in the same way.'

SCOTT: Are you saying that the German Zionists accepted the Nazi concept of race?

RUTH: No, but they did accept racial separateness. The

36

memorandum also said: 'We too are against mixed marriages, and are for maintaining the purity of the Jewish group' It also served as a cover for not fighting anti-semitism.

SCOTT: And did this 'special relationship' ever materialize?

RUTH: Only for as long as it suited the Nazis. To them there were no good Jews, only useful ones. And within this context, the Zionists became Hitler's favourite Jews. While every other political party in Germany was made illegal, they were allowed to exist and the Zionist banner was the only other political flag permitted — apart from the Swastika.

SCOTT: Are you saying that the German Zionists preferred Hitler and supported him?

RUTH: No. They were utilizing a threat which to them signalled the bankruptcy of assimilation and paved the way for the creation of the Jewish state.

SCOTT: And what in practical terms did Eichmann and the Nazis have to offer the Zionists?

RUTH: Patronage and support of immigration to Palestine.

SCOTT: And again in practical terms, what did the Zionists have to offer in return?

RUTH: Co-operation. Even to the extent of providing the Nazis with intelligence information.

SCOTT: You mean spying for them?

RUTH: Yes. According to German war records Feival Polkes, a Hagannah agent . . .

SCOTT: Could you explain to the court what Hagannah is?

RUTH: Militia. The military arm of the Jewish Agency in Palestine. He was sent by the Hagannah to negotiate with Eichmann in Berlin.

SCOTT: When was this?

RUTH: Early in 1937. And as evidence of his good faith, he offered to supply intelligence information to the Nazis, providing it did not collide with Zionist interests.

SCOTT: And did he?

RUTH: Yes. Polkes told Eichmann the location of an underground Communist radio station operating from the back of a lorry on the German/Luxembourg border. Later that same year, Eichmann accepted a Zionist invitation to visit Palestine, where he was met by Polkes who showed him round then took him to a kibbutz. Then the British discovered his presence and threw him out. Polkes followed him to Egypt, where they continued their negotiations.

SCOTT: Can you offer the court any further examples?

RUTH: Yes. Yitzhak Shamir. During the war he served as operational commander of the Stern Gang, a terrorist

organization led by Abraham Stern. In 1941, Stern wrote to the Nazis offering to co-operate with them in the building of a Jewish state along totalitarian lines. The proposal offered to protect Nazi interests in the Middle East.

SCOTT: And are you suggesting that Shamir approved, or was aware of this proposed alliance with Hitler?

RUTH: Well, he has never denied his knowledge of the letter sent by Stern, or its authenticity and he *was* operational commander.

SCOTT: And what happened to Shamir?

RUTH: He became a close friend of Ben-Gurion and is a prominent figure in Israel.

SCOTT: You accuse Zionism of being racialist, Miss Kaplan. Some people might see that as a grotesque conclusion. Can you explain to the court how you arrive at that?

RUTH: Zionists argue that there is a continuity stretching back 2,000 years, and that all Jews are direct descendants of Hebrew tribes. That the uniqueness of the Jews means that they cannot be assimilated into Gentile society. That there is an unbroken historical link cemented with ties of kinship, religion, culture and destiny. That only the in-gathering of the exiles, a return to the Jewish Homeland, will end their persecution and humiliation and solve the Jewish question.

SCOTT: And you obviously don't accept that.

RUTH: No. Apart from the fact that all they have managed to create is a ghetto state in the Middle East, the Jews constitute a mixture of races. Because of migrations, intermarriages and conversion, they are probably the most multi-racial group of people ever assembled. To preach purity of race is, by definition, racialist. To use crude religious mythology to justify political acts, and to demand unconditional loyalty from all Jews — despite the fact that 80 per cent of Jews prefer to live outside Israel — is racialist. So too is the Law of Return, which grants automatic citizenship to every Jew who chooses to settle in Israel, yet denies that same right to Palestinian refugees who were born there. I derive no pleasure from any of this, but facts are facts. Israel is a racist state, and we Jews must face up to this if we want to change it.

Pause. SCOTT *consults his papers. Then:*

SCOTT: Now let us talk about the Szamosi notebook which you discovered in Budapest. When you first got your hands on it, did your realize what it contained?

RUTH: I knew it was part of the diary, but I didn't know that Doctor Yaron's name was mentioned until I read it.

SCOTT: And what was your immediate reaction?

RUTH: I was sceptical. I didn't want to believe it. But then I compared the writing with the original diaries on display at the

institute in Budapest and realized that the notebook was genuine.

SCOTT: So then what did you do?

RUTH: Without mentioning the notebook I talked to members of the Jewish community in Budapest, some of whom remembered Doctor Yaron.

SCOTT: And having done so, did you then return to London and confront Doctor Yaron with the notebook?

RUTH: Yes, but it was a difficult decision. I knew the effect it would have on his life. I even considered whether or not I should destroy the notebook and forget about it.

SCOTT: Why didn't you?

Pause.

RUTH: Jacob Szamosi. His words. His suffering. I didn't have the right to destroy what he had written. Also because I am a Jew.

SCOTT: And what effect did the publication of your pamphlet have?

RUTH: Very little. The Jewish press ignored it completely, and a small piece appeared in the *Guardian*, misrepresented and distorted. It was as if Israel had been granted immunity from criticism.

SCOTT: Why do you think that was?

RUTH: Anything relating to the Jews is clouded over with guilt.

SCOTT: Because of the holocaust?

RUTH: Of course. And the Israeli government uses this. It commits outrageous crimes then silences its critics by invoking the holocaust.

SCOTT: Thank you, Miss Kaplan.

SCOTT *sits.* LAWSON *rises.*

LAWSON: You describe yourself as a freelance journalist, Miss Kaplan.

RUTH: Yes.

LAWSON: Was this pamphlet your first venture into writing for money?

RUTH: I didn't write it for money.

LAWSON: In between leaving the Library in January 1966 and July of that same year . . . did your . . . literary work receive any other recognition? Did you sell anything? Have anything published?

RUTH: No.

LAWSON: No other source of income apart from your savings?

RUTH: No.

LAWSON: Then where did the money come from for this rather glossy and expensive publication?

RUTH: Friends.

LAWSON: Jewish friends?

RUTH: Mainly.

LAWSON: Arabs?

RUTH: No.

LAWSON: You have no connections with any Arab organizations?

RUTH: No.

LAWSON: You are sure about that?

RUTH: I am sure.

LAWSON: Among Jewish people, is there not a term, an expression used to describe Jews who attack Jews?

RUTH: I have been described by Zionists as a self-hater, an alienated Jew, if that is what you mean.

LAWSON: And are you?

RUTH: No, I am proud to be a Jew.

LAWSON: Do you believe that the Jews have a right to a National Homeland?

RUTH: Yes, but not at the expense of the Palestinian Arabs. They too have rights.

Pause. LAWSON *consults a paper.*

LAWSON: You spoke touchingly about your experiences as a pacifist in Israel. About how you were harassed and persecuted.

RUTH: Yes.

LAWSON: Can you name one single woman in Israel who has been fined or sent to prison for refusing the Draft?

RUTH: (*Slight pause*) No.

LAWSON: And of course the truth is, Miss Kaplan, that if you had simply registered your opposition to the Draft and then gone quietly about your business, the likelihood is that nothing would have happened to you either. But you deliberately set out to provoke the authorities.

RUTH: That isn't true.

LAWSON: But I have a transcript from the High Court in Jerusalem here in front of me! You marched and demonstrated . .

RUTH: I took part in a peaceful demonstration.

LAWSON: Outside the Knesset.

RUTH: Is that a crime?

LAWSON: And I see here that you were arrested for violating public order.

RUTH: For protesting about the confiscation of Arab land.

LAWSON: And for assaulting a policeman.

RUTH: It was the other way round.

LAWSON: The court didn't seem to think so.

RUTH: Naturally.

LAWSON: You were fined 20 Israeli pounds and bound over. Is that correct?

RUTH: What you are not taking into account . . .

LAWSON: Is that correct?

RUTH: Yes.

LAWSON: Miss Kaplan, I don't wish to embarrass you but (*He looks again at the document*) have you at any time received psychiatric treatment?

RUTH: No.

LAWSON: But you were examined by a psychiatrist in February 1959, were you not?

RUTH: An army psychiatrist.

LAWSON: But you are not suggesting, are you, that that made him in some way less qualified? And his findings were that you suffered from hypersthenia and were neurotic . . .

JUDGE: What does hypersthenia mean?

LAWSON: A morbid condition characterized by excessive excitement, my Lord.

JUDGE: Thank you, Mr Lawson.

RUTH: Can I explain how that came about? After opposing the Draft I was ordered to report for a medical examination. The letter said that if I refused, I would be arrested, and that is how I came to see the army psychiatrist.

LAWSON: May I now turn to the Library where you worked. What about the rest of the staff at the Library? Were they all Zionists too?

RUTH: Yes.

LAWSON: Did you get on with them all right?

RUTH: Yes.

LAWSON: No feelings of animosity?

RUTH: No.

Pause.

LAWSON: What may puzzle the jury, Miss Kaplan, is why a person like yourself, with such high moral principles and a history of opposition to Zionism, should choose to work in a place run by Zionists.

RUTH: It was a job.

LAWSON: But surely with your qualifications it wouldn't have been too difficult finding other employment?

RUTH: It was what I was trained for, and I enjoyed the work.

LAWSON: Until, by a lucky combination of circumstances, you 'mysteriously' acquired the Szamosi notebook and then everything fell into place. Szamosi the trigger, Doctor Yaron the stalking horse and Zionism the target.

RUTH: I didn't invent Zionism.

LAWSON: No, but you did concoct this piece of worthless journalism even though the man in question had helped and befriended you.

RUTH: There was no other alternative.

LAWSON: You pushed Doctor Yaron into a corner where all he could do to protect his good name and reputation was to sue you for libel.

RUTH: There is more at stake than the name and reputation of Doctor Yaron.

Pause. LAWSON studies a sheet of paper on a clipboard. Then:

LAWSON: How would you define the difference between co-operation and collaboration, Miss Kaplan?

Pause as RUTH collects her thoughts. SCOTT's eyes are glued on her.

RUTH: In what context?

LAWSON: Can you envisage a situation where co-operation could ever be justified?

RUTH: Yes. Where it helps to save or prolong life in the ghetto, then co-operation on that level and for those reasons is not only justifiable but necessary. However . . .

LAWSON: Thank you.

RUTH: I would like to continue . . .

LAWSON: I need no more, Miss Kaplan.

RUTH: I would like to add . . .

SCOTT: (*Rising.*) She must be allowed to answer the question.

JUDGE: I agree, Mr Scott.

As SCOTT sits.

JUDGE: Proceed, Miss Kaplan.

RUTH: I just want to make the distinction. Co-operation ended and collaboration began when the *Judenrat* participated in the killing operation.

LAWSON: Participated, Miss Kaplan?

RUTH: Yes, their role has been well documented by eminent Jewish historians, like Hillberg, Trunk, and Hannah Arendt.

LAWSON: That Jews murdered themselves?

RUTH: That a majority of Jewish leaders acted as filing clerks in the extermination process, making up the lists for deportation, providing ghetto police to seize Jews and put them on trains, and

42

publishing Nazi dictated manifestoes similar to the ones issued by the Jewish Council in Budapest.

LAWSON *studies his notes.*

LAWSON: Then what about the Jewish people who helped run the camps? The technicians who serviced the gas chambers? The Jews who pulled the teeth in the crematoria?

RUTH: They were the victims, and I thought you were referring to the Jewish functionaries who helped to send them there.

LAWSON: Very well then, let us stay with them. Is there not such a thing as involuntary complicity? Of measures taken to alleviate suffering?

RUTH: Not when it involved the destruction of your own people.

LAWSON: What about Joel Brand and the Rescue Committee, of which Doctor Yaron was a member? Did they not attempt to purchase Jewish lives with money and military equipment?

RUTH: Yes.

LAWSON: Was that an act of collaboration?

RUTH: No, but finish the story, Mr Lawson. When Brand arrived in Palestine, the Zionist leadership put him on ice. When he charged them with abandoning the Jews of Hungary, they hushed it up and kept it out of the newspapers. When Weizmann arrived in Palestine, Brand wrote asking to see him. Weeks passed before they met, and Weizmann agreed to help. But nothing happened and Brand never heard from him again.

LAWSON: (*He smiles*) Are you seriously suggesting that Chaim Weizmann, first president of Israel, was part of the cover-up?

RUTH: Yes.

LAWSON: And not only Weizmann, but — according to your evidence — the entire Zionist leadership formulated policies which led Doctor Yaron into betraying the Jews.

RUTH: Yes. Most of them.

LAWSON: And that they knew what was happening in Hungary, yet for six weeks after the deportations began, did not utter one single word of protest.

RUTH: Did not 'publicly' utter one word of protest. Yes. That is correct.

LAWSON *shakes his head, smiling at the absurdity of it.*

LAWSON: But does not the record show, that even before the deportations began, Zionist leaders in Jerusalem were sending cables to heads of Allied governments urging them to take action?

RUTH: Private cables, private conversations.

LAWSON: But, Miss Kaplan . . .

RUTH: So that after the war they would be able to say that

43

everything possible had been done.

LAWSON: But were they not subject to restrictions imposed by the war-time conditions?

RUTH: There was no British censorship of the press in Palestine. They had access to the world media, and should have aroused world opinion.

LAWSON: The record also shows that on June 27, 1944, Zionist leader Moshe Sharett flew to London to appeal directly to Mr Eden and Winston Churchill.

RUTH: Yes, and he did not make one public statement to the hundreds of newspapermen assembled in the capital. He kept his mouth shut.

LAWSON: Wasn't that because the British government advised him to?

RUTH: With the lives of one million Jews at stake, it was his duty to ignore that advice.

LAWSON: And do what? Was the Jewish Agency capable of acting alone? Of producing ten thousand trucks, getting them into Nazi-occupied Europe, and fulfilling the German demands?

RUTH: Of course not.

LAWSON: Then is this not relevant?

RUTH: It is also relevant to inquire why there was not one single instance of the Zionist movement calling upon the Jews to resist the Nazis in Europe. Not one single proclamation of revolt.

LAWSON: You still haven't answered my question.

RUTH: With regard to the Brand proposals, the Jewish Agency should have published all the cables and mobilised world opinion, instead of whispering down the ears of politicians and statesmen who had already passively accepted the extermination of five million.

Pause. LAWSON *glances down at his notes then continues:*

LAWSON: Would you agree, that the Jewish Council in Budapest faced a situation without precedent?

RUTH: Yes.

LAWSON: And that they were totally isolated and cut off from the rest of the world?

RUTH: Physically, yes.

LAWSON: If this was the picture — if the Nazis had come to you and said: 'The Jews of Hungary are doomed, there is nothing you can do to stop it, but if you co-operate with us we will allow some Jews to escape.' What then?

RUTH: Different criteria must be applied.

LAWSON: Such as?

Pause. RUTH *is not sure how to answer.*

RUTH: You see, you are assuming the Jews were doomed, but the Zionists strangled all mass activity.

LAWSON: You mean resistance?

RUTH: Yes.

LAWSON: But what resistance had there ever been?

RUTH: Very little because they had abandoned the struggle, for collaboration.

LAWSON: But the Brand initiative had failed. They possessed no weapons, no organization, no trained men. Not even a government to plead on their behalf. (*Pause*) And that was the offer: to risk the many in order to save the few.

RUTH: And safeguard the lives and privileges of men like Kastner and Doctor Yaron.

LAWSON: Who needed the patronage of the SS to carry out the attempted rescue operation.

RUTH: And saw to it that included on the list of escapees were themselves and members of their own families.

LAWSON *shrugs.*

LAWSON: Well, doesn't everyone take care of himself and his family, Miss Kaplan? Or do you imagine that man is composed of moral principles alone?

RUTH: There is the morality of rebellion.

LAWSON: Easy to say when you are separated from the scene of conflict by a period of years.

RUTH: Or by an ocean, as the Zionist leaders were, sitting it out in Palestine.

LAWSON: Wouldn't that include your own parents, who had the good sense to get out of Germany and seek refuge in Palestine? (*There is a pause*) One final question, Miss Kaplan. What, in fact, are you suggesting about Doctor Yaron? Was he a sincere idealist doing the best he could in impossible circumstances? Or was he a callous, self-interested murderer concerned only with the welfare and safety of himself and his family? Or was he a political fanatic, obsessed by the cause of Zionism?

RUTH: I never knew him in that period, so your guess is as good as mine.

LAWSON: Yet you sit in judgement?

RUTH: No. The past sits in judgement: the things he did then. He committed criminal acts in so far as he knew in advance what was happening to the Jews. Therefore he was guilty of collaborating with murderers. But politics shapes the man, and this tells us more about Zionism than it does about Doctor Yaron.

LAWSON: Might not the same be said of yourself, Miss Kaplan?

LAWSON *sits down and* SCOTT *rises.*

SCOTT: What would have happened had the Jews not been organized into communities with their own leaders, political parties, and the various welfare organizations?

RUTH: I believe that the sheer physical task of uprooting six million people, of removing them from their homes in towns and cities, herding them into ghettos and marching them to the collecting points, and finally shipping them on special trains to the death camps would have been impossible. What made it possible was the presence of Jewish leaders who carried out the instructions of the Nazis.

SCOTT: Had they not been organized?

RUTH: There would have been chaos, but more Jews would have survived.

SCOTT: At his trial in Jerusalem, Adolph Eichmann testified that the Nazis feared that contact with the Allies might set off Jewish uprisings. How valid was this fear?

Pause. RUTH *shrugs.*

RUTH: The killings took place in May and June; by August the Red Army was in Romania, by December they'd reached the outer suburbs of Budapest. His fear was valid.

SCOTT: From your research, what can you tell the court of these special convoys that left Budapest and arrived in Switzerland in 1944?

RUTH: It was part of an arrangement which Kastner had been negotiating with Eichmann since April: that in return for keeping the peace in the camps, they would be allowed to select certain Jews for rescue.

SCOTT: Did Eichmann have any say about who should board the trains?

RUTH: No. It was left entirely to the Rescue Committee.

SCOTT: Did they prepare the list?

RUTH: First they selected members of their own families, then Jewish functionaries, Zionists, and what Kastner called 'the Prominents' — people with money.

SCOTT: And those Jews without money or status, the remnants hiding in the ghettos, did they know about the train?

RUTH: They were abandoned.

Lights cross-fade to a photograph. Music: one of the songs from the Ghetto.

Then the lights cross-fade to the courtroom.

GREEN: (*Rising*) Joseph Orzech, please.

ORZECH *enters. An alert 62-year-old. He takes the oath.*

GREEN: Please state your name and address.

ORZECH: Joseph Orzech. 217 Boarshaw Crescent, Chorlton, Manchester.

GREEN: What is your occupation, Mr Orzech?

ORZECH: Writer and historian.

GREEN: Are you Jewish?

ORZECH: Yes.

GREEN: And where were you born?

ORZECH: Poland.

GREEN: Date of birth?

ORZECH: October 7 1905.

Pause. GREEN *picks up a sheet of paper and glances at it.*

GREEN: I see you were educated at the University of Warsaw, where you received a Masters degree in History. You've written several books, among them *The Politics of the Holocaust* and *Jewish Councils Under Nazi Occupation* . . .

ORZECH: Yes.

GREEN: During the war you were a member of the Resistance in Warsaw?

ORZECH: Yes.

GREEN: And before that?

ORZECH: I was a member of the Polish Communist Party. *(Pause* GREEN *waits)* I joined when I was at university. In 1932 I was sent to Germany where I edited a party newspaper. After Hitler came to power and the party was outlawed, my name appeared on the Nazi 'blood list' and I escaped back into Poland. I continued with my party work until 1936, when I was ordered to Moscow, ostensibly to attend a conference. As soon as I stepped off the train I was arrested by the state police, the NKVD.

GREEN: What for?

ORZECH: *(He shrugs)* It was the year of the purge. Kamenev and Zinoviev were on trial for supposedly conspiring together with Nazi agents to assassinate Soviet leaders. All were suspect and thousands arrested. Because I had spent some time in Germany, I got caught up in it.

GREEN: Can you tell the court what happened?

ORZECH: Ten years. Enemy of the people. *(He smiles)*

GREEN: How long were you in prison?

ORZECH: Until Stalin signed the pact with Hitler in 1939.

GREEN: And were you released?

ORZECH: Not exactly. We were handed back to Hitler as part of the 'dowry'.

GREEN: Can you explain what that means to the court?

ORZECH: Russian prisons held hundreds of German and Austrian Communists who had been condemned to terms of imprisonment during the purges.

GREEN: These were Communists who had escaped from Germany and sought refuge in the Soviet Union?

ORZECH: Yes. To celebrate the pact, Stalin handed them over to Hitler. I was included.

GREEN: How many?

ORZECH: Five hundred. We were taken to the Butyyrki prison and told that we were being expelled from Russia, but they didn't say where to. Then we were put on a train and taken to Brest-Litovsk, the demarcation line which divided the German and Russian parts of Poland. There was a bridge, and waiting on the other side was the Gestapo. Many of the 500 were Jews and young Germans condemned to death. Some begged the Soviet officer not to send them across. The Gestapo came forward and took over from the NKVD.

GREEN: What happened to you?

ORZECH: I was fortunate. I managed to escape and return to Warsaw.

GREEN: Where you joined the Resistance?

ORZECH: Yes, but first I resigned from the Communist Party.

GREEN *smiles with him. Then:*

GREEN: (*Picking up the pamphlet*) Have you read this pamphlet, Mr Orzech?

ORZECH: Yes.

GREEN: Speaking from your knowledge and experience of the material, what do you say about it?

ORZECH: It doesn't tell me anything I didn't already know. The Kastner case in 1953 proved beyond any doubt that the Central Jewish Council in Budapest and the Zionist Rescue Committee co-operated with the Nazis. With regard to Doctor Yaron, I don't know. But if he was a member of that Council during that period, then he must at least bear some of the responsibility.

GREEN: Was co-operation the norm rather than the exception?

ORZECH: It was the norm. The pattern was the same in nearly every occupied country.

GREEN: Would you kindly explain that to the jury?

ORZECH: (*Slight pause*) The system was foolproof. The Nazis controlled the Councils, the Councils controlled the Jews. When the transportations to the killing centres began, the Germans would decide how many would go, and which particular group: Old people, children, the sick, the so-called non-productive elements. Then the Council would make up the list.

48

GREEN: Which literally meant deciding who shall live and who shall die?

ORZECH: Yes.

GREEN: So the Jewish Councils not only co-operated with the Nazis, but they actually held the power of life and death over their fellow Jews?

ORZECH: Absolutely. Within the structure of the ghetto administration, they were the elite. They received special privileges, more food, better accommodation. They were the last to be deported. In the Kutno ghetto where the majority of Jews lived in cellars and stables, the house occupied by Council members and ghetto police was referred to as 'the House of Lords'. Of course there were some notable exceptions. At Beretza Kartuska, all 12 members of the Council committed suicide rather than co-operate with the Nazis.

GREEN: But by and large . . .

ORZECH: They co-operated. The Jewish writer and historian Hannah Arendt, who was herself a Zionist activist in Germany before the war, wrote about it in her book, *Eichmann In Jerusalem*. 'Wherever Jews lived there were recognized Jewish leaders, and this leadership almost without exception co-operated.'

Pause.

GREEN *consults her notes. Then:*

GREEN: You joined the Jewish Resistance in Warsaw, and took part in the rising. Is that correct, Mr Orzech?

ORZECH: Yes.

GREEN: Can you tell us briefly what happened?

Pause.

ORZECH: The actual rising began in April 1943, but the lead-up to it started with the emergence of a leadership, Zionists included, strong enough to challenge the Council and win control over the community. There were a number of illegal political parties in the ghetto.

GREEN: Which party did you belong to?

ORZECH: After leaving the Communists, I joined the Bundists — well, I didn't actually join them, I attached myself to them.

GREEN: Bundists?

ORZECH: Bund. The Jewish Workers' League. Anti-Zionist. (*He pauses*) In July the Germans ordered the *Judenrat* to prepare a new list for resettlement. The quota was 10,000 a day, and as usual the families of policemen and Council bureaucrats were exempt. By September over 300,000 had been deported. Then on October 24 1942 the United Jewish Fighting Organization was formed.

49

GREEN *picks up the pamphlet* I Accuse.

GREEN: On page 6 of her pamphlet *I Accuse*, Miss Kaplan quotes a resolution passed by the Jewish Fighting Organization, on November 25 1942.

ORZECH: I was a member of the political committee that drew up the resolution.

GREEN: It reads: 'The monumental betrayal by the Warsaw Judenrat, which assumed the form of assent to the "resettlement" and which consisted in completely ignoring or pretending to ignore the real situation, will forever remain, next to the betrayal by the ghetto police, an unremovable stain on the Jewish ghetto authority. But while branding it with this deed, one must nevertheless stress that the Jewish ghetto authority, a creation of the occupational conditions, did not reflect the feelings and attitudes of the population'.

She puts the pamphlet down.

As one of the authors of this resolution, do you still stand by it?

ORZECH: Absolutely. The *Judenrat* and the ghetto police did everything possible to prevent mass resistance.

GREEN: You were telling the court how a Jewish Fighting Organization was set up.

ORZECH: Yes.

GREEN: Please continue.

ORZECH: From the Polish left-wing underground we managed to procure some arms, and then we waited. I was with some young Bundists constructing dug-outs linked to the sewer system when the attack came. It was 3 o'clock in the morning and we heard shots and explosions. When we came up, we saw the ghetto was surrounded. *(Pause)* From then on it was carnage. Against our rifles, home-made incendiary bombs and revolvers, they had tanks, flame-throwers, howitzers and explosive charges. We didn't stand a chance. They set the ghetto alight. It was a sea of flames.

In the sewers they tried to drown us by flooding, and when we tried to escape, engineers blew up the manholes. There were bodies floating everywhere. At the Azazel Theatre on Nowolipki Street, an audience of German women watched as Jewish prisoners were burnt alive. By May 16 it was all over.

GREEN: How did you get away?

ORZECH: Through the sewers. A group of us escaped to the forest and joined the partisans.

GREEN: Was it worth it?

Pause.

ORZECH: It had no effect on the extermination programme. Jews continued to be gassed and their ashes used to fertilize German

fields. But we smashed the power of the *Judenrat*, and for the first time in 2,000 years, Jews had hit back. Yes, it was worth it.

GREEN: Miss Kaplan has defined Israel as racialist. As a Jewish historian, do you subscribe to that?

Pause

ORZECH: I know many Zionists who would be horrified at the suggestion that they considered themselves superior to anyone else. But on the evidence, one must draw the conclusion that Israel, although not racialist in the sense that, say, South Africa is, does distinguish between the rights of Jews and non-Jews.

GREEN: Thank you, Mr Orzech.

GREEN *sits down and* LAWSON *rises.*

LAWSON: Would I be correct in saying, Mr Orzech, that the alternatives presented to the European Jew of your generation — especially the intellectual Jew — were either Communism or Zionism?

ORZECH: Yes.

LAWSON: And that both offered salvation from anti-Semitism?

ORZECH: Yes.

LAWSON: Can I ask, then, why did you choose Communism?

Pause.

ORZECH: Because I took the Marxist view that the problem of anti-Semitism could not be solved in isolation. That it was part of the general sickness of capitalist society . . .

LAWSON: By that do you mean that once capitalism was overthrown, there would be freedom and equality for everybody? The Jew assimilated?

ORZECH: (*Warily*) Something like that, yes.

LAWSON: Except that you overlooked Hitler and the Final Solution, didn't you? May I put it to you, the 'masses' turned in the wrong direction. Instead of building the new Jerusalem in Europe they set up barbed wire, built Auschwitz and exterminated six million Jews. Yet Israel lives. The Zionist dream — whatever criticism one may have about it — is now a living reality. Were you wrong, Mr Orzech? Did you choose the wrong escape route?

ORZECH: The analysis still holds.

LAWSON: . . . (*He looks at his notes*) . . . Would you not agree, Mr Orzech, that the reason why Jewish leaders organized the ghetto industries was to try and save Jewish lives and that their sole aim was to demonstrate to the Germans the productive usefulness of Jews, and that this was done in an effort to slow down the deportations and save their communities from destruction?

ORZECH: But it didn't, did it? The only Jews it saved . . .

LAWSON: Would you please answer my question.

Pause. ORZECH *shakes his head.*

ORZECH: It is impossible for me to give you a straight yes or no answer.

LAWSON: Why?

ORZECH: Because the leadership varied from ghetto to ghetto, and you are asking me about reasons and motivations. (LAWSON *smiles*) I can genralize and say that in the larger ghettos the 'rescue through work' idea saved some Jews and divided others. That it aided the Germany war economy, turned Jews against Jew, encouraged graft and corruption, and made it easier for the Nazis to carry out their policy of liquidation. But how do I compare a man like Adam Czerniakow, President of the Jewish Council in Warsaw who at least had the courage to commit suicide when he felt that he could no longer co-operate with the Nazis, with someone like Jacob Gens, police chief and leader of the Council in Vilna, who betrayed Jewish Resistance leader Yitzhak Witenberg to the Gestapo? Or with the Jewish Council in the Skalat ghetto who, after helping to drive the Jews out of their hiding places, threw a party for the SS? Over two thousand men, women, and children, lay all night in a field next to the railway track listening to the sound of laughter, singing and music, as they waited for the train that would take them to Treblinka. How do I compare?

LAWSON: I know of at least one eminent historian, an Oxford Don no less, who would offer a different version of what happened at the Skalat ghetto, Mr Orzech. (*As* ORZECH *smiles*) He is considered an expert on the Holocaust.

ORZECH: So am I. So too is Isaiah Trunk.

LAWSON: Isaiah Trunk?

ORZECH: The Skalat atrocity is well documented in his book, *Judenrat*. A massive piece of research that won him the National Book Award for history. It also carries an introduction by Zionist scholar, Jacob Robinson, who describes the book as the first detailed analysis in any language of the self-government imposed upon the Jews in Eastern Europe.

LAWSON *is sorry he asked. Pause.*

LAWSON: You said that the Warsaw uprising had no effect on the extermination programme. Wouldn't a Hungarian uprising have been just as futile?

ORZECH: (*Sharply*) I do not accept that the Warsaw uprising was futile.

LAWSON: In the heroic sense, neither do I. But let me re-phrase the question: Would a similar uprising in Hungary have stopped the deportations?

ORZECH: In my opinion, yes. Germany had already lost the war. They were ready to flee.

LAWSON: But weren't most able-bodied Jews already drafted into labour battalions?

ORZECH: Not all. And resistance can take many forms.

LAWSON: Tell me, Mr Orzech, are you today hostile to the policies of the Israeli government?

ORZECH: Yes.

LAWSON: You have no wish to celebrate their victory over the Arabs in the six-day war?

ORZECH: None whatsoever.

LAWSON: Then the jury will have to consider to what extent your political convictions colour your observations.

ORZECH: You could ask me why I am opposed to the Israeli victory.

LAWSON: For what purpose, Mr Orzech; you would hardly be described as an impartial witness, would you?

LAWSON *sits as the lights cross-fade to a photograph. The sound of marching. The lights cross-fade to the courtroom as* SCOTT *rises.*

SCOTT: Miriam Moser, please.

MIRIAM MOSER *is 41, smart, alert and very tense.*

SCOTT: Is your name Miriam Moser?

MIRIAM: Yes.

SCOTT: And do you live at 183 Drake Street, Harrow?

MIRIAM: Yes.

SCOTT: What is your occupation, Mrs Moser?

MIRIAM: I work as a teacher with mentally handicapped children.

SCOTT: You were born in Hungary?

MIRIAM: Budapest.

SCOTT: And were you a member of the Jewish underground during the war?

MIRIAM: Yes.

SCOTT: Can you tell the court what happened to you?

MIRIAM: I was sent to Auschwitz. Beginning of July 1944. I was on the last deportation train. I was put in Block 10. The experimental block. The Nazis were trying to discover ways of sterilizing Jewesses by radiation. There was this machine. No anaesthetic. Girls were carried in, kicking and screaming. Many died of their radiation burns.

SCOTT: And were you aware at the time what was happening to you?

MIRIAM: No. I was only 18. Some time after the ovary was radiated, it was removed and examined to see if it had worked, see if radiation had had any effect. In my own case, that didn't happen. The war was nearly over . . .

SCOTT: When did you leave Auschwitz?

MIRIAM: January 1945. I was moved to hospital where I stayed until May, when I was liberated.

SCOTT: And did you then return to Hungary?

MIRIAM: Yes. In 1948 I got married and came to England. I have lived here ever since.

SCOTT: And in what way does it still affect your life?

MIRIAM: I get depressed easily. I don't sleep well. Sometimes I hide inside myself. But I manage.

SCOTT: Any children?

Long painful silence. She shakes her head in silent grief. Then:

MIRIAM: No. *(Pause)* My menstrual periods came back after leaving hospital, and I was pregnant three times, but . . . I lost my babies because of what they did to me in Auschwitz.

She covers her face with her hands. The court waits. Then the JUDGE *leans forward.*

JUDGE: Would you like a glass of water, Mrs Moser?

She shakes her head, wipes her eyes with a handkerchief and looks up.

MIRIAM: I'll be all right.

JUDGE: Is it really necessary to continue with this line of questioning, Mr Scott?

SCOTT: No, my Lord. *(Pause)* In the period before you went to Auschwitz, did you know Doctor Yaron?

MIRIAM: Yes. He was a member of the Jewish Council.

SCOTT: You knew him to speak to?

MIRIAM: Yes.

SCOTT: And to your knowledge, was he ever actively involved with the Underground? Did he help in any way?

MIRIAM: *(Staring at* YARON*)* No. *(Looking at* SCOTT*)* The Jewish Council saw us as a threat to their position within the community. They were only concerned with building a working relationship with the Nazis, which meant carrying out their orders.

SCOTT: Miss Kaplan says that Doctor Yaron collaborated.

MIRIAM: He did. I was there. I saw it.

SCOTT: What did you see?

MIRIAM: Well, I could give you several examples. There was the occasion when Hannah Szenes was arrested.

SCOTT: One of the three Resistance fighters who parachuted into Hungary?

MIRIAM: Yes. Hannah was a British agent, and the Swiss were looking after Britain's interests in Hungary. I went to see Doctor

54

Yaron, asking him to inform the Swiss so that they could intervene on her behalf.

SCOTT: Could that have saved her?

MIRIAM: (*She shrugs*) I don't know. At least it was worth a try. Because at the time, the Hungarian government was very sensitive to world opinion. Germany had already lost the war and the Allies were threatening retribution for those responsible for war crimes.

SCOTT: So you went to see Doctor Yaron?

MIRIAM: Yes.

SCOTT: And what was his response?

MIRIAM: All he could talk about was the train, about how 'we' must not provoke the Nazis into cancelling it. We had a blazing row, and he started quoting Weizmann's famous 'dust speech' as if this in some way justified it.

SCOTT: 'Dust speech'?

MIRIAM: Something Wiezmann said before the war: 'The old ones will pass; they will bear their fate or they will not. They are dust. Economic and moral dust in a cruel world. Only a branch will survive.' When he started quoting that, I just walked out. I felt sick.

SCOTT: Can you tell us what happened to Hannah Szenes?

MIRIAM: She was executed. Then there was the business over the postcards sent by some deportees from Auschwitz.

A new element has been added. SCOTT *looks sharply at her while* YARON *talks to* LAWSON.

SCOTT: What postcards?

MIRIAM: Among the new arrivals at Auschwitz, some would be selected and made to send cards back to their families still awaiting deportation. SS guards would tell them what to write. Usually things like: 'I'm all right, see you soon. Everything is fine here.'

SCOTT: You mean sort of 'wish you were here' cards.

MIRIAM: Yes.

SCOTT: Were they posted?

MIRIAM: No, they went by special SS courier from Auschwitz to Budapest.

SCOTT: And most of the writers of these cards would be already dead by the time their relatives received them?

MIRIAM: Yes.

SCOTT: And who distributed these postcards?

MIRIAM: Members of the Jewish Council.

SCOTT: Would they have known what was happening in Auschwitz?

MIRIAM: Of course. They knew everything.

SCOTT: Why didn't the SS themselves distribute the cards?

MIRIAM: Because then it would have made them suspicious.

SCOTT: And the Jews may not have boarded the trains so easily?

MIRIAM: (*She nods*) But they trusted their leaders.

SCOTT: Did Doctor Yaron help distribute these cards?

MIRIAM: Yes. I saw him and another member of the Council giving out these cards to a family who lived on Rakoczi Avenue.

LAWSON *jumps up, protesting.*

LAWSON: My Lord, none of this was put to Doctor Yaron when he was giving evidence.

SCOTT: Mr Lawson is quite right to protest, and I do apologize to the court. These allegations were not put to Doctor Yaron, simply because until this very moment I was not aware of them.

JUDGE: Doctor Yaron may, of course, be recalled and be given an opportunity to deal with these matters.

LAWSON: Thank you, my Lord, I may wish to do that.

JUDGE: Carry on, Mr Scott.

SCOTT: Mrs Moser, you say you saw Doctor Yaron handing out these postcards on Rakoczi Avenue?

MIRIAM: (*Firmly*) With my own eyes.

SCOTT: Can you remember when this was?

MIRIAM: Yes. It was some time towards the end of May.

SCOTT: And did you speak to them about it?

MIRIAM: How could I? There were police all round.

SCOTT: Is there any doubt at all in your mind?

MIRIAM: None whatsoever.

SCOTT: Thank you, Mrs Moser.

SCOTT *sits down and* LAWSON *rises.*

LAWSON: Were there any other witnesses to this alleged incident?

MIRIAM: Only the families who received the postcards, but now they are all dead.

LAWSON: Well, did you attempt to warn them?

MIRIAM: Of course.

LAWSON: What happened?

MIRIAM: They refused to believe. Because men like Doctor Yaron and Kastner were telling them different.

LAWSON: Yet even though you told them everything that you knew about Auschwitz, they still did not believe you?

MIRIAM: They wanted *not* to believe. But had they known the

truth about Auschwitz, no power on earth could have persuaded them to board the trains.

LAWSON: But what could they have done?

MIRIAM: (*Fiercely*) Fought back. Resisted. Torn down the ghettos, flooded the streets.

LAWSON: With bare hands?

MIRIAM: If necessary.

LAWSON: Against armed troops, the SS and the local Fascist militia?

MIRIAM: They had nothing to lose.

LAWSON: Despite your criticism of Doctor Yaron and the others . .

MIRIAM: Condemnation, not criticism.

LAWSON: You say that the Jews of Budapest wanted not to believe.

MIRIAM: Can you blame them? Children were being burnt alive in the oven at Auschwitz, their young bones turned into fertilizer. Jewish leaders told them what they wanted to hear, that they would live. Tricked and lied to, they were lulled into a false sense of security by the likes of Doctor Yaron.

LAWSON: Could this not have been a case of bad leadership and judgement on their part, rather than outright collaboration?

MIRIAM: No.

Because they knew what they were doing. Eichmann was their patron and protector. Through them he issued his orders and in return for helping the Nazis they were promised safe passage for their families.

LAWSON: The court has heard how nearly 1,700 Jews escaped on a train to Switzerland.

MIRIAM: Including Kastner's family.

LAWSON: But the Rescue Committee saved a further 18,000 destined for Auschwitz.

They succeeded in having them sent to labour camps in Austria. Were you aware of that, Mrs Moser?

MIRIAM: Yes.

LAWSON: Did you know that Doctor Yaron's mother and two sisters were liquidated by the Nazis in Poland?

MIRIAM: No.

LAWSON: And that prior to the occupation of Hungary he and other members of the Rescue Committee were risking their lives helping Jews escape from the East?

MIRIAM: Helping Jews escape into Hungary was routine work for the Resistance.

LAWSON: Thank you, Mrs Moser.

She calls out as he returns to his seat.

MIRIAM: That still does not give him absolution!

SCOTT: That concludes the evidence for the defence.

MIRIAM *returns to her seat.*

LAWSON: (*Rising*) I will, if I may, recall Doctor Yaron to deal with the last matter.

YARON *enters the witness box. Tense and nervous, his eyes are fixed on* LAWSON.

LAWSON: Is it true, Doctor Yaron, that postcards were sent from Auschwitz to Jewish families in Budapest?

YARON: Yes.

LAWSON: Did you ever see any of these cards?

YARON: No. But I was told about them.

LAWSON: How were they delivered?

YARON: As far as I know, they came through the post.

LAWSON: You have just heard Mrs Moser say that they were distributed by members of the Jewish Council.

YARON: I don't see how.

LAWSON: And she actually saw you and other members of the Jewish Council giving out these postcards to a family on (*He looks at his notes*) Rakoczi Avenue.

YARON: That is not true. (*He shrugs*) Monstrous things happened to her in Auschwitz.

LAWSON: Well, have you seen her or spoken to her since those terrible days in Hungary?

YARON: No.

LAWSON: How well did you know her in Budapest?

YARON: Only slightly. I can't remember. She was one of many.

Perhaps I should say it is possible that some individual members of the Jewish Council may have participated with the postcards. All my efforts were concentrated on rescue.

LAWSON: When you say 'rescue', are you referring specifically to the train?

YARON: Not only the train. We were trying to help our people in the provinces, sending money to the different ghettos through Christians and Young Zionist boys and girls who acted as couriers. I personally was involved in helping hundreds of Jews to reach Budapest who would otherwise have been deported.

LAWSON: Which would offer them refuge for the time being, at least?

YARON: Yes.

LAWSON: And were the Jewish leaders meanwhile seeking other ways of effecting their escape?

YARON: Yes, but Budapest was the end of the line. There was nowhere else to hide. All we could do was move heaven and earth to inform the Allies, the churches, world opinion. Try and get them to stop the deportations. We sent detailed memoranda . . .

LAWSON: Doctor Yaron, was there anything else that could possibly have been done to ease the fate of your co-religionists?

YARON: No.

LAWSON: Did you distribute these postcards to any Jewish families?

YARON: No, sir. Definitely not.

LAWSON: Thank you, Doctor Yaron.

LAWSON sits down and SCOTT rises.

SCOTT: You have added that some members of the Jewish Council were involved in the distribution of postcards?

YARON: I said it was a possibility.

SCOTT: Were you one of these?

YARON: No.

SCOTT: How many did you say were on the rescue train, Doctor Yaron? Was it sixteen hundred?

YARON: Don't forget the 18,000 we saved from Auschwitz, and those we got into Romania.

SCOTT: I am speaking about your train, Doctor Yaron. How many?

YARON: (*Contemptuous*) One thousand, six hundred and eighty-four.

SCOTT: And approximately half a million perished. Well, how did you go about preparing the list? How did you decide who would live and who would die?

YARON: Our first choice was to save the children.

SCOTT: Why didn't you?

YARON: Eichmann and Wisliceny refused. They thought that a children's transport might attract too much attention.

SCOTT: But twelve trains a day were already leaving for Auschwitz.

YARON: It was their decision.

SCOTT: And so naturally you agreed. So where did the rescue train take them to?

YARON: The transit camp at Bergen-Belsen.

SCOTT: And eventually Switzerland?

YARON: Yes.

59

SCOTT: Were your wife and children on the train?

YARON: Yes.

SCOTT: How about you?

YARON: I stayed behind.

SCOTT: But joined them later?

YARON: Yes.

Pause. SCOTT *looks at his notes.*

SCOTT: But of course, as a member of the Rescue Committee that wasn't too difficult, was it, Doctor Yaron? After all, providing you did as you were told, you were immune from deportation. You were more or less allowed to come and go as you pleased?

YARON: Within certain limits, we were permitted freedom of movement in order to carry out our duties.

SCOTT: (*Scathingly*) Duties?

YARON: Responsibilities.

SCOTT: To Eichmann?

YARON: To the community.

SCOTT: From which you chose suitable candidates for salvation, did you not? The rich, the 'prominents' and the Zionist functionaries. Those best fitted, not only to salvage what was left of the Jewish social structure with its institutions, but also to transplant, to recreate that same ruling establishment in Palestine. Is that not right?

YARON: Our community was doomed to destruction. We were given an opportunity to save a few; we took it. What good would the shedding of more blood have done if all had perished?

SCOTT: Is there not a crying discord between the Jewish masses who had no place to hide or retreat to, and the functionaries who secretly crept out of Hungary at the height of the deportations?

YARON: I've already told you. That was Eichmann's decision, not ours.

SCOTT: First you placed a noose around the neck of every Jew in Hungary, then you tightened the knot and legged it for Palestine, did you not?

YARON: That is how a non-Jew would see it.

Pause.

SCOTT: Where was Kastner's home town?

YARON: He came from Kluj.

SCOTT: In the provinces?

YARON: Yes.

SCOTT: In June, 1944, at the very height of the deportations, Eichmann permitted Kastner to visit Kluj. Is that not so, Doctor Yaron?

YARON: Yes.

SCOTT: Why?

Pause.

YARON: To select people from Kluj for the rescue train.

SCOTT: The figure, I believe, was 388.

YARON: Something like that.

SCOTT: Mainly Zionists, and members of his own family.

YARON: Yes.

SCOTT: Why else do you think Eichmann sent him there? (*Pause. YARON looks tensely at SCOTT*) Surely it was not because he was concerned with the welfare of 388 Jews? He was already slaughtering 12,000 a day at Auschwitz. (*Pause. SCOTT looks at his notes*) At the time of Kastner's visit, were there not 20,000 Jews of Kluj, men, women, and children, waiting in a ghetto to be transported?

YARON: (*After a long silence*) Yes.

SCOTT: Will you tell the court how far Kluj is from the Romanian border?

YARON: About three miles.

SCOTT: (*Nodding*) Three miles. And at that time, would it be true to say that Jews were relatively safe in Romania?

YARON: Yes.

SCOTT: These 20,000 Jews were guarded by one SS man, and 20 Hungarian police. Escape would have been easy, yet they chose to stay. Why? (*YARON stares frostily back at SCOTT*) Was it not because Kastner strolled amongst them, patting them on the back, smiling and reassuring them?

Pause. SCOTT picks up a sheet of paper.

SCOTT: I would remind the court that at the Jerusalem trial in 1953, when Kastner was accused of collaboration, one of the survivors from Kluj testified. I have here the official court transcript. Jacob Freifeld told Judge Benjamin Halevi: 'After the first train load left Kluj, all the Jews were assembled in the ghetto. Kohani, one of Kastner's group, jumped up on a platform and read aloud a letter he said was from a Jewish family in Kenyermeze. The letter said the whole family was working at good jobs and were all in good health and being well taken care of. I had a friend, Hillel Danzig. In Kluj I asked him, what's the truth about those letters Kohani read in public. Are they really true? He told me, "Yes, they're true". And he gave me a tip; I should try to go to Kenyermeze as soon as I could. Because the first arrivals there would get the best places. So I decided to go on the next train — instead of waiting for the last one. Yes, we all hurried to Kenyermeze. (*SCOTT looks up*) The train took them to Auschwitz, and when Defending Counsel Tamir asked him if

his Zionist friend, Hillel Danzig had also finished up at
Auschwitz, Jacob Freifeld replied: (*Reading*) 'God forbid. How
could such a thing happen. He was a member of the Jewish
Council — working hard with that clique. So he remained with
the saviours — safe. My whole family — ten people — were
exterminated.'

SCOTT *puts down the sheet of paper and stares hard at* YARON.

YARON: (*Angrily*) What has all this to do with me? I am not
responsible for what Doctor Kastner did.

SCOTT: You shared his secrets; you were part of the deception.
But the real significance of this, is why the Israeli government
chose to defend Kastner? (*He snatches up a slip of
paper*) Attorney General Chaim Cohen, arguing his appeal before
the Supreme Court: (*Reading*) 'If in Kastner's opinion, rightly
or wrongly, he believed that one million Jews were hopelessly
doomed he was allowed not to inform them of their fate; and to
concentrate on the saving of a few . . . It has always been our
Zionist tradition to select the few out of the many in arranging
the immigration to Palestine.'

Pause. SCOTT *puts down the slip of paper and consults with*
GREEN. *She hands him a book. He thumbs through the pages and
holds it up.*

[excised]

[excised]

YARON: Our Zionist tradition compelled us to save the few out of the many. That is how our sages and leaders taught us.

SCOTT: What about Hannah Szenes, the young Jewess who parachuted into Europe along with two other comrades to help organize resistance in Hungary?

YARON: She was captured and shot by a Hungarian firing squad.

SCOTT: Mrs Moser says that she asked you to intercede on behalf of Hannah Szenes and that you refused. Search your memory. Did Mrs Moser come to your office on Sip Street?

YARON: Yes. She did come to see me about the Szenes girl, and I referred her to Doctor Kastner.

SCOTT: Because he was closer to Eichmann?

YARON: He had more influence.

SCOTT: And then . . .

YARON: I don't know what happened. But she was a brave girl . . . God rest her soul.

SCOTT: What about the other two?

YARON: They turned themselves over to the Germans.

SCOTT: (*In disbelief*) You mean that after travelling thousands of miles, dropping into Nazi-occupied Europe and smuggling themselves into Hungary, they just surrendered to the Nazis?

YARON: Yes.

SCOTT: Why?

YARON: Doctor Kastner advised them to.

SCOTT: For what reason?

YARON: Because of the train. He thought their presence might jeopardize the rescue operation.

SCOTT: And because he spoke with the authority of the Zionist movement, they agreed?

YARON: Yes.

SCOTT: What happened to them?

YARON: They were sent to Auschwitz.

SCOTT: (*Coldly*) Three young Jewish resistance fighters drop from the skies to help organize resistance in Hungary, and all three were abandoned by your Committee?

YARON: It was Doctor Kastner's decision.

SCOTT: Kastner. Always you reiterate the same old plea, Kastner. If I can revert back to the Kastner trial. (*He picks up a document*) The verdict of the district court in Jerusalem indicts not just Kastner, but every member of that Rescue Committee. If I may remind you again of it:

(*Reading*) 'The masses of Jews from Hungary's ghettos obediently boarded the deportation trains without knowing of their fate. They were full of confidence in the false information that they were being transferred to Kenyermeze. The Nazis could not have misled the Jews so conclusively had they not spread their false information through Jewish channels. The Jews of the ghetto would not have trusted the Nazis or Hungarian rulers, but they had trust in their Jewish leaders. Eichmann and others used this known fact as part of their calculated plan to mislead the Jews. They were able to deport the Jews to their extermination by the help of Jewish leaders.'

SCOTT *puts the document down and turns to the jury (audience).*

These are not my words or the words of my client, Miss Kaplan. They are the words of an Israeli Supreme Court judge, Benjamin Halevi — one of the three judges who tried Adolph Eichmann.

. . . Need we proceed any further?

SCOTT *looks down at his notes and throws them down again, as if to say 'why bother'. He looks across at* YARON.

SCOTT: It is clear, Doctor Yaron, isn't it? That you, Kastner, and he other members of the Committee collaborated with the Nazis.

YARON: We represented the best interests of our people.

SCOTT: By sending them to the gas chambers?

YARON: I explain, but you won't listen!

SCOTT: (*Harshly*) Because the language is unequivocal. Betrayal.

YARON: (*As if reciting*) The creation of the Jewish state above all other considerations.

SCOTT: Coined in the blood and tears of Hungarian Jewry.

YARON: We had to subordinate our feelings.

SCOTT: (*Mockingly*) The cruel criteria of Zionism!

YARON: All deeds good or bad must be judged by the final outcome.

SCOTT: By their consequences.

YARON: And by the historical aims they serve.

SCOTT: The end justifies the means.

YARON: (*His confidence growing*) A maxim invented by your Jesuits.

SCOTT: But not if the means are criminal.

YARON: Today America forces its end upon Vietnam with Fire, napalm, explosives. Whoever stands in her way is considered immoral.

SCOTT: Then official morality serves special interests?

YARON: Of course. It has a political function.

SCOTT: Would you not agree, Doctor Yaron, that the more earthly demands of Zionism are reduced to territorial ambition? After all, that is what the six-day war was all about, wasn't it? Expansion.

YARON: Protection.

SCOTT: Morally justifiable, of course.

YARON *offers a wintry smile.*

YARON: Was it morally right to drop the bomb on Japan?

SCOTT *is thrown slightly.*

YARON: You talk to me of territorial ambition? For 300 years, England plundered, raped and pillaged. Your colonial system oppressed millions. In seven-league boots, England strode the world as if she owned it and God was an Englishman.

LAWSON: (*Stands*) My client is obviously under great emotional stress, and I request a short recess so that I can consult with him. That is if Mr Scott has no objection.

SCOTT: (*Sitting*) I have no objection.

YARON *sits. His composure slipping away. A disapproving look on his face.*

JUDGE: I will allow a five-minute recess, if you wish, Doctor Yaron.

YARON: For what purpose?

JUDGE: You will be well advised to allow your legal representative to decide that.

YARON: What good would it do?

A frown marks the JUDGE's *face*.

JUDGE: (*Curtly*) Very well. Carry on, Mr Scott.

LAWSON *sits down, shaking his head. An expression of resignation on his face.*

SCOTT *rises*.

SCOTT: What surprises me, Doctor Yaron, is why you even considered bringing this case to court.

YARON: Yes.

SCOTT: I beg your pardon?

YARON: I agree. I am on trial here, not the person who slandered me.
They eye-ball each other.

The greatest evil is not to oppose evil. We begged you to bomb the railway lines leading into Auschwitz and you refused. You expressed sympathy for the Jewish refugees, then invoked your immigration laws to keep them out. You planted the seeds of violence and we learnt from you. We picked up your habits and we hated you for it because now the world is afraid of us. Now we inflict pain and we don't like it, but you cannot create out of an imaginary material. The submissive Jew, meek, cowardly, reviled, subdued and stripped of all human dignity is gone.

We are no longer content to provide the world with a creative nucleus, with revolutionary leaders who serve all other interests but their own. After 2,000 years of exile, the Jew has returned home and the words of the Prophet Ezekiel have come true: 'Thus saith the Lord God, I will gather you from the people and assemble you out of the countries where you have been scattered, and I will give you the land of Israel.' (*He smiles*)

We are no longer in hiding, Mr Scott. The wheel and the ghetto have gone. We shout from the roof-tops: 'I am a Jew' — and people listen with fear and respect.

SCOTT: Because militarily you are a strategic asset.

YARON: Power commands respect. Something else you taught us.

SCOTT: You know this is a creative fantasy, Doctor Yaron. You know Israel is a paid watchdog: a nation built on the pillar of Western guilt and subsidized by American dollars.

YARON: We know that. We are not fools. We know there are rich American Jews who hurl tax-deductible donations, yearning, with the grit and determination of non-combatants, for Armageddon in the Middle East. (*He smiles*) We know all about that.

SCOTT: Tomorrow you may become expendable.

YARON: We have other plans. You had 300 years; we've only been in existence for nineteen. Give us time.

SCOTT: And never has the situation of the Jews been more tragic. After all the sacrifice and suffering, Israel today is the most

dangerous place on earth for a Jew. You face endless military confrontation: one defeat and you are finished.

YARON: We won't allow that to happen.

SCOTT: Your own history should have taught you better.

YARON: Our history has taught us to survive.

SCOTT: The Arab countries can absorb defeat. Israel cannot. In which case the temptation to use nuclear weapons will be great. Then what? Another holocaust? Computerized, clean, more efficient? You should have stayed in Europe, Doctor Yaron . . . No more questions.

The lights cross-fade to the montage and then immediately cross-fade to pick out SCOTT, *who is standing, making his closing speech.*

SCOTT: The simple, terrible truth is that the Jews of Hungary were murdered not just by the force of German arms, but by the calculated treachery of their own Jewish leaders. In terms of salvation, the only 'chosen people' left in Budapest were the elite, the 'prominents'. It has been argued that some of these Council members were themselves victims and this is undoubtedly true. But the fact that as their influence and usefulness to the Nazis suffered eclipse and that they then followed their brethren to the gas chambers is hardly to their credit.

Pause.

I must confess, members of the jury, that I took this case with a feeling of anxiety and trepidation, for Miss Kaplan was right when she said that because of the holocaust, 'anything related to the Jews is clouded over with guilt'. And yet when you come to think about it, isn't that all too easy? Isn't this a way of spreading the guilt until it becomes meaningless and ineffective? As useless as the theory of German war guilt, of American guilt over what is happened today in Vietnam, of British guilt for what happened in India, the colonies and Ireland? If the well is polluted, do we blame the water-carrier? If anti-Semitism is indeed 'the Socialism of fools', should we not ask where and how that consciousness arose in the first place? What it is in our society that generates this evil? If our remorse for what happened to the Jews is to have any meaning, must we not tear out the roots of this evil and eradicate it completely so as to ensure that never again will a people be exterminated simply because they exist?

If another major economic crisis occurs at some time in the future, can we with confidence assert that Fascism will not arise again like a broken sewerage pipe disgorging its filth and corruption on society? Have we been given not a victory over Fascism but a reprieve, a warning, a breathing space?

The lights fade on SCOTT *as he speaks, and fade up on* LAWSON, *mid-speech.*

LAWSON: Remember also that Doctor Yaron is a Jew, and that six million of his own people, including members of his own

family, were murdered by that very same people he is accused of collaborating with. For him personally, the destruction of European Jewry is not just a matter of files, testimony, statistics and graphic charts. The holocaust was the pogrom writ large: the nails driven into the skulls, the babies tossed from windows, the insults and racial bigotry which led directly to the gas chambers at Auschwitz, and this accusation identifies Doctor Yaron as being part of that killing process. The fact is, of course, as Doctor Yaron himself explained, that members of the Jewish Council were compelled to liaise daily with Eichmann and his band of cut-throats simply because there was no one else there to negotiate with, and they were trying by whatever means possible to evade the coming blow. They knew that at that stage no rescue was possible, and that the Jews of Hungary were doomed. It was then that they were faced with the agonizing dilemma: whether to save the few at the price of the many and keep quiet about the extermination camp at Auschwitz. This was the choice presented to them by Eichmann. 'Make your selection,' he said. 'Prepare your lists.' What should they have done? The train was there, ready and waiting.

The light on LAWSON *fades, and the lights rise on the whole courtroom.* LAWSON *and* YARON *are leaving. The junior counsel is gathering papers before she leaves.*

RUTH: What happens now?

GREEN: (*Beaming*) Acquittal!

RUTH: How long will it take?

GREEN: They should have it wrapped up within the hour. (*To* SCOTT) You destroyed him.

SCOTT: The rope was already around his neck. All I did was jerk the noose.

I still can't figure out why he brought this case to court.

GREEN: Because her pamphlet smoked him out. He had to.

SCOTT: But with such a limited circulation, why bring more attention to himself?

GREEN: He must have thought he'd win. Are you coming?

GREEN *and* SCOTT *leave.* RUTH *has been putting something in her bag, and is about to follow when* YARON *walks back into the courtroom.*

RUTH *and* YARON *look at each other for a moment.*

RUTH: He thinks the jury will return a verdict of justification.

YARON: (*Dismissively*) Congratulations.

RUTH: Thank you, but now the shoe pinches.

YARON: Why? It's what you wanted.

RUTH: Yes. But it was your decision. You took me to court.

YARON *presses his fingers against his eyes.*

RUTH: You don't have to stay.

YARON: I must.

RUTH: The jury could be out ages.

YARON: I don't think so. Your Mr Scott is no fool.

RUTH: He gave you a hard time.

YARON: But I didn't lie. I took the oath, but I didn't lie and the truth can be painful.

RUTH: Truth?

YARON: When I sat in that witness box, *I* was on trial. There was no pretence. I suffered.

RUTH: Is that what you wanted?

YARON: Scott was good. Sharp as a razor, but the credit goes to you. You brought back the diary and insisted on publishing it . . .

RUTH: Which you refused to do.

YARON: I was afraid of the scandal. Of what people might say. Of my good name! You were tenacious as a leech! You kept on. Letters. Phone calls.

RUTH: Unanswered.

YARON *sits on one of the benches.*

YARON: Then when it happened, it came as a blessing.

RUTH: Why are you telling me this?

YARON: Words hard as nails. My name written on the page. The indictment (*He stares into space, remembering*) In Budapest, I watched two young Jewish girls in summer dresses walking arm-in-arm to the transport waiting to take them to Auschwitz. They were eating ice-cream.

RUTH: You didn't warn them?

YARON *shakes his head. Suddenly he breaks down, crying.*

RUTH *watches him for a moment, then moves to sit near him. She takes a handkerchief out of her pocket and hands it to him.*

RUTH: Here.

YARON: As Mrs Moser said. For me there is no absolution.

He takes the handkerchief and wipes his eyes.

YARON: And yet I have this dream . . .

Both turn as SCOTT comes into the centre of the court. They stare at him.

SCOTT: Excuse me, I forgot my briefcase . . .

SCOTT *starts to fill his briefcase. Then stops.*

SCOTT: Why?

RUTH: You heard?

SCOTT: Because you wanted a platform?

YARON: More a tribunal.

SCOTT: Repentance?

YARON: Too late for penitence, Mr Scott.

SCOTT: To purge yourself, then?

YARON: Only partly that. To have quietly denounced myself . . .to have offered myself for moral execution was not enough.

SCOTT: You needed an audience.

YARON: (*Harshly*) I needed a judgement, Mr Scott. The question remained: was it right to co-operate with the Nazis? With good faith we believed that we were contributing to a great mission.

RUTH: Palestine.

YARON: A Jewish homeland where Jews might find shelter from the incendiary fires of anti-Semitism.

SCOTT: You utilized this court to reach a conclusion.

YARON: (*Decisively*) Yes. (*Throwing out his arms*) It was all here in this courtroom. Jury, judge, counsel.

Files, records, testimony, Szamosi's diary. The material evidence, Mr Scott.

And I fought you all the way.

SCOTT: And lost.

SCOTT *picks up his briefcase.*

SCOTT: Will you be staying for the finale?

YARON: Yes.

RUTH: (*To* SCOTT) You won't say anything?

SCOTT: Why should I? Shalom.

They watch him leave.

YARON: Shalom.

Exit SCOTT. *Pause.* YARON *looks at* RUTH.

YARON: I was wrong . . . Now we must cry out . . . warn . . .

RUTH: (*Taking his hand*) Later. Sit down and tell me about your dream.
Gradually the lights fade in the courtroom, except for a pool of light on RUTH *and* YARON. *Behind them, the full photo-montage is illuminated for the first time.*

YARON: I found myself standing at the gates of Auschwitz. There was a crypt-like silence. A hot wind blew in my face and there was not a smoking chimney in sight. A party of German schoolchildren passed through the gate escorted by their woman teacher. A tall black crucifix of a woman — black starched blouse, black shirt, black shoes. I tried to decipher her thoughts and feelings as she led the children to the waiting coach. She gave me an embarrassing apologetic smile. I said nothing. She had

70

made her pilgrimage. A modest deposit, but not full payment.

I am about to creep away when one of the children, a child with a trusting smile, hands me a bunch of freshly cut flowers.

Long silence.

Scott was right about one thing, Ruth. If the well is polluted . . .

RUTH: Then we dig a new well.

Lights fade, first on RUTH *and* YARON, *and then on the montage.*

Curtain

Zionism and Rescue *by Lenni Brenner**

I - Zionism and anti-Semitism before Hitler

The strategy of the World Zionist Organisation (WZO) toward anti-Semitism was laid down by its founder, Theodor Herzl, in his *Diary*. In 1895 he had been a journalist at the Dreyfus trial, and he developed his thoughts in his first entry into his personal chronicle:

> "In Paris . . . I achieved a freer attitude toward anti-Semitism, which I now began to understand historically and to pardon. Above all, I recognized the emptiness and futility of trying to 'combat' anti-Semitism."[1]

Herzl openly sought to utilize anti-Semitism for the benefit of his fledgling WZO. In his 1896 *Jewish State*, he analogized Jew-hatred to steampower,

> "generated by boiling water, which lifts the kettle-lid . . . I believe that this power, if rightly employed, is powerful enough to propel a large engine and to move passengers and goods."[2]

Such conceptions inexorably led to attempts to collaborate with anti-Semitism. In 1903, the Kishinev massacre in the Tsarist empire inspired a Zionist youth to try to assassinate the prime agitator, and the regime cracked down on the movement. Herzl went to St Petersburg to parlay with Vyacheslav von Plevhe, the Minister of Interior, whom the world blamed for the atrocity. The two worked out a deal. The Russians declared its vague support for Zionism on condition the WZO would keep out of the struggle for Jewish rights within the empire.

Herzl went from Russia to a World Zionist Congress. Behind the scenes he had a discussion with Chaim Zhitlovsky, then a leading figure in the Social Revolutionary Party. Later Zhitlovsky revealed Herzl's proposal:

> "I have just come from Plevhe. I have his . . . promise that in 15 years, at the maximum, he will effectuate for us a charter for Palestine. But this is tied to one condition: the Jewish revolutionaries shall cease their struggle against the Russian government."[3]

The revolutionaries scorned the crackpot scheme. Herzl died soon after, leaving behind his conception of *hochpolitik*, or diplomatic intriguing with the enemies of the Jews that was to continue to be the strategic line of the WZO straight down to the Hitler era. The fundamental axiom of the movement was that anti-Semitism could not be fought. Its second principle was that it could be utilized to create a Jewish state in Palestine. To be sure, the WZO became a world wide organization. In some countries at some times it had a mass base and responded to pressure from its constituency. Even then the local affiliates never waged a militant struggle for

*Lenni Brenner is the author of *Zionism in the Age of the Dictators*, *The Iron Wall: Zionist Revisionism from Jabotinsky to Shamir* and *Jews in America Today*.

Jewish rights, for this is only possible if you do really believe Jews should be living in the country.

II – Zionism and Nazism in the Weimar Republic

Prior to the rise of Hitler, the *Zionistische Vereinigung für Deutschland* (ZVfD), the Zionist Federation of Germany had little importance for the mostly assimilated Jewish population. The ZVfD underestimated Hitler's initial success in the June 1930 Saxony election, when the Nazis got 14.4 per cent of the vote. Siegfried Moses, a leading figure, wrote that, while they believed in defence work, 'defence against anti-Semitism is not our main task . . . and is not of the same importance for us as is the work for Palestine.'[4]

Even as late as 1932, with Hitler growing in strength, the ZVfD was organizing classes against 'red assimilation'. Inevitably some Zionists moved from stoic indifference to the threat to an illusionary policy of accommodation. Stephen Poppel, in his *Zionism in Germany 1897-1933*, relates that:

"Some Zionists thought that there might be respectable and moderate elements within the Nazi movement who would serve to restrain it . . . with [Robert] Weltsch [editor of their magazine] . . . arguing in its [accommodation] behalf."[5]

III – German Zionism seeks collaboration with Hitler

With Hitler in power it took no time before the ZVfD sought the accommodation it had only discussed in the last days of the Weimar Republic. In March 1933, Kurt Tuchler of the ZVfD executive convinced Baron Leopold von Mildenstein, the SS Jewish specialist, to accompany him to Palestine, to research a series of articles for the Nazi press. Von Mildenstein was the guest of the Zionist movement for six months.

Meanwhile the ZVfD continued its efforts in Germany. Rabbi Joachim Prinz, one of the ZVfD's leaders, later described their mood in the first months of the new order:

"Everyone in Germany knew that only the Zionists could responsibly represent the Jews in dealing with the Nazi government. We all felt sure that one day the government would arrange a round table conference with the Jews . . . The government announced . . . there was no country in the world which tried to solve the Jewish problem as seriously as did Germany. . . . It was our Zionist dream! . . . Dissimilation? It was our own appeal! . . . In a statement notable for its pride and dignity, we called for a conference."[6]

The 'pride and dignity' of their stance will be immediately appreciated when we learn that the ZVfD memorandum of 21 June 1933 to the Hitlerites remained secret for the next 29 years.

"May we therefore be permitted to present our views, which, in our opinion, make possible a solution in keeping with the principles of the new German State of National Awakening, and which at the same time might signify for Jews a new ordering of the conditions of their existence . . . An answer to the Jewish question truly satisfying to the national state can be brought about only with the collaboration of the Jewish movement that aims at a social, cultural and moral renewal of Jewry . . . On the foundation of the new state, which has established the principle of race, we wish so to fit our community into the total structure, so that for us too, in the sphere assigned to us, fruitful activity for the Fatherland is possible . . . For its practical aims, Zionism hopes to be able to win the collaboration even of a government fundamentally hostile to Jews, because in dealing with the Jewish question no sentimentalities are involved, but a real problem whose solution interests all peoples, and at the present moment especially the German people. The realisation of Zionism could only be hurt by resentment of Jews abroad against the German Development. Boycott propaganda – such as is currently being carried out against Germany in many ways – is in essence un-Zionist, because Zionism wants not to do

battle but to convince and to build . . . Our observations, presented herewith, rest on the conviction that, in solving the Jewish problem according to its own lights, the German Government will have a full understanding for a candid and clear Jewish posture that harmonizes with the interests of the state.[7]

The Nazis seem never to have replied. But they did work out an accommodation with the WZO. The new regime was still weak. It had announced an undefinite boycott of Jewish stores and professionals, to begin on 1 April 1933. But it had to be called off after one day because German business feared a Jewish counter-boycott of German goods in Europe and America. Accordingly, Berlin sought to break the Jewish front by a deal with the WZO.

In August 1933, the Nazis announced a trade agreement, the Transfer or Ha'avara, with the WZO's bank. German Jews could put money into a German bank. The money bought exports, which were sold by the WZO, usually in Palestine, sometimes elsewhere in the Middle East and Europe. When the emigrating Jew arrived in Palestine, he received payment for the goods. The Transfer's appeal was that it was the least painful way of getting Jewish wealth out of Germany, in that it avoided the 'flight tax' imposed on emigrants to any other country, be they Jew or German. The Nazis determined the rules and they got worse as time went on. By 1938 the average user lost 30% to 50% of his wealth even through the Transfer. But this was still three times better than the losses taken by those who went elsewhere.

The top limit through the plan was only $20,000, so rich Jews barely utilized it. Therefore $650 million went to the US and $60 million to Britain, while only $40 million went to Palestine. But that $40 million was 60% of all capital invested in Palestine between 1933 and the war. Zionism was operated largely as a charity then, and the Depression had dried up its usual funds from Jewish capitalists. The WZO in Palestine was on the verge of bankruptcy when the Transfer saved them. Additionally, Britain, which set the annual Jewish immigration quota, admitted 'capitalists', those bringing $5,000 in addition to the quota.

It might be thought the Transfer saved lives. In fact it was never defended in its day in those terms. Today Zionism calls upon all Jews to emigrate to Israel. In those days the WZO wanted only an elite immigration. In the 20s, after the US imposed immigration quotas, thousands of middle class Polish Jews emigrated to Palestine. Their presence led to intense land speculation, forcing the WZO to pay inflated prices for land it needed. These small merchants generated a boom, which turned into a deep local Depression by the late 20s. Thence forward the WZO decided that emigration would be determined by its economic needs, rather than by the plight of Jewish communities abroad.

The British established the quotas, but the WZO distributed the immigration certificates. According to Professor Yehuda Bauer of the Hebrew University, only 'about 20 per cent' of immigrants from 1933 to 1938 were from Germany (and later Austria).[8] During the years 1933–35, 3,743 immigrants came from America, with an additional 579 coming from the rest of the Western Hemisphere. Africa sent 213 immigrants, Britain 513. Turkey sent 1,259 in 1934–35.[9] During 1933–35, two-thirds of all German Jews applying for certificates were turned down.[10]

Chaim Weizmann, later Israel's first President, was in charge of German immigration. He determined that almost all immigrants had to be under 30, and excluded whole categories, 'former businessmen', ie, small shop keepers, and musicians, as not needed in Palestine.[11] Most Jews were automatically excluded as non-Zionists. Abraham Margaliot, a leading Israeli Holocaust scholar, reports a speech by Weizmann to the Zionist executive in 1935:

"he declared that the Zionist movement would have to choose between the immediate rescue of Jews and the establishment of a national project which would ensure lasting redemption for the Jewish people. Under such circumstances, the movement, according to Weizmann, must choose the latter course.[12]

If the Zionists gained from the Transfer, the Jews did not. Meanwhile the Nazis got what they wanted: a breach in the anti-Nazi boycott. In 1933 Jewish leaders from various countries tried to organize the spontaneous boycott, and the Nazis were concerned to sabotage their efforts. The Gestapo's agent in Jerusalem later wrote that:

"The London Boycott Conference was torpedoed from Tel Aviv because the head of the Transfer in Palestine, in close contact with the consulate in Jerusalem, sent cables to London. Our main function here is to prevent, from Palestine, the unification of world Jewry on a basis hostile to Germany."[13]

The best illustration of the symbiosis of Zionism and Nazism was the outcome of von Mildenstein's tour. He wrote a massive 12 part series on his trip for Goebbels' *Der Angriff*, the leading Nazi propaganda paper (September 26–October 9, 1934). He started studying Hebrew and collected Hebrew folk song records. When Tuchler visited his new friend he was greeted by Hebrew music. The maps on von Mildenstein's walls showed the new strength of Zionism inside the Reich. Goebbels commemorated von Mildenstein's trip with a medal with a swastika on one side and the Zionist star on the other.[14]

IV – Hitler takes a second look at Zionism

Inevitably collaboration went beyond economics. In 1936 the Palestinians, alarmed at the growth of the Zionist settlement since 1933, revolted. The British sent out a Royal Commission to find a solution to the Palestine question. The Zionists wanted Germany to back Jewish immigration to Palestine. The Haganah, the military arm of the Labour Zionist faction, the precurser of the Israeli army, received permission to negotiate in Berlin with the SS. Their agent, Feivel Polkes, met with Adolf Eichmann on 26 February 1937. Eichmann had been trained on Zionist matters by von Mildenstein and like him had been studying Hebrew, and had read Herzl's *Jewish State*. A report, by Eichmann's superior, was found by the US army after the war:

"Polkes is a national–Zionist . . . As a Haganah man he fights against Communism and all aims of Arab–British friendship . . . He noted that the Haganah's goal is to reach, as soon as possible, a Jewish majority in Palestine . . . He declared himself willing to work for Germany in the form of providing intelligence as long as this does not oppose his own political goals. Among other things he would support German foreign policy in the Near East. He would try to find oil sources for the German Reich without affecting British spheres of interest if the German monetary regulations were eased for Jewish emigrating to Palestine."[15]

The Germans were having second thoughts about patronage of Zionism. Pushing Jews to Palestine, where they could not hurt German trade, was one thing. But with the British contemplating partitioning the country a danger arose of establishing a 'Vatican' for the Jews, as Hitler saw it. Such a statelet could cause diplomatic problems. Polkes had invited Eichmann to Palestine as the Haganah's guest and the Germans decided to send him to report on the situation.

On 2 October 1937, Eichmann and his superior, Herbert Hagen, arrived in Haifa. Polkes only had time to take them to a kibbutz as the British spotted the Germans two days later and deported them. Later, in Argentina, Eichmann taped his memoirs and remembered his visit with nostalgia:

"I did see enough to be very impressed by the way the Jewish colonists were building up their land . . . In the years that followed I often said to Jews with whom I had dealings that, had I been a Jew, I would have been a fanatical Zionist . . . In fact, I would have been the most ardent Zionist imaginable."[16]

Polkes followed the Germans to Cairo for discussions on 10–11 October. The German report, found by the US army, gave Polkes' words:

". . . in Jewish nationalist circles people were very pleased with the radical Germany policy, since the strength of the Jewish population in Palestine would be so far increased thereby that in the foreseeable future the Jews could reckon upon numerical superiority over the Arabs in Palestine."[17]

Polkes gave two pieces of minor anti-Communist information as intelligence bait:

> "The Pan-Islamic World Congress convening in Berlin is in direct contact with two
> pro-Soviet Arab leaders – Emir Shekib Arslan and Emir Adil Arslan . . . The illegal
> Communist broadcasting station . . . is, according to Polkes' statement, assembled on
> a lorry that drives along the German–Luxembourg border."[18]

The Nazis never took up the spy offer. The Zionists' wish to collaborate was greater than the
Nazis'. Hitler always intended to wipe out Jewry, and realized that too close a linkage with
Zionism meant trouble with the Arabs and British.

V – The Zionist fight against Hitler

There was opposition within Zionism to the accord with Nazism. Rabbi Stephen Wise,
reflecting America's more liberal traditions, denounced the pact with the devil in 1934:

> "One leading Palestinian put it over and over . . . 'Palestine has primacy' . . . while
> Palestine has primacy . . . primacy ceases when it comes into conflict with a higher
> moral law."[19]

However the liberals had no confidence in the masses and feared to mobilize them. Wise wrote
in 1933 that 'You cannot imagine what I'm doing to resist the masses. They want organized
boycotts. They want tremendous street scenes.'[20] The liberals remained loyal to those making
the pact. Eventually their opposition subsided.

No one thought to look to 'Your Fascist, Vladimir Jabotinsky', as Mussolini called him, ᶠᵎ
anti-Nazi leadership. Yet he was the major Zionist opponent of the Transfer.[21] As founder of
Zionist-Revisionism he cooperated with anti-Semites, but on condition that they allowed Jews
to defend themselves against violence. He called for a boycott. He forbade followers from
saluting Hitler and saying that 'if he had given up his anti-Semitism we would go with him.'[22]
Once Jabotinsky's followers in Palestine, the *Brit HaBiryonim*, the 'Union of Thugs',
understood their job was to bury Hitler, not to praise him, they proceeded to assassinate Chaim
Arlosoroff, the WZO's Political Secretary, on 16 June 1933. He had just returned from Berlin,
where he had worked out the Transfer. A British Mandate Court found one Revisionist guilty
but he was later freed on a technicality.

Revisionists did boycott work everywhere but as fascist sectarians. They never wanted to
unite with the far larger Jewish left, and by themselves they could do nothing. Eventually their
focus became their separatist terrorist war against the Palestinians in 1936–39. However,
because they were opposed to the WZO leaders in Hitler's epoch, they came to form the critics'
chorus to Kastner's 1944 connivance in the greater Jewish tragedy.

There appears to be no further WZO attempts to link up with the Nazis after the Polkes
affair. But the Transfer continued up to the beginning of the war. Even after the 11 November
1938 *Kristalnacht* pogrom the WZO urged growers to ship their oranges to Europe on Nazi
boats. Not even Jewish deaths could shake the primacy of Palestine in the mentality of David
Ben-Gurion, the Labourite leader. On 7 December 1938 he told his movement that:

> "If I knew that it would be possible to save all the children in Germany by bringing
> them over to England, and only half of them by transporting them to Eretz Yisrael,
> then I would opt for the second alternative. For we must weigh not only the life of
> these children, but also the history of the People of Israel."[23]

VI – The Wartime Failure to Rescue

Even after war broke out, their first thought was how to turn it to their advantage in Palestine.
Gelber gives the Labourite view in September 1939:

> "the leaders tended to view Palestine . . . as the touchstone of their attitude towards

the war. They were inclined to leave the front-line fighting as such, if unconnected to Palestine, to the Jews of the Diaspora."[24]

During 1940–41 the Zionist Executive rarely discussed occupied Europe. Aside from half hearted efforts to continue to bring in selected youths from pioneer camps still functioning in Germany, via boats breaking British not German laws, they did nothing for enslaved Jewry. Nor were their colleagues in neutral America more helpful. Reports of massacres in the Ukraine reached the West in October 1941. In May 1942 the Bund, Jewish socialists in Poland, radioed London that 700,000 Jews had already been exterminated there. On 28 August, Wise discovered that the State Department had kept information from him, from his World Jewish Congress office in Geneva, describing Hitler's plan to gas European Jewry. He agreed to a State Department request that he keep silent until they verified the report. He said nothing for 88 days, until November 24, writing Roosevelt that

"I have had cables and underground advices for some months, telling of these things. I succeeded, together with the heads of other Jewish organizations, in keeping them out of the press."[25]

�7O1

[excised]

After Wise had finally publicly denounced the slaughter, the Journalists' Union in Palestine cabled similar organisations abroad, asking them to focus on the carnage. Dov Joseph, acting director of the Jewish Agency's Political Department, cautioned them against

"publishing data exaggerating the number of Jewish victims, for if we announce that millions of Jews have been slaughtered by the Nazis, we will justifiably be asked where the millions of Jews are, for whom we claim that we shall need to provide a home in Eretz Israel after the war ends."[27]

The inadequacy of the Jewish Establishment's response was so glaring that if brought forth a furious denunciation by a veteran Labourite, Chaim Greenberg, in the February 1943 *Yiddishe Kemfer*:

"There have even appeared some Zionists in our midst who have become reconciled to the thought that it is impossible to stay the hand of the murderer and therefore, they say, it is necessary 'to utilize this opportunity' to emphasize . . . the tragedy of Jewish homelessness and to strengthen the demand for a Jewish National Home in Palestine."[28]

With Wise's November 1942 statement, the Zionist leadership in Palestine could no longer doubt the murder reports. Many Jews in Palestine were appalled by the WZO's preoccupation with its political ambitions while their relatives were being destroyed. They cried out against Yitzhak Gruenbaum, the director of Palestine Zionism's Rescue Committee. He finally defended himself at a Zionist Executive meeting on 18 February 1943:

"Meanwhile a mood swept over Eretz Yisrael, that I think is very dangerous to Zionism . . . How is it possible . . . people will call: 'If you don't have enough money you should take it from the Keren Kayesod . . . I thought it obligatory to stand before this wave . . . when some asked me: 'Can't you give money from the Keren Hayesod to save Jews in the Diaspora?' I said no! And again I say no! . . . we have to stand before this wave that is putting Zionist activity into the second row . . . Because of this, people called me an anti-Semite, and concluded that I am guilty, because we do not give priority to rescue . . . I think it necessary to say here: Zionism is above everything . . . Naturally, it is incumbent upon us to continue all action for the sake of rescue and not neglect one chance to end the slaughter . . . At the same time we must guard Zionism. There are those who feel that this should not be said at a time when a Holocaust is occurring, but believe me . . . Zionism is above all . . . And we must guard – especially in these times – the supremacy of the war of redemption."[29]

VII – The Emergency Committee

Only one Zionist group realized rescue had to become their top priority. A small group of Revisionists had come to the US to raise funds. When war broke out they had demanded the formation of a Jewish Legion in the British army. They noticed some articles by Ben Hecht, a famous journalist of the day, deploring the silence of prominent Jews on the situation of European Jewry. He agreed to help them. Wise's statement convinced them to focus on getting US governmental action on behalf of European Jewry. They planned a pageant, *They Shall Never Die*, in New York's Madison Square Garden on 9 March 1943. The mainstream Zionists suddenly announced a rally at the Garden for 1 March. Thus two demonstrations over the tragedy took place only nine days apart. The difference was that Wise and his friends had no plans for sustained mobilizations, whereas Hecht's Emergency Committee toured America with their pageant which Wise's American Jewish Congress kept from being performed in Pittsburgh, Baltimore and Buffalo at least.[30]

In the Autumn of 1943 the Emergency Committee's efforts resulted in Congressional hearings on rescue. Wise opposed the Committee's bill for a rescue commission because it did not mention Palestine. The Committee understood the public wanted to save Jews, not fight Churchill over Palestine.

Wise fought them to the end. Eventually Roosevelt became concerned that the Committee would make a scandal out of the State Department's anti-Semitism, clearly revealed at the hearings, and he established a War Refugee Board, but without funds. Far from uniting with the Emergency Committee to force the US to rescue Jews, WZO loyalists continued their campaign against the Committee. Nahum Goldmann, official spokesman for the WZO, went to the State Department on 19 May, 1944 – while ten thousand Jews a day were being shipped out of Hungary – to complain that the Palestinian Revisionist Peter Bergson and his associates 'were in this country on temporary visitors' visas'. According to a Department memo, 'he added that he could not see why this government did not either deport Bergson or draft him.' The same memo noted that Wise 'regarded Bergson as equally great an enemy of the Jews as Hitler, for the reason that his activities could only lead to increased anti-Semitism'[31]

78

The British did not want to rescue Jews. Sooner or later that would cause problems with the Arabs in Palestine. Washington did not want Jews coming to the States. But by 1942 western public opinion was ready for a rescue campaign. However the WZO was never the one to mobilize opinion against governments and bureaucracies. They had their eyes on the future, on Schwalb's bargaining table. But if you want support from diplomats you can not embarrass them in the here and now.

The WZO hated the Emergency Committee as fascists and terrorists. Paradoxically, because they were terrorists they were more successful, if only slightly so, in their rescue efforts. They came to understand in the 30s the British would never give them Palestine. They would have to take it by force. In the 40s they similarly realized they would have to pressure Washington to set up a rescue board.

The Board was only of minimal help to the oppressed. It never managed to circumvent the State Department reactionaries. If Wise had united with Hecht, Roosevelt might have been forced to do more. The former leaders of the Committee now knew they started late. And they did not put the Jewish masses on the streets. Marches would have been more worrisome for the politicians than a pageant. Hunger strikes would have galvanized the public.

Only one of the WZO's wartime leaders seems ever to have looked back at that time with regret. Nahum Goldmann had been a leading figure in Weimar Zionism before becoming the WZO's representative to the League of Nations Mandatory Committee in the 1930s. He spent the war largely in the US, where he was the director of the WZO's operations for the duration. In a 1963 article, he confessed that

"we all failed. I refer not only to actual results – these at times do not depend on the abilities and wishes of those who act, and they cannot be held responsible for failures resulting from objective considerations. Our failure was in our lack of unwavering determination and readiness to take the proper measures commensurate with the terrible events of the times. All that was done by the Jews of the free world, and in particular those of the United States, where there were greater opportunities than elsewhere for action, did not go beyond the limits of Jewish politics in normal times. Delegations were sent to prime ministers, requests for intervention were made, and we were satisfied with the meagre and mainly platonic response that the democratic powers were ready to make."

He had no doubt that tens of thousands of Jews, at least, could have been saved by vigorous action by the Allies. But, he insisted,

"the main responsibility rests on us because we did not go beyond routine petitions and requests, and because the Jewish communities did not have the courage and daring to exert pressure on the democratic governments by drastic means and to force them to take drastic measures. I will never forget the day when I received a cable from the Warsaw Ghetto, addressed to Rabbi Stephen Wise and myself, asking us why the Jewish leaders in the United States had not resolved to hold a day-and-night vigil on the steps of the White House until the President decided to give the order to bomb the extermination camps or the death trains. We refrained from doing this because most of the Jewish leadership was then of the opinion that we must not disturb the war effort of the free world against Nazism by stormy protests."[32]

"They are moral bankrupts," he declared, "and I have no qualms in saying 'they', for this 'they' includes myself." He insisted that Jews must, if only to find their future bearings, make a spiritual self-reckoning, a 'heshbon ha nefesh.'[33]

1 Marvin Lowenthal (Ed) The Diaries of Theodor Herzl p 6
2 Theodor Herzl The Jewish State p 70
3 Samuel Portnoy (Ed), Vladimir Medem The Life and Soul of a Legendary Socialist, pp 295–98.
4 Margaret Edelheim-Muehsam, 'Reactions of the Jewish Press to the Nazi Challenge,' Leo Baeck Institute Year Book, vol V, (1960), p 312

5 Stephen Popple *Zionism in Germany 1897-1933* p 124
6 Joachim Prinz 'Zionism under the Nazi Government', *Young Zionist*, London, Nov 1937, p 18
7 Lucy Dawidowicz (Ed), *A Holocaust Reader*, pp 150-55
8 Yehuda Bauer, *My Brother's Keeper*, pp 156-63
9 See my *Zionism in the Age of the Dictators* p 145 for more detail
10 Abraham Margaliot, 'The Problem of the Rescue of German Jewry during the Years 1933-39; the Reasons for the delay in the Emigration from the Third Reich,' *Rescue Attempts During the Holocaust* p 249
11 Barnett Litvinoff (Ed), *The Letters and Papers of Chaim Weizmann*, (letters), vol XVI p 279
12 Margaliot, p 255
13 David Yisraeli, 'The Third Reich and the Transfer Agreement,' *Journal of Contemporary History*, vol vi, 1971, p 132
14 Jacob Boas 'A Nazi Travels to Palestine,' *History Today*, Jan 1980, p 38
15 Yisraeli, *The Palestine Problem in German Politics 1889-1945*, (Hebrew Phd Thesis), pp 301
16 Adolf Eichmann, 'Eichmann tells his own Damning Story,' *Life*, Nov 28 1960, p 22
17 John Mendelsohn (Ed) *The Holocaust* vol 5, p 98
18 Ibid, p 103
19 'Dr Stephen Wise on Policy of World Jewry,' *World Jewry* (Lond), 24 August 1934, p 395
20 Carl Voss, 'Let Stephen Wise speak for himself', *Dimensions in American Judaism*, Fall 1968, p 37
21 Michael Bar-Zohar, *Ben-Gurion* (American edition), p 67
22 Eli Lubrany, 'Hitler in Jerusalem', *Weltbuhne* (Berlin), May 31, 1932, p 835
23 Yoav Gelber, 'Zionist Policy and the Fate of European Jewry (1939-42)', *Yad Vashem Studies*, vol XII, p 199
24 Ibid, p 171
25 Eliahu Matzozky, 'The Response of American Jewry and its Representative Organizations', November 24, 1942 and April 19, 1943, (Unpublished Yeshiva University Masters Theses), App II
26 Michael Dov-Ber Weissmandel, *Min HaMaitzer* (From the Depths), Hebrew pp 92-3
27 Gelber, p 195
28 Chaim Greenberg, 'Bankrupt', *Midstream*, March 1964, p 7
29 Yitzhak Gruenbaum, *Bi-Mei Hurban ve Sho'ah*, pp 62-70
30 Sarah Peck, 'The Campaign for an American Response to the Nazi Holocaust, 1943-1945', *Journal of Contemporary History*, April 1980, p 374
31 'Attitude of Zionists Toward Peter Bergson,' memorandum of conversation, 867N.01/2347, Department of State, May 19, 1944, pp 3-4
32 Nahum Goldmann, 'Jewish Heroism in Siege', *In the Diaspersion*, Winter 1963/4, pp 6-7
33 Maurice Carr, 'The Belated Awakening', *Jerusalem Post*, May 5, 1964, p 3

The Kastner Case, Jerusalem 1955 *by Akiva Orr**

In 1954 I was a student at the Hebrew University, Jerusalem, when the papers announced that the Israeli Government was suing for libel a 71 year old Hungarian Jew, Malkiel Greenwald, who had accused another Hungarian Jew, Dr Israel (Rudolph) Kastner, of collaborating with the Nazis in Hungary during 1944/45.

Like most other Israeli youths I was surprised and puzzled by this news. The questions raised in my – and many other's – mind were: Who is this Greenwald, and who is this Kastner? What exactly did Greenwald say about Kastner? Where did he say it? Why didn't Kastner himself sue for libel? Why did the Government find it necessary to sue an individual for libelling another individual? How was it possible for a Jewish collaborator with the Nazis to live in Israel for 9 years without being publicly denounced?

Greenwald had come to Palestine in 1938 from Vienna, where he had been badly beaten up by the Nazis. Many of his family were exterminated in Auschwitz. He ran a tiny family hotel in Jerusalem, and used to write pamphlets headed: 'Letters to my friends in the Mizrahi', (Mizrahi was a small political party of religious Jews who supported Zionism. At that time the majority of religious Jewry before the war was opposed to Zionism). He then mailed his pamphlets to selected members. In pamphlet 51 (mailed in 1952) he accused Dr Israel, Rudolf, (Rezso) Kastner, 48, of collaborating with the Nazis in Hungary during the period 1944/45 and of assisting them in their extermination of some 500,000 Hungarian Jews. Greenwald called for a public enquiry committee to investigate his accusations.

Kastner himself came from Kluj (now in Rumania), a town with a Jewish community of some 20,000 which was annexed to Hungary during the war and was known as Koloszvar. He was born in Kluj, and from 1925 to 1940 was the Political Editor of *Uj Kelet* (*New East*), the Jewish daily paper in that town. From December 1942 till the Russians entered Budapest in February 1945, he headed the Jewish Relief Committee in Budapest, which was affiliated to the Relief Committee of the Jewish Agency in Palestine ('The Agency' was, in effect, the 'Government' of the Jewish community in Palestine, and as such the spearhead of the entire Zionist movement). He arrived in Palestine in 1946 and joined Ben-Gurion's ruling party MAPAI (The Zionist Labour party 'Land of Israel Workers Party'). He became a MAPAI candidate to the first Knesset, was given the post of Spokesman of the Trade and Industry Ministry, was appointed Director of Broadcasts in Hungarian and Rumanian languages on the state's radio, was appointed Chief Editor of 'Uj Kelet' (ie the same title as his old paper) MAPAI's paper in Hungarian, as well as Chairman of the Organization of Hungarian Jewry. In other words, he was head of the Hungary department of the ruling Party.

This information, from the daily press in Israel, answered some of our first questions. It was obvious that Kastner was a prominent figure of the Israeli Establishment and had either to clear his name or to be sacked. Two quetions emerged: Why didn't Kastner himself sue Greenwald? Had Kastner sued Greenwald himself and lost his case he would be liable to

* Akiva Orr is the author of *The unJewish State: the politics of Jewish identity in Israel*

81

prosecution under the Law for judging the Nazis and their collaborators (1950), the only crime in Israel for which the death penalty exists. Could it be that the Establishment decided to sue because Kastner's failure to do so would have implicated others above him? His posts indicated that he had connections with the very top of the ruling party (Prime minister Sharett noted in his *Personal Diary* on Saturday, 27.2.54: 'At 9 am [a meeting with] Israel Kastner (one of the leaders of the Zionist organization in Transilvania) testifying for some days in a libel case initiated by the Attorney General in his defence (as a state employee) . . .')[1]. We don't know what was discussed in that meeting, but it emerged during the trial that Sharett was involved in the issue.

I attended some of the hearings in the tiny court room in the Russian Compound in Jerusalem and like most Israelis I followed intently the press reports about the trial. A law student friend became the assistant to the defence lawyer and provided me with more details. What emerged was beyond anything I – and most Israelis – imagined, even the judge and the two attorneys had to repeat their questions occasionally due to disbelief. The revelations were shocking and disturbing. New, alarming, and unexpected questions emerged, and have never been answered.

The Trial

What became popularly known as 'The Kastner Trial' was, legally, a trial not of Kastner but of Greenwald, who was sued for libel by the Israeli government. Kastner was a witness for the prosecution. But it was the pressure of the questions of the defence, and his own evasions, contradictions, and lies, that transformed Kastner from a witness into a defendant.

The Attorney General filed his libel case against Greenwald on the 25 May 1953. The trial began on 1 January 1954. The case was known was Criminal case 124/53, in the District Court, Jerusalem, The Attorney General against Malkiel Greenwald, before the President of the court, Dr Benjamin Ha'levi.

The final hearing was on the 3 October, 1954. The hearings lasted about 70 days. 52 people testified. Some, more than once. Kastner himself took the witness stand ten times. The prosecution provided 130 documents, the defence – 180. The summing up of the defence lasted 30 hours.

After the hearings Ha'levi retired for nine months to consider the case (there is no Jury system in Israel, and the judge alone must decide whether a witness lied or told the truth, and whether that truth was partial or complete). On 22 May 1955 Ha'levi began to read his judgement.

Ha'levi grouped Greenwald's accusations against Kastner under four headings:

1 Collaboration with the Nazis; 2 'Indirect murder' or 'preparing the ground for murder' of Hungary's Jews; 3 Sharing plunder with a Nazi war criminal; 4 Saving that war criminal from punishment after the war.

After an exhaustively reasoned judgement of 200 pages, he ruled that apart from charge 3, all charges were true and therefore not libellous. Charge 3 he found not fully proved and he fined Greenwald a symbolic, 1.00 Israeli pound. He ordered the Government to pay the costs of the trial.

During the trial one of the witnesses, Phillip von Freudiger, the political leader of the religious (Orthodox) Jewish community in Hungary, submitted a document stating that when the Nazis entered Hungary in March 1944 '. . . anyone known as anti-Nazi, or not completely pro-German, was arrested, . . . within 36 hours the public arena was cleared completely of all courageous and conscientious figures . . . who could cause problems for the Germans . . . the way was open for political and economic adventurers, for politicians whose whole purpose was to achieve the power they coveted and for which they would have sold their soul to the devil'.[2]

Ha'levi used Freudiger's last phrase in his judgement when he stated: '. . . by accepting this gift [the Nazi promise to allow 600 Jews selected by Kastner to travel to a neutral country] Kastner has sold his soul to the devil'.[3] The press headlines next morning were: HA'LEVI: KASTNER HAS SOLD HIS SOUL TO THE DEVIL, and that is how the case became registered in the minds of most Israelis in 1955.

82

Prime Minister Sharett noted in his Personal Diary on the day of the verdict:

"Kastner. A nightmare, horrific, what did the judge take upon himself. The Party suffocates. A pogrom."[4]

The Government immediately appealed to the Supreme Court. It took another 3 years before the five members of the Supreme Court gave judgement. Before that, on the 3 March, 1957, Kastner was shot by an Israeli and died two weeks later. I shall discuss the appeal and the assassination later.

Background of the case

During the Second World War Hungary was a willing ally of Germany and sent troops to fight against the Russians. The Nazis did not invade the country. However, early in 1944, as it became clear that the Nazis were going to lose the war, and the Russians were already driving the German Army out of nearby Rumania, Admiral Horthy, the Head of State, tried to negotiate a separate peace treaty with the British. On 19 March 1944 the Nazis invaded Hungary to prevent any separate peace.

On that day, a special SS unit whose sole purpose was the extermination of the Jews, headed by Adolph Eichmann (Head of dept. 4B in the SS) entered Budapest.

Eichmann had only 150 SS people with him, and could muster a few thousand Hungarian soldiers. The Jewish community in Hungary numbered some 800,000. Of these, 300,000 lived in Budapest, and the rest in the provinces. Most of the Jews were living amongst the Hungarians. Eichmann decided to deal first with the Jews in the provinces, and later with those in Budapest. His task was divided into three stages:

1 Locate and mark the Jews (by the yellow star); 2 Move them into special concentrated areas (ghettos); 3 Deport them from the ghettos to Auschwitz.

As the German army was busy fighting the Russians Eichmann could not rely on its help. Even securing the necessary trains was a problem. And yet between 15 May, and the end of June, some 500,000 Jews from the provinces boarded the trains to Auschwitz, roughly 12,000 per train, often 4 trains a day, and were gassed there.

When this became known in the West, Roosevelt sent a strong letter to Horthy, and bombers to bombard Budapest. The deportations were stopped for a while. The Nazis continued with their efforts, and on 16 October they engineered a coup which ousted Horthy and handed power to the Arrow-Cross (Hungarian Fascists), who continued the process with a vengeance. The Russians entered Budapest on 16 January and saved its remaining Jews. 'The Liberation of the Jews, who had been living under the dark shadow of sudden death for so long, was exclusively the merit of the Red Army and its offensive spirit. The armies of Tolbuchin and Malinowski, occupied the capital in the nick of time. A delay of only a few days would have meant total annihilation for the Jews. Nobody could have stopped the rioting Nylias ('Arrow-Cross') horde, blood thirsty and undisciplined as it was'.[5]

How could it happen?

Why did half a million Jews, many of whom were young and had military training in the Hungarian army, board the trains to the gas chambers, without making any effort to hide, escape, or resist?

The answer, which sounds unbelievable, is simple: the Jews who boarded the trains did not know that they were heading for Auschwitz. Many knew about Auschwitz, some believed it, some didn't, but all were led to believe that the trains were transferring them to another place in Hungary for 'resettlement'. Some even made special efforts to get on the earlier trains in order to get better housing in the new settlements . . .

Given the acute shortage of Nazi manpower and the general retreat of the German army Eichmann knew that it was absolutely essential that the destination of the trains be kept secret

from the Jews. Had they known their destination they would have made every effort to avoid deportation, and many could have escaped. Eichmann knew that the Jews would not trust the Nazis or the Hungarian authorities. The only people they would trust were their own leaders. He and his staff had to make sure that the Jewish leaders would not inform the rest of the Jews about the destination of the trains.

The questions which Ha'levi had to answer were: 1 Did the Hungarian Jews know that the trains were going to Auschwitz? 2 Did the Jewish leaders know that the trains were going to Auschwitz?

Ha'levi determined, from witnesses and documents, that the majority of Hungary's Jews did not know that the 'resettlement' trains were heading for Auschwitz, whereas Kastner and other Jewish leaders did know. Moreover, when the trains arrived at Auschwitz the Nazis forced some Jews to write postcards saying 'I have arrived. Am well', postmarked 'Waldsee'.[6] These were handed to Kastner who had them distributed amongst those still awaiting deportation. Other postcards mentioned Kenyermeze (a fictitious Hungarian place) as their origin.[7] This withholding of information was compounded by helping to spread misleading information.

These facts were not challenged by the Supreme Court which discussed the appeal against Ha'levi's judgement.

To substantiate Ha'levi's conclusion a report by a Jew who escaped from Auschwitz provided – in April 1944 – a detailed report on Auschwitz plus a warning to Hungary's Jews about the preparations being made in Auschwitz for their extermination. His report became known to Jewish leaders in Czechoslovakia and Hungary before the deportations began. It also reached the West. The author of that report, Rudolf Vrba, wrote in 1966:

> "Even today few can believe that 400,000 human beings collaborated by their mere passivity in their own brutal destruction.
>
> Some historians, indeed, seem puzzled by this contradiction of the well-known biological facts concerning self-preservation, despite all the proof that it happened – the trials, the silent testimony of the principal witnesses.
>
> Yet the answer to the riddle is very simple. The victims were kept in ignorance of their real fate until the last possible moment, often until they entered the gas chambers, when nothing was left to them but to die.
>
> They had been told repeatedly by the Horthy propaganda machine that they were going to resettlement areas, to ghettos, to 'reservations for Jews in the East', where they would have to 'work hard', but would be safer than they were at home, where pogroms threatened constantly.

No denial came from their own leaders and so they believed it all, as Major himself makes clear when he writes: 'Many survivors and witnesses affirmed that they either had not heard of the extermination camps, or, if they had heard about them, did not believe it.'

No doubt before they left Hungary, they were worried about the real nature of their sinister, unknown destination; but there is a critical difference between vague suspicion and exact knowledge. They were people who had spent their lives under civilized influences and thus they were inclined to hope in their darker hours that, by obedience, they might avoid a massacre of their children. The Jewish leaders in Hungary, though knowing the truth, the detailed facts about Auschwitz, did nothing to dispel this unrealistic hope.

Had they spoken, they might have changed the history books which record mournfully that 400,000 Jews were transported to Auschwitz and died without resistance. As an ex-prisoner of Auschwitz–Birkenau, one who was forced to witness from the closest possible quarters the functioning of this annihilation apparatus, I cannot emphasize sufficiently strongly that secrecy was the main key to its successful operation.

The Fascists in German-occupied or semi-occupied countries, under the protection of and with encouragement from the authorities, created a pogromistic

atmosphere. Against this background, the Jews were hoodwinked into going voluntarily to the 'resettlement areas'. When they arrived and realized they had been swindled, they were inside the confines of the extermination camps, which were, for all practical purposes, watertight. In most cases, indeed, as I have said, they were inside the actual gas chambers or at their gates. Their only choice was between being wounded and tortured to death or dying less elaborately.

Often they were killed before they had time to think, to weigh the alternatives, for that was a vital part of the mass annihilation technique. While I was in Auschwitz (June 30, 1942 – April 7, 1944), I saw this process going on daily, but on a smaller scale than that of the Hungarian holocaust. During my time there, the daily quota was 'only' 1,000 to 5,000 victims. From January 1944, however, I witnessed unusually extensive technical preparations, designed to step up the intake of this murder machine to 20,000 victims a day. It was no secret *in* Auschwitz that these extraordinary preparations were designed for the rapid annihilation of Hungary's Jews, who were almost 1,000,000 strong.

In March 1944, after the complete occupation of Hungary by the Germans, it was evident to us Auschwitz prisoners that the start of this well-prepared action was quite imminent.

It was equally clear that the whole complicated annihilation procedure could be slowed down by revealing the secrecy of the 'resettlement areas' to its potential victims, by exposing the extermination machinery to the world in general and the Jews in particular.

With this in mind, Fred Wetzler and I escaped from Auschwitz–Birkenau on April 7, 1944, and reached Slovakia 14 days later. We immediately contacted the Jewish leaders and, at meetings in Zilina on April 24, 25 and 26, informed them in detail of what the Nazis had in store for the Hungarian Jews. The information contained in our testimony to them (the 'Auschwitz Report') contained all technical details of the annihilation process.

The leaders of Hungarian Jewry were in full possession of these facts by the end of April, 1944, at the latest. This can be confirmed by the surviving members of the Jewish Committee in Slovakia, Dr O. Neumann, Mr Krasnansky and Mr Steiner, the first two of whom now live in Israel.

The facts of our report were supported by Rabbi Michael Dov Weissmandel, whose own report on Auschwitz to the Hungarian Jewish leaders incorporated that by Wetzler and myself, though he improved it, naturally, by rabbinical style and authority.

. . . Wetzler and I saw the preparations for the slaughter. Morgowicz and Rosin saw the slaughter itself. It was their description of it that the Rabbi quoted, proof, indeed, that Wetzler and I were not exaggerating. So the Jewish leaders knew what was happening, even when they were lending their administrative help to the Nazis by preparing lists of deportees. Those who did not know were the men, women and children who were herded on to the trains when the deportations began in the middle of May, 1944. They went on day and night, sometimes at a rate of 10,000 or even more daily (see A. Eichmann's Memoirs, *Life*, Jan, 1961).

They boarded those trains passively with or without their families. They did not know that their fate was sealed as tightly as the trucks that carried them, that death was awaiting most of them and all their children at the other end of the line. I make no apology for being repetitious because it seems that it is necessary.

Instead of information, the Jewish leaders provided the adults with sandwiches and the children with milk for the journey. Had these had knowledge of hot ovens, instead of parcels of cold food, they would have been less ready to board the trains and the whole action of deportation would have been slowed down. This is accepted by the historian, Gerald Reitlinger, versatile though he is in the English art of understatement (see his *The Final Solution*, NY, 1953).

On p 427 of this well-known work, he writes: 'On April 7, two Slovak authors of the War Refugee Board Report made their sensational escape from Birkenau (ie the annihilation centre in Auschwitz) to Bratislava. The knowledge contained in this report could at this time have saved at least 200,000 lives'.

On page 540 of the same book, Reitlinger writes about the Auschwitz report: 'The author, who had been registrar of one of the Birkenau infirmaries, was exceptionally accurate and conveyed his report to the Swiss Red Cross as early as June, 1944, thereby making history'. But Major surely is aware of these quotations because in his article in JEWISH CURRENTS, Reitlinger's book is quoted liberally.

It is, unfortunately, an historical fact that, between May 15 and June 30, about 120 trains, loaded with Jewish men, women and children, left Hungary for Auschwitz, while Kastner and other Jewish leaders were negotiating with Eichmann in Budapest. They negotiated with the Nazis five years after Chamberlain, at a time when any child could have told them that they were dealing with people who understood only one brand of argument!"[8]

Rudolf Vrba, did not live in Israel, and was not called to give evidence in the trial. The prosecution, keen to clear Kastner, had no interest in such information, and the defence couldn't locate him. But there were many other witnesses, living in Israel, who gave similar accounts.

Levi Blum, from Kastner's hometown Kluj, whose brother was arrested for lack of documents went to the Jewish council in Budapest to deal with the matter:

"They asked me where I'm from, I said: 'from Kluj'. They said: 'there is a good friend here, a leader dealing with rescue. I said: who is he? The man said it was Mr Kastner. I went to the Hotel to look for Kastner. There was someone there, his secretary I think, I told him my brother was arrested. He left and after I waited for twenty minutes he returned and said that Mr Kastner was sorry but he couldn't do anything in the matter.

What happened to your brother?

I do not know what happened to him.

When did you meet Kastner? asked Tamir [the defence lawyer.]

Blum: In 1948, or the beginning of 1949. I saw that there was a reception for Kastner in Tel-Aviv. I went with a few friends to the place of the reception at the corner of Diezengoff street. Dr Arne Marton [a leader of the Hungarian community] rose to speak. He said to Kastner something like: 'You'll get a street named after you even before you get a flat', this was too much for me. I jumped up and said: 'You are making a great mistake gentlemen', and to Kastner I said: 'you are the only one who was the best friend of Eichmann, and you were a Quisling, you are a murderer.' I asked him to sue me, because I am too poor to sue. And I added: I know that you are responsible for the Hungarian Jews, mostly from Kluj, who went to Auschwitz without knowing where they were being sent and what the Germans intended. You knew where they were being sent and what the purpose of the Germans was. Kastner did not reply. I continued and asked: 'Why did you send postcards from Kenyermeze?' Someone in the audience jumped up and said: 'that was Kohani!', Kohani was also in the hall, he stood up and said: 'Yes, I received those postcards'. I then asked: 'from whom did you receive them?' he replied: 'It's none of your business, I don't owe you a report'.

The judge stops the witness: Was this in public?

Blum: Yes, there were a few hundred people there.

Tamir: When did you meet Kastner again?

Blum: The war of independence began, I was in the army, it was before the elections to the first Knesset, I suddenly see that Kastner was a candidate to the Knesset for MAPAI [Ben-Gurion's party], it stated: 'Dr Kastner, head of the Rescue committee in Hungary'. Your honour, when I read this the blood rose to my head.

What did you do?

86

I have here a good friend [Yambur a journalist from *Al-Hamishmar*], I went to him and said: 'look Yambur bachi, Kastner again!".[9]

The Deal

Many more witnesses gave similar evidence. The facts were overwhelming and were not challenged by the prosecution. Ha'levi faced a new question: Why did Kastner (and other leaders of Hungary's Jews) withhold from their communities the information that the 'resettlement' trains were heading for Auschwitz?

Ha'levi states in the judgement:

"A few days after this letter, [of 25.4.1944, from Kastner and his deputy Brand, to Sally Meyer in Switzerland, asking for $2 million to bribe the Nazis], in the last days of April, Kastner received the black news from Auschwitz (the preparing of the gas chambers for Hungary's Jews, the railways agreement, the first deportation to Auschwitz, a secret rumour about the decision for a general deportation) which brought him to the verge of despair. From all the data he concluded that the deportation was imminent and inevitable, he suddenly realized the futility of all the lengthy negotiations conducted so far. At this moment of depression and crisis, during a meeting with Krumey [Eichmann's subordinate] requested by Kastner to decide on the continuation of the 'negotiations', (para 26) Krumey pulled out the card authorizing 600 emigration permits. It is clear that his aim was to prevent a break with Kastner by providing him with a real interest and justification for continuing his relations with the SS, and even strengthening the relations for the imminent extermination period.

"The temptation was great. Kastner was given the actual possibility of rescuing, for the time being, 600 souls from the imminent holocaust, with some chance of somewhat increasing their numbers by payment or further negotiations. Not just any 600 souls, but those he considered, for any reason, most prominent and suitable for rescue. His relatives, if he so wished, his friends if he wished, members of the movement if he wanted, and the heads of Hungary's Jews, if he wanted. The extermination plan threatened not just the communities in the provinces but also the Jews of the Capital, and Kastner didn't expect the total deportation to halt, miraculously, at the gates of Budapest. Here he had an opportunity to save his mother and wife from Budapest, his brother and father-in-law from Kluj, and all his other relatives and friends. The possibility of saving the 'prominents of the provincial towns and Budapest appealed to him also from the public aspect. The rescue of the important people in the community due to the activity of the Rescue Committee appeared to him as a personal, and Zionist, success. A success which could also justify the entire policy of his previous leadership: his initiative to negotiate with the Nazis, his usurpation of the 'political' contact with the authorities, the exhausting negotiations, the protective relationship between the authorities and the committee. He still didn't give up completely the hope of a total arrangement with the Nazis based on the 'Europe Plan' or a similar big plan. Kastner was very pessimistic about the chances of the Jews to escape by their own efforts from the Nazi extermination machinery, which had already finished off almost all of Europe's Jews, and he saw the main hope of rescue in an agreement with the Nazis. No wonder that under these circumstances he accepted, without hesitation, Krumey's gift.

"But 'timeo Danaos et dona ferentes' (I fear the Greeks even when they bring presents). By accepting this present Kastner had sold his soul to the devil. The immediate outcome of his agreement with Krumey was that Kastner became dependent on the favours of the Nazis. It cannot be said that he was independent before. Already his appeal to Wisliceny on behalf of the 'illegal' rescue committee, the negotiations with the Nazis leaders, and accepting the Nazi protection for the committee made Kastner himself, and the committee, considerably dependent on the Nazi regime. But before the agreement with Krumey Kastner was free, if all was lost,

to cut off his contacts with the rulers and go underground with the committee, as was done in Warsaw ghetto and other extermination locations. After the agreement with Krumey Kastner was tied to the Nazis in the matter of saving the 600. As long as he had any hope that the Nazis would honour the rescue agreement – and indeed, despite some bad disillusions he had to face, the agreement was, after all, honoured – Kastner was interested, for saving the 600, to maintain correct relations with the authorities. As the general agreement with Krumey became actualized and acquired a living form by choosing Kastner's candidates for rescue – including his family (more than 20 people), friends, comrades, leaders of the Zionist movement and other prominent Jews, and as the number of the souls included in the rescue agreement continued to grow, so did Kastner's interest in good relations with the Nazis grow. The success of the rescue agreement depended, until the last minute, on the Nazi goodwill, and the last minute didn't arrive until long after the end of the extermination of the Jews in the provincial towns. Throughout this period Kastner depended on, and had an interest in, the goodwill of the exterminators, in order to achieve the rescue of his candidates.

"The first promise to save the 600 was given to Kastner by Krumey, but the final decision on honouring and executing it lay with Eichmann. Kastner, who visited Eichmann with Mrs Brand, had no illusions about the role and authority of that hater of the Jews: 'We knew we were facing the head of the Jews' extermination project but that he also held the possibilities for rescue. He – and he alone – decided on life and death'. (Kastner's report p 38).[10]

". . . Kastner had no reason to assume that Eichmann got involved in rescuing Jews out of humane motives. He well knew that all Eichmann's activities were directed towards one goal – the extermination of Hungary's Jews.

"The fact that during the period crucial to the fate of the Jews the head of the Rescue Committee in Budapest was tied to the head of the exterminators by a joint rescue plan, interested and dependent upon his goodwill, was, without doubt, a serious weakness in the defence system of Hungary's Jews."[11]

The Choice
Ha'levi continues:

"On 2 May (the day of the agreement with Krumey) Kastner was at the crossroads, one way for the rescue committee was to continue the method of free rescue which was not dependent on the Nazis, in the way prepared by the committee before the Nazis invasion and strengthened by the pioneer's organizations. The main means of that rescue method so far were warnings and 'journeys'.

"With the deterioration of the situation at the end of April, the accumulating evidence for a total deportation, and the Nazi efforts to soothe the Jews and hide from them the preparations for the deportation, the duty of the committee at that moment was to spread the truth, to warn the people of the Nazi lies and plans, to strengthen the escape organization by all possible means, and to prepare the masses of Jews everywhere for organized activities at the moment of need.

"The Jews in the ghettos, and until early May only part of the Jews in the provinces were concentrated in ghettos and the process was continuing, were totally cut off from any sources of valid information, even the Jews not yet imprisoned in the ghettos were confused by the waves of Nazi deceptive propaganda and the false announcements concerning their future.

"Kastner possessed at that moment the first news about: the preparation of the gas chambers in Auschwitz for Hungary's Jews, the agreement between the railway

authorities of Hungary, Slovakia, and Germany for directing 150 deportation trains to Auschwitz, the first actual deportation of 1500 Hungarian Jews to Auschwitz, and the secret information from German agents about the decision on a total deportation.

"Spreading this substantive news among the leaders of the Jews, especially the Zionists, in the provincial towns, and through them among the masses, could, more than the earlier general warnings by holocaust refugees which were received with indifference and disbelief, warn the leaders and the masses about the real danger of the imminent total deportation facing Hungary's Jews, and immunize them against Nazi deceptions. Spreading the truth about the actual preparations for the deportations to Auschwitz could have undone not only the Nazi disinformation plots in the provinces or made it harder to implement them, but was also a first condition for preparing the people for any organized action like large scale escape, hiding children with [non-Jewish] Hungarians, disrupting the efforts to concentrate the Jews and the preparations for deportation, passive or active resistance to the deportation, defence or sabotage.

"I do not say that all these means were suitable or possible everywhere, at every stage and in every case, but that only when faced with the alternative of Auschwitz would the Jews, leaders as well as the people, have been able to consider fully and properly the ways and means suitable for defence or rescue according to the circumstances of the place and the time. There is no doubt that this way – the free rescue method independent of the Nazis – was dangerous to all involved in it and its results were not guaranteed in advance. It was impossible to know how many would be rescued in this way and how many would be lost. It was impossible to know in advance who would be rescued and who would be lost. The Nazis were totally opposed to this way and it was impossible to take it unless it was done without their knowledge and against their will.

"The other way opened for Kastner by Krumey was the method of rescuing Jews by the Nazis themselves, with their help, according to agreement with the heads of the SS. This way was convenient and offered predictable results. The number of Jews saved in this way was fixed, and it was possible to determine in advance who would be rescued. True, the number of candidates for rescue by this method was very small, but, as stated, it could be increased by further negotiations and large ransom payments.

"The head of the Rescue Committee had to decide and choose between these two ways. It was difficult to vacillate for long and hold the rope at both ends: to enjoy Nazi help to rescue the 'Prominents' and also to save ordinary Jews by anti-Nazi methods. Perhaps the desire to attract the Committee made the Nazis close their eyes to smaller rescue efforts like forging of documents, financing 'journeys' on a small scale. But it was clear that the Nazis could not allow Kastner to warn the Jews in the province towns about their lies and plots, or to organize them to disturb the deportation plan. The totalitarian authority forced Kastner – like anyone seeking its benefit – to face a sharp choice: with us or against us. The moment he chose one way he gave up the other.

"To take both ways together Kastner would have had to deceive the Gestapo and the 'Juden-Commando', an extremely difficult and dangerous task. It was not without reason that Eichmann said to him (on another matter – Brand's mission), that he (Eichmann) was cleverer than his rivals and could not be deceived, more than once did he hint to Kastner very politely about the possibility of sending him too to Auschwitz: 'Your nerves are too tense Kastner, shall I send you to Theresienstadt for recuperation, or do you prefer Auschwitz' (Kastner's report p 43). [Ha'levi does not

89

give full reference].

"Indeed, one of the main reasons that Kastner and the members of the Rescue Committee were not sent to Auschwitz, despite their connections with the Pioneers underground, was that Kastner chose the second way dependent on the Nazis goodwill and preferred it to the first method. Eichmann was interested to prevent the Jewish and Zionist rescue and defence system from developing in an anti-Nazi direction.

"Kastner did not dare to deceive the Nazis by double dealing. From the moment he chose the joint rescue method with the Nazis (rescuing the prominents) he remained loyal to his method and to his partners in this rescue. Not merely the threat of Auschwitz prevented him from any serious deviation from this line. Kastner knew that any anti-Nazi act on his behalf or of one of his subordinates would endanger and foil the rescue of the prominents, a rescue operation he began and whose success was dependent on Nazi goodwill. Kastner didn't want to destroy by his left hand what he built with his right. He also didn't want to endanger the lives of those who relied on his rescue. For these reasons Kastner had to walk the line for rescue determined for him by the Nazis.

"The rescue agreement with the Nazis forced Kastner and the Committee to give up any rescue operation which could endanger this agreement. Kastner and the Committee had to give up the independent rescue method; they had to refrain from a real warning of the Jews in the provinces, from organizing large scale escape, not to mention organizing resistance or disturbing the deportations. They had to stop or refrain from efforts to save the public or part of it by any suitable means, and had to restrict and confine the activity of the Committee to rescue specific people previously agreed to by agreement with the Nazis.

"The real meaning of the rescue agreement between Kastner and the SS was to make the rescue which depended on the Nazis – the rescue 'authorized' by the rulers – the only rescue method of the committee. Giving up the free rescue was the price paid by Kastner for the rescue 'authorized' by the SS.[12]

". . . An admission by Kastner that he put the fate of all rescue on the Nazi card alone is implied in that part of his report where Kastner describes his deliberations on 3 June due to Eichmann's temporary refusal to honour his word about the rescue of the prominents of Kluj and the provincial towns (para 39).
In that part says Kastner:

"It was clear to me what is now in the balance. It is not a matter of saving a few hundred Jews from the provinces. If here and now Eichman can't be made to compromise, then the committee, which in roulette played with human lives bet on the German number, would be a not less naïve loser than so many others before us in conquered Europe. Then the millions paid would not only have been a folly. The loser in that game would also be called a traitor."[13]

A Double Secret

The agreement with the Nazis to keep the real purpose of the Ghettoization process and the real destination of the deportation trains secret implied that the mere fact that there was an agreement also had to be kept secret.
Ha'levi commented in his judgement:

"The agreement with the SS imposed on Kastner the duty of secrecy. It was a 'Reich

Secret'. Already at the early stages of the negotiations, at the stage prior to the agreement, Kastner was warned by Krumey that the plan for the emigration of the 600 and everything related to the negotiations, constitutes a 'Reich Secret', and only with difficulty did Kastner inform Kraus [the Jewish Agency representative in Budapest], who was responsible for 600 immigration permits to Palestine, of the secret of the 'Aliyah camouflaged as deportation', (para 23)

"The heads of the SS forbade Kastner at the beginning of the negotiations to have any contact with the Hungarian authorities. They insisted on the secrecy of the negotiations. On 10 May Kastner was arrested by the Gestapo andd during his two day detention was interrogated by Klages, Head of the Gestapo, about his connections with Grezoli, member of the Hungarian General Staff, and about information on the negotiations with the SS which he divulged to Hungarian circles. (Kastner's Report p 34)
Rescuing the prominents of the provincial towns was a 'Reich Secret' kept both from the Hungarians and from the Jews of the provincial towns.[14]

". . . Why was it forbidden to reveal to inhabitants of Kluj, and even – according to Kastner – to most of the rescued themselves until they left Kluj, the 'Rescue Secret'?

"The truth is that both Eichmann and Kastner had an interest in keeping the rescue plan secret. Eichmann's words to Kastner on the danger of murders in the ghetto hint at this common interest. Had the ghetto inmates known or worried that the Nazis intended to send them to Auschwitz and the prominents to safety there could have been a rebellion endangering the prominents and the deportation plan as well. Not only a clear and complete knowledge of the Nazi plan to destroy the majority and rescue the minority but any partial information, any escaped detail on an early agreement between Kastner and the SS for a separate rescue of the prominents could raise suspicions among Jews. The success of the extermination plan depended on surprising the Jews and on totally misleading them, to this end it was necessary to remove suspicions from the victims. To ensure the success of his task Eichmann imposed a total blackout on all his plans, including the plan to rescue the prominents. The sheer term 'rescue' could hint to the victims about the danger of extermination, therefore it was preferable to the heads of the SS that Kastner talked of *Aliyah*.

"Dr Hermann, one of the Zionist leaders in Kluj, and of the heads of the Bergen-Belsen transport [A Nazi concentration camp in Germany where the 'prominents' stayed for a while.] testified (pp 380, 382):

In our eyes it was not a train of rescue, but of aliyah, *therefore we wanted to join it, to emigrate to Palestine via Spain. The possibility of* aliyah *in those days was of course most attractive given the cruel conditions in which we lived . . . the decision then was not whether to rescue 380 out of 18000, but whether to bring about* aliyah, *since there was no awareness of extermination, there was an awareness of danger not an awareness of extermination.*

". . . Kastner understood very well – and the sections above on the danger of 'murder in the Ghetto', avoiding 'attention' and maintaining the 'Rescue secret' indicate that even Eichmann and his aides clarified to him fairly explicitly – that the prominents as a whole and his friends in Kluj in particular would not be rescued from the holocaust if the mass heard a hint about the real purpose of the operation: to save the leaders from the holocaust prepared for the people.

"Kastner knew that the more blurred the difference between the fate of the

prominents and the fate of the people the better the prospects for the success of the operation, whereas the more true information about the Nazi plans whether about the extermination of the majority or the rescue of the minority infiltrate the ghetto the smaller the chances of the prominents to be rescued. Eichmann and Kastner were both interested, for different reasons, in keeping the 'Reich's Secret'. Eichmann – for ensuring the success of the extermination, and Kastner – for ensuring the success of the rescue plan. This is not confined to the 'Rescue Secret' alone, the secret which Kastner describes by this innocent name, when saying 'the Rescue Secret had to be kept' – was in reality nothing else than a branch of that terrible central secret on which a Nazi blackout was imposed – the secret of the extermination.

"The domains of rescue and extermination fed each other. Anyone divulging the 'Rescue Secret' revealed an inkling of the extermination secret. The prominent's rescue operation was declared a 'Reich's Secret' to defend and guard strictly the secrecy of the extermination plans. If Kastner was forbidden to reveal the 'Rescue Secret' he certainly couldn't reveal the extermination secret. If revealing the 'Rescue Secret' could have led to 'murders in the ghetto', revealing the extermination secret even more so. If revealing the 'Rescue Secret' could have sparked off disturbances and rebellion in the ghettos, could endanger the rescue of the prominents and disrupt the total deportation, then revealing the extermination secret could have acted like dynamite destroying all plans together. Kastner knew that any leak of the extermination secret would endanger him and the entire Rescue Committee and put an end to all joint rescue plans.

"The association with the heads of the SS on which Kastner placed the entire fate of the rescue forced him to withhold his information about the extermination plans from the majority of Hungary's Jews".[15]

The Paratroopers

In the course of the trial the prosecution (ie the Attorney General) brought up a totally unknown issue, which wasn't mentioned in Greewald's pamphlet at all. His intention was to show that Kastner was trusted by the Jewish Agency.

The issue concerned the sending of 3 young Jews from Palestine to Hungary in April 1944 to warn Hungarian Jewry about the impending extermination, and to initiate and organize resistance or escape. The three, who migrated to Palestine from Hungary before the war, knew Hungary well. One of them (Joel Nusbacher 'Palgi') came from Kastner's hometown Kluj, and was before the war a member of the Zionist youth organization headed by Kastner. Another, Hannah Senesh, was the daughter of Bela Senesh a writer and critic who was a close friend of Otto Komolly, head of Hungary's Zionists.

The three were trained by the British army, commissioned as officers, and given the additional task of helping Allied prisoners of war, and radioing military useful information to the Allies. An RAF plane dropped them into a part of Yugoslavia held by Tito's partisans, and from there they crossed the border to Hungary. They were given Kastner's address as the reliable contact.

Senesh was caught on crossing the border into Hungary and was arrested. She was imprisoned in Budapest, tortured, and finally shot in October. Nusbacher arrived at Kastner's place, and as a result of their conversation decided to hand himself over to the Gestapo. Before that he managed to locate Goldstein, who was hiding in Budapest, and persuade him too to hand himself in.

Both were sent to Auschwitz but Nusbacher managed to escape, returned to Palestine, and eventually became a director of El-Al, the national airline. Goldstein perished in Auschwitz.

During Kastner's cross examination in the trial it turned out that he hid from the court the fact that he informed the Gestapo about Goldstein and Nusbacher while they were still free, two days before they actually handed themselves in. He asked for, and was granted, a

further testimony to clarify the issue.

Ha'levi states:

> "The reception given by Kastner to the two paratroopers was not very encouraging.
> Kastner was horrified and very perturbed by their unexpected arrival (Palgi's
> testimony, 399; exhibit 35,110; exhibit 40, 416). He turned pale when he recognized
> Palgi who entered first. His first words were: 'Are you crazy? how did you get here?'
> After a brief conversation with the two youths he invited them to a meeting next
> morning while still dark. During their first night the two Haganah emissaries had to
> stay in Nazi Budapest in a Hotel watched by the police. To reduce the risk Palgi
> registered only one guest in the hotel book and Goldstein entered Palgi's room
> without registering. For some reason Kastner, despite his close links with the
> Pioneers' underground was unable to find a refuge to the two paratroopers. (Palgi's
> testimony, B,77, 426/7; exhibit 40,416/7; exhibit 35,110)".[16]

After 20 pages of detailed analysis Ha'levi sums up his conclusion.

> "We'll sum up the main facts as proved indisputably by the evidence mentioned so
> far: It has been proved that Kastner forced the two paratroopers, with extremely
> heavy moral pressure exercised secretly and on the basis of false explanations, to give
> up their duty. That Kastner informed the head of the Gestapo about the two
> paratroopers. That Kastner tried, by his pressure and tricks already mentioned to
> make the paratroopers hand themselves to the Gestapo and succeeded at that stage
> with Palgi. It had also been proved that these acts were not done on behalf of the
> paratroopers, but, on the contrary, endangered their lives.

> ". . . the real explanation for these acts of Kastner stems from his relations with the
> Nazi regime. Kastner has put as he admits (end of para 40), all his rescue operation
> on the Nazi card. All his enterprise until the arrival of the Paratroopers was actually
> the rescue, with the help of the SS, of 700 prominents out of half a million Jews from
> the provinces sent to Auschwitz.

> "Even those didn't reach a safe shore, but only Budapest, where they were joined by
> 500 of capital's prominents and wealthy, and all the 1200 rescue candidates –
> including more than 20 of Kastner's family (his wife, mother, brother, father in law,
> and more) and many of his friends and comrades – waited in the SS camp for the
> prominents in Columbus street, desperately awaiting the departure of the promised
> train to Spain. All of Kastner's hopes for the departure of the train depended on
> Eichmann who could have tormented him again at the last minute, as he did on 3
> June (para 39), and on Klages, head of the Gestapo, who, on 3 June, intervened on
> behalf of Kastner and who was also in these days before the train's departure in
> close contact with him (testimony of Kastner and Mrs Brand) . . . Kastner gave up
> long ago any possible position compatible with the arrival of the paratroopers and
> their mission. Any Jewish resistance, particularly Zionist, amongst Budapest's Jews
> would have endangered immediately the chances of success of his efforts – the rescue
> of the Bergen–Belsen train – and endanger all his links with the Germans. Moreover,
> the arrival of the paratroopers involved Kastner in a complication touching the roots
> of his loyalties. On the one hand he was asked to provide shelter and assistance to
> two members of the Haganah who relied on his loyalty as self evident. On the other
> hand Kastner had long ago given his loyalty to the Nazi regime, not out of love of the
> Nazis, but due to circumstances, as a pre-condition and foundation of his entire joint
> effort with the Nazis which depended on their goodwill. Eichmann and Klages
> could, and did, rely on Kastner because all the assurances and guarantees were in
> their hands. His most vital interests:- the rescue operation, the fate of the rescued,
> the fate of his relatives, his own fate and safety, forced on Kastner loyalty to the

ruler. The totalitarian regime did not accept 'dual loyalty' . . . It was impossible to enjoy daily the favours of the ruling tyrant without reciprocating. Kastner who knew the Nazi murderous regime from close quarters could not deviate even minutely from this loyalty. Secret contact with paratroopers of the enemy, or knowledge of their arrival without informing the Gestapo would have constituted a serious breach of his loyalty to the Nazi regime. The vital interest of Kastner to exist and act under the protection of the Nazi regime forced him to inform Klages as early as possible on the paratroopers arrival."[17]

As for Senesh, who is revered as a hero in Israel and whose poem *Happy the Match that expired and kindled a Flame* became her epitaph, Ha'levi concluded:

> "Apart from the futile proposal of 14 October [months after their arrest, when he asked the Red Cross and Hungarian Defence Ministry to release the three] Kastner did nothing for Hannah Senesh. Despite the comfortable possibilities of help that existed during the prolonged relaxation period [at the end of August Hungary expelled Eichmann and stopped all actions against the Jews due to pressures by the Allies. This lasted until mid-October when the Nazis and the Hungarian Fascists (the 'Arrow Cross') staged a coup and took over. A.O.] Kastner didn't visit Hannah in prison, didn't appoint a lawyer, didn't approach the department for POWs at the Swiss embassy, and prevented Kraus from approaching it, didn't reply to Hannah's appeals to him, didn't send her any parcel, didn't receive her mother who tried, unsuccessfully, to see him, didn't inform the head of his committee the late Dr Komoly who was a family friend of the Seneshs and knew Hannah personally, about her being in prison in Budapest. Kastner admitted only a few of these facts and denied most in his testimony, but all were proved true by the reliable testimony of Mrs Catherine Senesh, [Hanna's mother] and other testimonies."[18]

Sharing the Plunder

The *Black Book on the martyrdom of Hungarian Jewry* by Eugene Levai states:

> "Grievous charges were brought against Kastner & Co in general (Brand having left his place was taken by his wife) because no account had ever been rendered by them in respect of the huge sums collected by that time. Similarly, Kastner never accounted for the amounts paid into his account from foreign sources. Dr Kastner and his companions have therefore only themselves to blame if Jewish circles in general distrusted their activities from the beginning and, even up to the present time, are suspicious of their management of the funds."[19]

Ha'levi states:

> "Kastner contradicted himself seriously about the 'Becher Treasure'. In his letter to the Jewish Agency of 21.10.45 (exhibit 142) he informed the Executive of the Agency 'with special delight and satisfaction' based on the accompanied report by Dr Schweiger about the treasure handed him by Becher that 'the valuables handed by the committee in Budapest were never used by the Germans, meaning they were never used in the German war effort'.

> "'. . . clearly, Becher handed Dr Schweiger only a very small part' of the property received from the committee. By contrast, Becher in an affidavit given after his release [from Nazi war criminals' prison] in 1948, stated (exhibit 74) that he gave Schweiger 'the diamonds, gold, etc given to me by Dr Kastner, worth some SF 2M', and Kastner, in his letter to the late Minister of Treasury, Mr Kaplan (exhibit 22) supported Becher's claim, and gave details of the items that disappeared according to

94

Becher and accused of negligence 'those emissaries of the Agency whose duty it was at first to guard scrupulously the fate of the suitcase . . . Kastner's version corresponds to Becher's words to Schweiger (exhibit 142) and to Becher's affidavit (exhibit 74) but is implausible and merely forms part of his continuous efforts to 'purify' Becher in the eyes of the Jewish Agency – efforts which began before the end of the war and continued afterwards.

"Continuous steps to clear Becher were the joint alibi actions, the agreement to hand the treasure to the Jewish Agency, the letter of 21.10.45 (exhibit 142), and the whole of Kastner's report handed to members of the Zionist Congress. Kastner gradually prepared the ground for the decisive step – his intervention in Nuremberg on behalf of Becher in the name of the Jewish Agency. His continuous support – before Arian's report and after it – for Becher's claims about returning the plundered Jewish property is merely a part of this purification process . . .

". . . Kastner's contradictions concerning 'Becher's Treasure' do not prove that he shared the plunder with Becher. It has not been proved that he spent 'an empty and licentious' time in Switzerland, as the accused [Greenwald] stated in his pamphlet, nor has it been proved that he had considerable property after the war, on the contrary, it seems that he lived a normal life of an official living on his salary.[20]

Ha'levi held the accusation of 'sharing the plunder with a Nazi war criminal to be unproved.

Saving Nazi War Criminals after the War

As already mentioned by Ha'levi, Kastner went to the International War Crimes Tribunal after the war (in 1945 and 1947) and gave evidence on behalf of Becher. That evidence saved Becher from the death penalty, the fate of many high ranking SS officers. The SS itself was declared 'a criminal organisation', so that by definition all its high ranking officers were war criminals.

During the trial Kastner at first denied that he gave any evidence on behalf of Nazis, when the defence pressed him he admitted that he testified before the German denazification authorities (who had no authority to issue death penalties). The Attorney General Haim Cohen, trying to help Kastner out the contradictions in his statements questioned him:

– Before appearing as a witness in the court did you consider the problem whether it is a national crime or national sin to testify on behalf of Becher?
– I certainly did.
– We heard that you talked to many people and tried to convince them. But after the event did you talk to people, did you defend yourself?
– No.
– Did anyone tell you that you committed a national crime by testifying on behalf of Becher? did they tell you in the (Jewish) Agency that you committed a national crime?
– No.
– Does this distinction between intervention and testimony, did you ever present it before your interrogation in this court?
– No.
– You said that intervention is a crime whereas testimony is not. Do you know this distinction today?
– I wish to answer that question with a few sentences. In the cross examination, which proceeded as it did, I didn't always express myself in the best manner. On Becher I was asked today whether I ever stated in court that I didn't give a statement. I remember that I said I gave a statement before a member of the International court. I regret some of the statements I made regarding Becher in the cross examination.

Tamir: I'm not certain whether today he can still regret.

Ha'levi: He can.

Kastner: I also don't think I formulated my testimony in this matter in the most proper form, but my testimony to the police, and to some extent my letter to the late Kaplan [Minister of Finance] indicate that I've never tried to hide my activity in this matter, and I acted with a calm conscience and good faith in this matter. If under the pressure of a demagogic interrogation I said here and there things that I regret today it does not change my basic position on this matter.

Cohen: let us return to that statement. If you had to make that statement [on behalf of Becher] today, would you make it or not?

Kastner: Yes, but without the last phrase. That is, I wouldn't have given it also on behalf of the Jewish Agency.

Would you do it in your name?

– Yes, or I would have asked for written authorization, or showed my statement in advance.

– But apart from that would you give that statement with the same formulation?

– The same formulation.

Do you consider this your duty as you were in that situation with Becher, or was this the duty of every decent person?

– Every decent person should have done as I did.

– Did you testify on behalf of any other Nazi officer apart from Becher?

– I did not give a testimony that could help them.

– I hear you testified against Nazis.

– Tens of times.

– But do you know of a case apart from Becher's? [where a Jew testified on behalf of a Nazi.]

– There was a committee of Orthodox Rabbis in USA and Canada, who, as far as I know, intervened on behalf of Shelenberg who was a war criminal.

– How do you know they intervened on behalf of Shelenberg?

– I saw the letter they wrote to the International court in Nurenberg, where there was also a trial of Shelenberg, and I was about to prove he was a criminal.

– Did you appear against him?

– Yes.

Haim Cohen takes out of his file a bunch of papers.

– Did you ever see these statements? These are sworn affidavits from the Becher file in the German denazification court.

– I don't know if this is all, but I saw them.

– When did you see them?

– When I was in Nurenberg the second time.

– Did you see them before your statement?

– No. After my statement. Part I knew before but as a file I saw them when I was there the second time.

The Attorney General begins to hand the judge statement after statement and suddenly . . . what is this document that Mr Cohen himself is so surprised by?

'Your honour, I'm afraid that I've misled the court . . . I have here the original English version of the affidavit . . .''

Once again, total shock in the courtroom.[21]

Kastner's affidavit on behalf of Becher before the International war crimes tribunal, whose existence was first denied by Kastner, and whose Hebrew translation was later contested by him and which the Attorney General pretended to know nothing about was suddenly found in his file, turned up by accident. It ends with the words:

Having been in personal contact with Becher, from June 1944 until the middle of April 1945, I should like to emphasize, on the basis of personal observations, that Becher did

everything within the realm of his possibilities and position to save innocent human lives from the blind fury of killing of the Nazi leaders. Therefore, even if the form and basis of our negotiations may be highly objectionable, I did not doubt for one moment the good intentions of Kurt Becher and in my opinion he is deserving, when his case is judged by Allied or German authorities, of the fullest possible consideration. I make this statement not only in my name, but also on behalf of the Jewish Agency and the Jewish World Congress.''[22]

This statement was given by Kastner to the International War Crimes Tribunal 11.8.47. In December 1947 Kurt Becher was released by the International Court in Nurenberg, which ruled that he should not be tried, he was then handed to a German denazification court, which released him in 1948.

In his letter of 26.7.48 to Mr Eliezer Kaplan, the then Minister of Finance, Kastner wrote:

"It is known that Becher was a former SS Colonel and served as a liaison officer between me and Himmler during the rescue operations, he has been released in the meantime by the occupation authorities due to my personal intervention".[23]

Ha'levi states:

"Kastner knew well that Becher did not stand up 'courageously' against the current as he stated but obeyed Himmler's orders, from the Bergen–Belsen transport [the train of the 'prominents'] to the transfer of the Bergen–Belsen camp to the British, and that the initiative to all these acts was Himmler's and not Becher's. He also knew that the aim of Himmler and Becher was not to save Jews but to achieve Nazi interests – whether for the Nazi regime as a whole or for the relevant war criminals. There is no truth and no innocence in his statement 'I did not doubt for one moment the good intentions of Kurt Becher'. That statement by Kastner was a deliberate lie given on behalf of a war criminal in order to save him from being tried and punished in Nurenberg. The defendant has proved the truth of his accusation."[24]

Ha'levi concludes:
"Kastner's behaviour, defending Becher after the war, attempting to purify him in the eyes of the Jewish Agency, and even saving him from trial and punishment as a war criminal in Nurenberg do require strong and most unusual motives but there is no need to look for the explanation in the financial domain as the accused assumed in his pamphlet. There are many signs in Kastner's report that strong personal sympathies were formed with the time between him and Becher, which blurred the natural separation between the Jew and the SS man. The prolonged collaboration of Kastner with the Nazis had its effect of blurring his sight and the identification with his period of greatness continued to affect him after the change of period. Kastner needed the purification of Becher and his justification for justifying himself. Such, or similar motivations can explain Kastner's behaviour. But there is no need to ascertain the motive when the act has been proved."[25]

But the story does not end there. In 1960, six years after the trial, Joel Brand, Kastner's closest friend and deputy in Budapest [until he left for Palestine with Eichmann's offer to trade Jews for goods, when his wife replaced him.], published a book in Israel where he states:

"When I investigated the Kastner affair, I searched and found Dr Robert M. V. Kempner, the American prosecutor in those days, who later worked in Frankfurt as lawyer for Jewish compensation claims, he answered my questions:

"Yes, I invited Kastner from Tel-Aviv to Nurenberg as a witness for the prosecution. Immediately after his arrival I regretted this invitation. Apart from the

fact that he turned out to be a very expensive witness, and the expenses incurred by his visit were extremely high, a curious situation developed. We were, after all, the authorities of the prosecution. I consider it my duty to state explicitly that Kastner roamed the Nazi prison camp for Nazi Officers searching for those he could help by testimony or intervention on their behalf. In the end we were very glad when he left Nurenberg."[26]

There is more. Brand writes:

"On 13 September 1945 [ie four months after Germany's surrender] Kastner stated before the Chief American military attorney Warren F. Farr, as follows:

'According to Krumey's statement . . . given in February or March 1945, Eichmann convened in Berlin, in spring 1942, a meeting of the officers of the 4th dept [in charge of exterminating the Jews. AO] informing them that the German government has decided on the extermination of Europe's Jews, to be carried out secretly, in gas chambers . . . Krumey insisted that as long as this secret – to be carefully guarded – not be revealed by Eichmann, only a few officers of the 4th dept. knew the details . . . the entire German Reich machinery collaborated with the 4th dept. in this task . . . The officers of this dept. moved from country to country . . . the operative plan was identical in almost all countries . . . Krumey and . . . were at the head of the operations in Hungary, Austria, and Poland . . .',

"And yet, despite this decisive testimony against Krumey, Dr Kastner stated before the deputy director of testimonials office in the headquarters for rounding up war criminals, on 5 May 1948:

"I first met Hermann Krumey in April 1944 . . . in those days he was an SS colonel, member of the staff for special actions [the Nazi term for exterminating the Jews] under the command of SS colonel Eichmann in charge of the final solution [Nazi euphemism for 'murdering'] of the Jewish question in Hungary. As a result of my negotiations 15,000 Jews – out of 50,000 already deported [to Auschwitz] – were sent to Austria rather than to Auschwitz. This meant that people who could work were given jobs and their families – children, babies, old and sick – were also not sent to the gas chambers as happened to those deported to Auschwitz. They were saved from death. Hermann Krumey was appointed head of a small staff placed in Vienna as the officer responsible for that special group of 15,000 people.
I wish to stress that Krumey carried out his duty with commendable goodwill towards those who depended, decisively, on the manner in which he interpreted his orders. As I spent the last three months of the war in Vienna I could observe the facts stated here with my own eyes. I presented Krumey with a series of proposals designed to improve the hard conditions of people in this group and always found him understanding and willing to help".[27]

Brand concludes:

"When I read Kastner's statement I was confused. Nobody knew better than Kastner that Krumey was the immediate deputy of the mass murderer Eichmann. Nobody knew better than him that the anti-Jewish regulations pasted on houses in Budapest, and the orders for concentration and deportation of Hungary's Jews were signed by Krumey.
He certainly remembered how Krumey faked innocence, stating that those who were already dead in Auschwitz were transferred from Hungary to 'Waldsee' in Germany for forced labour, and even exclaimed in surprise: 'Haven't you received letters from them? You'll soon get them'. But Obersturmbahnfuhrer Hermann Krumey arrived in Hungary already crowned by glorious achievements. He was the commander in Poland of the SS deportation battalions. His pet occupation was the confiscation of

Polish and Ukranian peasants' lands, the deportation of the peasants to Germany as forced labour, and the transfer of the lands to influential persons in the SS.

He it was who received for 'special treatment' the 86 children of Lidice [a Czech village whose entire population was murdered as retribution for the assassination of Heydrich.], and no one has seen them since.

Hermann Krumey didn't like the front, and service in the Jewish dept. suited him admirably. This dept. didn't hold the promise of fast promotion but it gave him more power than that of Generals. I cannot understand how Rezso Kastner could give such a positive testimony on behalf of this war criminal. Yet Rezso told me 'I never testified on behalf of Krumey. I never defended members of Eichmann's staff, since these were nothing but murderers of the worst kind. It was different with people like Becher".[28]

Even as late as 17.2.1957 Kastner wrote a letter to Brand insisting:

> *I cannot remember that I ever testified on behalf of Krumey. When asked to confirm what, to my mind, he did for us, I presumably, didn't refuse.*
>
> *In my statement in London I presented Krumey as a war criminal. I described in my report how he very cynically misled me during our negotiations.*
>
> *. . . In repeated memorandums to General Taylor I demanded a trial about the Holocaust, and when Eichmann disappeared without a trace I demanded that Krumey stand trial as the main culprit . . ."*[29]

Brand comments:

> "This letter left a bitter taste in my mouth. Kastner has always denied that he gave a testimony on behalf of Krumey. Even in this letter he argues that he cannot remember so to say anything. But such testimonies are not forgotten easily".[29]

Kastner's testimony on behalf of Krumey was never mentioned in the trial in 1954.

The Appeal

Ha'levi found that Greenwald has proved allegations 1, 2, and 4. (collaboration with the Nazis, 'preparing the ground for murder' of Hungarian Jewry, and saving a Nazi war criminal after the war) accordingly Greenwald was fined a symbolic one Israeli pound whereas the Government had to pay the costs. The government appealed to the Supreme Court.

The Supreme Court consists of five judges each of whom reconsiders the entire case and may deliver a separate judgement. The Court's verdict consists of the majority's view. All five judges agreed that the charge of sharing the plunder with a Nazi war criminal has not been proved, and hence constitutes libel.

As for collaboration four judges disagreed with Ha'levi and one agreed with him, whereas on the point of 'preparing the ground for murder' all five disagreed with him. The arguments for the disagreements differed. Justice Goitein argued:

> "and yet, my opinion is that we should uphold the appeal, the reason being that the libel in the pamphlet which is the subject of the trial constitutes one whole and cannot be divided and split into parts except for the convenience of analysis. If the defendant justified it in its entirety he is innocent, if he justified it only partially he is guilty of the entire charge'.[30]

Justice Olshan, the President of the court had a similar view:

> "When a defendant in a libel case argues that he spoke the truth – he must, according to the law, prove the truth of all the allegations, if he did not do so he has failed in his defence. With all due respect I think that splitting the main charge into two is artificial and unrealistic'.[31]

Justice Silberg argued:

> "The claim of the Attorney General shrinks to one point only, namely: the subjective aspect. Kastner was convinced and believed that there is no shred of hope for Hungary's Jews: not even for one, and if he, as a result of this absolute despair, didn't reveal the secret of the extermination in order not to undo or endanger the rescue of the few, then he acted innocently and cannot be charged with collaboration with the Nazis in facilitating the extermination of the Jews, even if he, de facto, contributed to this result.

> "I must say that I cannot accept this argument. Is this 'innocence'? Is there 'representation' of despair? Can a single individual, even jointly with some friends, despair on behalf – and without the knowledge – of 800,000 people? Let us consider – and that is the crux of the matter in my opinion – the charges of the witnesses against Kastner is not that but for the guarding of the 'extermination secret' a large part of the Ghetto inmates could have been saved by one major rescue operation, organized, on a national scale; this is not the argument. The argument is that had they known about Auschwitz, thousands, or tens of thousands could have managed to save their lives by partial, sporadic, or many individual rescue acts, like: local uprisings, resistances, escapes, hiding, hiding children with Gentiles, forging documents, paying ransom, bribes, etc. And if so, and since we speak not about a few seeking rescue, nor about a few thousands, but of many thousands, how dare an ordinary mortal reject, with total certainty, and with an absolute 'No' the efficiency of all this multitude and variety of rescue possibilities? How can he test those tens of thousands possibilities? Is he a god?

> "Indeed, he who behaves with such usurpation towards the last hope of hundreds of thousands cannot claim the defence of innocence.
> The burning question of 'By what authority?' and 'quo warranto' is an adequate answer to such a claim of Bona Fide".[32]

And yet Justice Silberg argued that whereas the charge of collaboration was fully proved, the charge of 'preparing the grounds for murder' was not, arguing that unless it can be shown that Kastner willed the murder of entire Hungarian Jewry the libel is not justified.

This was also the gist of the argument of Justice Agranat, whose view spans 109 pages. He first argued that since Kastner was accused of murder in the libel, it must be shown as it would in a criminal action that he had a guilty intention [*mens rea*] and had willed this murder. Agranat argued that it has not been proved that Kastner willed the murder of Hungarian Jewry, and that he strove, at every point, to save the largest possible number of Hungarian Jews. He stated his views as follows:

> "I summarize my final conclusions on Kastner's behaviour during the holocaust of the provincial towns: 1 During that period Kastner was motivated by the sole motive of saving Hungary's Jews as a whole, that is, the largest possible number under the circumstances of time and place as he estimated that could be saved; 2 This motive fitted the moral duty of rescue to which he was subordinated as a leader of the relief and rescue committee in Budapest; 3 Influenced by this motive he adopted the method of financial or economic negotiation with the Nazis; 4 Kastner's behaviour stands the test of plausibility and reasonableness; 5 His behaviour during his visit to Kluj (on May 3rd) and afterwards, both its active aspect (the plan of the 'prominents') and its passive aspect (withholding the 'Auschwitz news' and lack of encouragement for acts of resistance and escape on a large scale) - is in line with his loyalty to the method which he considered, at all important times, to be the only chance for rescue; 6 Therefore

one cannot find a moral fault in his behaviour, one cannot discover a causal connection between it and the easing of the concentration and deportation, one cannot see it as becoming a collaboration with the Nazis".[33]

Agranat then used an example given in Ha'levi's judgement about a guard of a camp betraying his duties:

The enemy informs the guard that the camp is surrounded by superior forces, that it intends to destroy the entire camp and even if the guard tries to wake his friends they won't manage to escape. The enemy promises the guard to spare the lives of a small number of friends which he may choose on condition that he will not wake all other friends and not make any attempt to rescue them. The guard presents the enemy with a list of his best friends and avoids alarming the camp and helping it. The enemy destroys the entire camp and leaves alive only the guards friends. The guards act constitutes a betrayal of his friends and duty, collaboration with the enemy, and assistance to destroying the camp. (para 64)

My answer to this example is that it fails to apply to our case for two reasons:

First, The Plan of the prominents was never considered by Kastner as a singular rescue mission for whose sake he forsook the rescue of the rest of the Jews in the provinces. It was only a by-product of the negotiations to prevent the deportation of Hungarian Jews as a whole, and in his eyes this plan was in line with the plan of maximum rescue and not opposed to it.

Second, the duty of the guard in the example above – to alarm the camp on the sudden arrival of the enemy who comes to destroy is a ministerial duty, well defined in advance, from which he couldn't deviate in the slightest. But Kastner's public duty obliged him to care for the rescue of the whole of Hungarian Jewry, in other words his sole moral duty was to aspire to rescue the largest number of Jews which it was possible to save. Therefore the decision on the question whether he had to tell the Jews in the ghettos his actual information depended on his evaluation of the use of this means for the said 'maximal' end. But we saw that his evaluation of this issue – which was reasonable – was negative. Therefore my view is that the president (of the District Court) was wrong in his conclusion that the defendent proved, with regard to the holocaust of the provincial towns in Hungary, his first two charges. The tragedy which these Jews suffered is enormous and horrifying both in its substance and scope. But the proofs to substantiate it in this case does not justify the conclusion that Dr Kastner knowingly contributed to this sad outcome and does not justify that he be stained, accordingly, by the stain of a collaborator with the Nazis".[34]

The law on which Justice Agranat, and all the judges of the Supreme court, based their considerations were the Israeli rules for dealing with ordinary criminals. But can a political leader, whose policies proved catastrophic, be judged according to the narrow rules designed to deal with ordinary crimes?

Justice Agranat argued that as long as the aim of saving the majority of Hungary's Jews was foremost in his mind Kastner could be accused neither of 'collaboration with the Nazis' nor of 'preparing the ground for murder'. Judge Kheshin agreed, but added:

"In the moral domain: This is not a question whether a person be allowed to kill many in order to save a few or vice versa. The question is in a totally different domain, and has to be formulated thus: A person sees that an entire community is doomed, is he allowed to make efforts to save the minority, although some of the efforts consist of hiding the truth from the majority, or must he reveal the truth to all even though to the best of his knowledge all will destroyed by this.

I think that the answer is clear: what will the blood of the few add to that of the many.

On this point we have the illuminating testimony of Freudiger, that man seen by all as honest, and a capable leader. He was asked by the court a simple question and gave a clear answer:

Ha'levi: Was it necessary for a Jew who wished to save Jews to study the aims of the Nazis in this trading or was it enough for a Jew to say: every Jewish soul the Nazis allow me to save I save, and if they ask for money I pay money, if they have political or other unknown aims it is none of my business, or must the Jews answer the question: perhaps in this deal they want to facilitate the extermination of the rest of the Jews?

Freudiger: This is really a very hard question, Mr President, and I can only answer according to religious law. To my knowledge if it is possible to save a single Jew one must save him. This is one of the three laws for which one must be ready to die rather than forsake. If I can save someone even if later this will cause worse things to others, then according to my understanding of religious law I must save him, whether there is worse to come or not . . . If I can save I must save . . . according to my understanding, he who must save the people, and can save, should save' (Freudiger's testimony, 24/53)'. [35]

Justice Kheshin quotes and accepts this view. Actually, the next sentence in Freudiger's testimony (which Justice Kheshin failed to quote) says:

Had someone approached me with the problem as the honourable president formulated it to me I would have asked my rabbinical office what to do. [36]

Kheshin states:

"No law, national or international, determines the duties of a leader in time of emergency towards those who rely on his leadership and depend on his command. Moreover, there is no law attaching criminal responsibility to a leader who does not behave in such circumstances with the reasonable responsibility of a leader. I think we can state explicitly that if we rule that Kastner collaborated with the enemy because he failed to inform those who boarded the trains in Kluj that they were heading for extermination then it is necessary today to bring to court today also Dantzig, Herman, Hanzi Brand, Rahbes, and Marton, and many other leaders and half leaders who also kept silent in times of crisis, who didn't inform others about what they knew, who didn't raise the alarm, and didn't warn, about the impending danger. Even Freudiger himself, that man of pure conscience and direct manner will not come clean. If the honourable president was right in his judgement then Kastner deserves death according to the law of judging the Nazis and their collaborators (1950). I refuse to believe that a Jewish judge would pass a death sentence on Kastner and others like him on the basis of the evidence presented in this trial.

"For these reasons I cannot accept the conclusions of the lower court on the accusations of the defendant against Kastner on collaboration with the Nazis to exterminate the masses of the Jews in Hungary during the last war". [37]

It is little wonder that the judges in the Supreme Court agreed that the proper forum for judging Kastner's behaviour and policies would be a public enquiry committee. But the government did nothing to set it up.

The Assassination

Even before the Supreme Court heard the appeal Kastner was assassinated. On the evening of 4 March, 1957 he was shot outside his house by Ze'ev Ekstein, who was then driven away by Dan Shemer in a stolen jeep. The police arrested them in their homes that same night. Next

morning the police had their confessions. A third man, Joseph Menkes, was arrested a little later. Shemer and Ekstein were former employees of the Israeli Secret Service. On the day of the assassination an agent of the Secret Service warned his superiors that the assassination would take place that night. No precautions were taken.

Kastner was alive and conscious in hospital for another 12 days.

Brand, Kastner's deputy and close friend wrote:

> "Perhaps cautious politicians didn't know what to do with one person after his trial, where to 'house' him. Needless to add that the public enquiry committee, suggested by the judges of the Supreme Court, was never established".[38]

Who authorized Kastner?

In his actions both in Hungary and Nurenberg, Kastner claimed to have the authority of the Jewish Agency. When his statement on behalf of Becher was given he signed as a representative of the Agency and reported to its treasurer. Kastner stated in his testimony to Ha'levi:

> "Before going to Nurenberg [to testify] I sat with the people of the Jewish Agency and with people from the [Jewish] Congress to discuss what to do to bring the Nazis, particularly those who participated in the extermination of the Jews, to trial. There was also a question what to do about the few cases in which we received help from the Nazis. I mentioned then especially Becher, and the court knows my opinion on him. I asked if in case of a request to give an opinion on this matter I may say, not only in my name, but also on behalf of the Jewish Agency or the Congress, that he deserves consideration for his help in rescuing the Jews. I got a positive answer.

Ha'levi: You mentioned Becher's case specifically?
Kastner: Yes. Specifically.
 – With whom did you talk then?
 – With Perlzweig and Ridner of the Jewish Congress and Barlass and Dobkin from the Jewish Agency.
 – And these four people gave the permission?
 – They agreed. Yes.
 – They agreed in relation to Becher specifically?
 – Yes.
. . . Dobkin takes the witness stand. He is a member of the Executive Committee of the Jewish Agency. His testimony is very short. He was asked to testify on one point only. Did he or didn't he give Kastner permission to make a statement on behalf of the Jewish Agency.
 Tamir: Mr Dobkin, when did you first hear the name of the SS officer Kurt Becher?
 Dobkin: I met this name for the first time only now, when I read the report about the trial.
 – There is a version that you and Barlass agreed that Kastner should testify on Becher's behalf and even add a recommendation in your name. Do you remember such a thing?
 – No. I don't remember any such a thing. I don't remember discussing this subject with him.
 – Did you know that Dr Kastner was going to Nurenberg to testify?
 – I cannot remember.
 – Did you ever face a moral dilemma for testifying on behalf of a Nazi?
 – No.
 – Were you authorized – as head of the Jewish Organizations Department [in the Agency] – to give permission to testify on behalf of an SS General or Colonel?
 – I had no authority in these matters.
 – Do you remember a debate in the Executive of the Agency on the problem of testifying on behalf of a Nazi?

– No. I have searched my memory, referred to documents and spoke to Mr Barlass about it, and failed to recall.

Tamir: Thank you Mr Dobkin.[39]

In his book *Satan and the Soul* published six years after the trial Joel Brand comments:

"Kastner testified under oath in court that Eliyahu Dobkin and Haim Barlass authorized him on behalf of the Agency to testify in Nurenberg on behalf of the SS Colonel Becher. I don't know if this was so or not. But I do know that Dobkin's claim, under oath, that he heard the name Becher for the first time during that trial, and hence couldn't have authorized Kastner to testify on his behalf is contrary to the facts. In 1944 Dobkin was due, together with the director of J.O.I.N.T. Joe Schwartz, to meet Becher and Kastner in Lisbon. All the preparations for that meeting were made, but at the last moment it was cancelled since the Allies forbade their citizens to meet with a representative of the Nazis. Therefore, by the way, the dealing with Becher was transferred from Dobkin and Schwartz to Sally Meyer, who was a Swiss citizen. In addition, Dobkin was, with Greenbaum, also the head of the central relief and rescue committee in Jerusalem, one of whose main duties was to meet Kurt Becher and follow the progress of the negotiations with the Nazis. The name of SS Colonel Becher was one of the names mentioned more than others and Dobkin was one of those who knew more than most. I myself spoke to him on the day of my release by the British [having been arrested on bringing Eichmann's offer of 'lorries in exchange for Jews', in 1944] in his office and flat in Jerusalem. He offered me then to go with him to Lisbon to meet Becher. Dobkin's testimony, that he had never heard the name Becher strengthened my doubts whether the central institutions, despite the fact that the Attorney General personally took over the defence of Rezso, were really interested in clearing him.[40]

Brand mentions in his book that when Tamir met him privately asking him to testify in the Kastner trial he replied:

'Mr Tamir, I have such horrifying and incriminating material against the heads of the State – who were the heads of the Jewish Agency at the time – that would shock the entire state. They simply cannot afford to allow such material to become public knowledge. If I testify blood will flow in the streets of Tel-Aviv, therefore I doubt whether it is desirable from a national point of view.'

Tamir smiled with sad irony and said: 'You don't know the Jewish community Mr Brand. Not a single window will be smashed as a result of your testimony. That is perhaps the worst tragedy that has happened to us, the senses have been dulled, the national body doesn't respond normally even to the most painful blows'.[41]

Eventually Brand testified, and not a window was smashed. On one occasion he was driving home with Ehud Avriel, the representative of the Political Department and of the Jewish Agency, headed by M. Sharett during 1944, and who was instrumental in handing Brand over to the British when he arrived from Budapest. Avriel commented on Brand's book:

"I understand that you wish, and even must, tell the truth, but bear in mind that it is the tone which makes the music. It is not necessary to tell everything. In fact, we should all have been put up against the wall".[42]

References
1 *Personal diary* of Moshe Sharett (Hebrew) Vol 2 p 376 Ma'ariv Publishing Co Tel-Aviv 1978
2 *The Judgement of the District Court in Jerusalem on Case 124/53:* The Attorney General against Malkiel Greenwald before the President of the Court Dr Benjamin Ha'levi (Hebrew) Karni Publishing Co Tel-Aviv 1956 p 38

3 Ibid p 45
4 *Personal Diary Vol 4* Op cit p 1073
5 *The Black Book on the Martyrdom of Hungarian Jewry* by Eugene Levai. Panorama Publishing Co Vienna 1948 p 418
6 *The Black Book* op cit p 187
7 *Criminal Case 124 The Greenwald–Kastner Trial* by S Rosenfeld (Hebrew) Karni Publishing Co Tel-Aviv 1955 p 101.
8 Rudolf Vrba 'Footnote to Auschwitz Report' in *Jewish Currents* March 1966 p 22
9 Rosenfeld op cit p 100 10 The Judgement op cit p 44
11 ibid p 47 12 ibid p 47 13 ibid p 50 14 ibid p 50 15 ibid p 54–55 16 ibid p 123 17 ibid p 153 18 ibid p 168
19 *The Black Book* op cit p 272
20 *The Judgement* op cit p 204
21 *Criminal Case* op cit p 254
22 *Judgements of the Supreme* [Appeal] *Court in Israel* Vol 79 p 2210 Hebrew. State Publishing House, Jerusalem 1958
23 Ibid p 2210
24 *The Judgement* op cit p 204
25 Ibid p 206
26 *Satan and the Soul*, by Joel and Hansi Brand. Hebrew. Ledori Pub Co Tel-Aviv 1960 p 107
27 Ibid p 6 28 Ibid p 7 29 Ibid p 8–9
30 *Judgements of the Supreme* [Appeal] *Court* 1958 Vol 83 op cit p 2315
31 ibid vol 82 p 2279 32 ibid vol 81 p 2251 33 ibid vol 78 p 2176 34 ibid vol 78 2179 35 ibid vol 83 p 2302
36 *Criminal Case 124* op cit p 37
37 *Judgements of the Supreme* [Appeal] *Court* op cit vol 83 p 2309
38 *Satan and the Soul* op cit p 209
39 Criminal Case 124 op cit p 256
40 *Satan and the Soul* op cit p 146
41 ibid p 128 42 ibid p 138

To whom it may concern

 re: PERDITION

I have read the play twice, first in one go, because I couldn't put it down, then again to consider its human and political implications. The most telling tribute I can pay it as a writer is this: I am envious that I have not written it myself. It deals with matters that concern me very much. I was born in Vienna in 1921, of Jewish parents. More than half my family were murdered by the Nazis. I have fought against anti-semitism ever since I came to England in 1938, and I am fighting now against some German historians who are trying to apply some whitewash to the Hitler regime (e.g.: Herr Nolte speaking of "the so-called destruction of Jews".) I would obviously never like an anti-semitic play.

PERDITION is definitely not anti-semitic. I think that Dr. Yaron is drawn with deep understanding and human sympathy. His position is necessarily attacked and criticised, but in the end he even gets some affection from Ruth. I did not expect the play to be so mild in that respect. PERDITION is not a total condemnation of all Zionists, but it correctly quotes and unmasks the terrible attitude of some leading Zionists, It is also quite correct to describe, as it does, how the parachutists were blackmailed and/or betrayed by the Judenraete, how simple Jewish families were deceived about the trains transporting them to their death. Jewish collaborators and some of their temporary privileges are correctly shown. At the same time the play shows that these people became collaborators only because of the fiendish system worked out by the Nazis, or by mistaken ideology.

PERDITION is a grim play, but it depicts a grim reality. Perhaps in one or two places a couple of words could be changed, such as 'practices' instead of 'doctrine', and perhaps somewhere it should be stressed that some individual young Zionists, as different from their leaders, did, in several instances, fight against the Nazis. To accuse the play of faking history or of anti-Jewish bias is monstrous. PERDITION should be staged and published whereever possible.

Erich Fried
22 Dartmouth Road
London NW2 4 EX
Tel.: 01-452 4953

MASSACHUSETTS INSTITUTE OF TECHNOLOGY

20-D-219
Department of Linguistics and Philosophy
Cambridge, Massachusetts 02139

March 8, 1987

Dear Mr. Calmels,

Thank you for sending me the text of Jim Allen's play and the critical commentary. I have been following the censorship of this play in England, a disgraceful and all-too-typical performance. I've personally been subjected to something similar in England, just a few months ago, when an article I wrote for Index on Censorship on US media treatment of Israel evoked a hysterical response from British establishment circles, in part -- but only in part -- reflected in subsequent issues of the journal. The totalitarian streak in these circles is quite evident.

I'm looking forward to a chance to read the play, but I do not expect that I will want to comment on the contents explicitly. It is the refusal to allow such material to be expressed that is, in my view, the crucial issue, whether the play is right or wrong on some factual matter or question of interpretation. By the standards employed by the totalitarian critics, virtually nothing could appear in public apart from some situation comedies, perhaps. There are, incidentally, masses of material in Hebrew on the unsavory record of the Zionist movement with regard to the Nazis and the Holocaust victims, and there are very serious issues with regard to the behavior of the American Jewish community, both during and after the war, that have yet to be properly explored. The purpose of the hysterical response to Allen's play is, surely, to guarantee that all of this will be kept under cover.

Sincerely yours,

Noam Chomsky

107

ÉCOLE PRATIQUE
DES
HAUTES ÉTUDES
IVᵉ SECTION
SCIENCES HISTORIQUES
ET PHILOLOGIQUES

SORBONNE
45-47, rue des Écoles - 75005 PARIS

Paris, February 24ᵗʰ, 1987

I have read with passion, from beginning to end,
the text of the play by Jim Allen (Perdition) and I have
skimmed through the David Cesarani's report. I have not seen
the book, pamphlet or report whose pages are cited by
D. Cesarani.

I take the risk to write directly in English. Please,
excuse my possible mistakes. But I had frequently the experience
that my good French is often less correctly understood by
English-speaking people than my bad English. My (corresponding)
fellowship of the British Academy had, unfortunately, no
automatic influence on my command of English, less of all of
the spoken language.

I shall limit myself to what, seemingly, has been the
chief or only charge against Jim Allen's play : the charge of
Anti-Semitism. I have not the least doubt that there is not the
slightest sign of Anti-Semitism in the play. I do not know
personnally Jim Allen and I cannot say if he is an Anti-Semite
in his heart. But, if so, he has in a masterly way hidden
this trend in his writing. I could only wish that all Anti-
Semites will suppress their tendency with the same success.

On the other hand, he is strongly Anti-Zionist. Through
his characters, he gives many arguments against Zionism. I
agree with them for the most part and I have written on the same
lines from a long time.

Of course, anti-Zionism is not Anti-Semitism, even if
there are anti-Zionists who are equally Anti-Semites and some
Anti-Semites who hide their ideas under the cover of Anti-
Zionism. Zionism is a trend of thought between others among
the Jews. During a very long time Zionism was professed only
by a tiny minority among the Jews and fiercely opposed by
religious Jews among others. To say that Anti-Zionism means
Anti-Semitism is often heard. It is, for obvious reasons,

108

a theme favoured by Zionist propaganda. It is nonetheless a purely nonsensical idea. It amounts to say that all Anti-Communists are so by hate of the Russian people or that states and people fighting against Oliver Cromwell and the Puritans were moved by a violent anti-British mania.

On the ideas and interpretations expressed, outside this cardinal point, I agree in general, but have sometimes some doubts. This would have needed lengthy discussions and referen to sources, for which I have no time just now. On the idea that the ignorance of the hideous facts played a great role in the submission of the Jews to their fate, I have the witness of my own mother. Summoned by the French police in Paris in 1943, she went without fear to the police station, saying that she was in good terms with the policemen. As a result, she was ultimately sent to Auschwitz where she was killed. On the guilt of members of the Jewish Councils (Judenräte), I have read much - I was outside Europe during most of the wartime, in Lebanon - and concluded that, at least, there were many different situations. This needs various judgements with qualifications. Nobody could swear honestly to act as an hero in unforeseen circumstances.

Some of J. Allen's statements (or implied statements) seemed to me a bit schematic, but perhaps I read too quickly. For example, in some regions of occupied Europe (notably in France) there were Jewish resistance group, among which Zionist ones. But conditions in Hungary were different. On the whole (I have studied this point a long time ago), it is historically undeniable, to say the very least, that an important part of the Zionist leadership played down the Nazi threat in favour of the furtherance of the process of creation of a Jewish state in Palestine. Some of the facts cited in the play are known to me for certain.

It is certain too that Hitler, during a long time favoured the emigration of the German Jews to Palestine (I quoted myself documents of the German Foreign Office in witness of the fact); the endeavours for a common struggle of Nazi Germans and Zionist Jews by Abraham Stern, the founder of the famous Stern Gang (of which Itzhak Shamir was a leader), are undeniable historical fact (but very few Zionists went so far!).

109

The background of these convergences (and some others) is
obvious and well formulated by Jim Allen after many others
and myself : Anti-Semites and Zionists had the common goal
of promoting the migration of European Jews toward Palestine.
Cooperation would have been a logical conclusion. Fortunately
all people are not consistently logical. But always, there
are some who are driven to extremes by the logic, especially
in the field of political ideologies.

In brief, it cannot be said, to my mind, that Jim Allen
distorted the facts. There are probably in his book some
minor mistakes or a selection of facts, like in every work,
which could give an impression of overdrawing. But the core
of the play is the exposure of real facts, commonly distorted
or unduly denied by the pervading Zionist propaganda and, in
consequence, largely ignored by most people.

Maxime Rodinson
directeur d'études à l'École pratique
des Hautes Etudes (IVe section), Sorbonne
Paris

Perdition & the Press

Publishers' Note The complete list of all the items known to us is given below. Limited space and budget has obliged us to make a selection for reprinting. After excluding news reports, we have sought to include as much as possible from *The Guardian* and the *New Statesman* plus leaders and the longer articles published elsewhere. We regret that permission to reprint from the *Jewish Chronicle* was withdrawn.

Several months have passed since the Royal Court Theatre Upstairs distributed the play script to journalists shortly before the staging scheduled for 22 January 1987. In that time the text has been revised in a number of points. Since the critics who challenged the play were commenting on this or an earlier draft, Dr David Cesarani one of the chief critics of the play has kindly consented to write a note drawing attention to these changes: this does not imply that he agrees in any way with the version of the play printed here. Jim Allen's rejoinder is given below.

Thanks are due to all those who gave us their permissions and who helped to compile the list.

Genesis of a Text: a note on the rewriting of *Perdition* by *David Cesarani*
Any discussion of Jim Allen's *Perdition* and the controversy which it caused must begin with an important caveat. The text of the play printed here is a drastically revised version of the one that went into rehearsal and which was released to the press for pre-performance information. This text was itself a remodelled edition of the play that was first commented on by the historians Martin Gilbert and Dr David Cesarani. At each stage of rewriting significant alterations have been made.

The extent of the current revision is such that it renders a good deal of the commentary at the time of the 'Perdition affair' almost irrelevant: much of the detailed critical comment has been deflected in the editorial process. Yet these changes have themselves now become an important dimension for any assessment of the play. This is the case for a number of reasons. First, Jim Allen and the play's director, Ken Loach, insisted on the complete accuracy and veracity of the text in January 1987. Yet now it has been radically amended. Secondly, the author dismissed the substantive points made by his critics, but he has subsequently incorporated into his text many corrections to accommodate the objections levelled against his version of history.

This is not to say that the play now represents anything approaching a truthful representation of the past. Often the changes are token and sometimes they are contradicted by mis-statements that have still not been excised. Above all, the play remains a distortion of history based on a selective interpretation of the facts and the citation of actions and documents taken out of context. This could not be otherwise since the ideological assumptions on which

111

the drama was based and its function as a piece of propaganda have been consistent from first to last.

This writer was commissioned by the Royal Court in November 1985 to given an informed opinion of the play's accuracy and validity. The report pointed out many serious flaws some of which were subsequently amended. These inaccuracies and falsifications are beyond the scope of this note, which will concentrate on the three latest versions of *Perdition*. Mk. 2 is the press copy distributed by the Royal Court when the play went into the final stages of preparation for the production in January 1987. Mk. 3 was an altered version, declared final, and supplied to participants in the Channel Four *Diverse Reports* discussion of the play in February. Mk. 4, printed here, has a number of further, substantial changes. For the sake of clarity, these emendations will be presented separately for the transition from *Perdition* Mk. 2 to Mk. 3 and from Mk. 3 to Mk. 4. The differences will be listed under the categories of major additions and deletions of historical material and significant alterations to the language of the play.

From Perdition *Mk. 2 to Mk. 3.*

Additions
Between *Perdition* Mk. 2 and Mk. 3, there was an accession of important information concerning the work of the Zionist Rescue Committee and the Zionist Resistance in Hungary. Much fresh material relating to the mission of Joel Brand was provided. Significant detail was added covering the numbers of Jews saved and the various rescue trains.

An article by Dr Stephen Roth, one of the Zionist underground engaged in warning and saving Hungarian Jews, showed that Kastner also managed to save a further 18,000 Jews from immediate deportation to Auschwitz. This was incorporated as new information.

In the wake of *The Guardian*'s role in exposing the play, a friendly reference to the paper was transformed into a hostile aside in the mouth of Ruth Kaplan. When Kaplan recounted the effect of the pamphlet, version two read: 'a small piece appeared in *The Guardian*'. The next version read: '*The Guardian* misrepresented and distorted.'

Deletions
Several lengthy passages relating to the origins of Zionism, the State of Israel and Judaism were dropped. These included the claim that Theodore Herzl was a racist and inaccurate statements about the legal status of women in Israel.

The description of American Jewry as 'all powerful' was deleted in the wake of observations that this was both inaccurate for the period in question and derived from stereotypes of Jewish power.

Language
The text omitted several objectionable phrases such as the description of Hungarian Zionists as 'working hand in glove' with the Nazis and 'the Zionist knife in the Nazi fist'. Phrases which stereotyped Jews in terms of financial dealing and Christian rhetoric also disappeared. For example: Scott's question to Yaron 'Was it [Israel] worth it? Was the purchase price of half a million Jews worth it?' and Yaron's reference to 'the road to Golgotha [which] passes along Park Avenue' where rich American Jews in 'fur-lined dug-outs' hurl contributions at Israel. The line in which Green says to Scott, 'You crucified him' also went.

From Mk. 3 to Mk. 4

Additions
Version four mentions, for the first time, that the Israeli Supreme Court finally exonerated Kastner. It contains a fuller, more correct account of the mission of Joel Brand.

The Brand mission is further enlarged in a new dialogue between Kaplan and Lawson. Here it is stated unequivocally, for the first time, that the British put Brand 'on ice' and not the Zionists as had been wrongly alleged in earlier scripts. There is also an insertion dealing with the efforts of the Zionists to alert the British to the urgency of the rescue and who tried to reach

Brand when he was in British custody. These additions closely follow criticism by Martin Gilbert and David Cesarani (see letters). However, they are subverted by new lines given to Kaplan to suggest (a) that Zionist pressure was exerted only behind the scenes (b) and that they failed to 'mobilise world opinion' – a somewhat preposterous idea since very little of the world was not already fighting the Nazis or occupied by them.

Kaplan cites various historians – Hillberg, Trunk, Arendt – in support of her contentions concerning the behaviour of Jewish Councils under the Nazis. Similar additions are made to the dialogue between Orzech and Green. This includes an indirect reference to Martin Gilbert 'an Oxford Don' and his clash with Allen over the issue of the Skalat ghetto.

It is interesting to note that Kaplan and Lawson have an entirely new interchange. The reference to the 'self-hating Jew' syndrome and Kaplan's reply that she is 'proud to be a Jew', is lifted from an exchange between Lenni Brenner and Rabbi Hugo Gryn in the Channel Four programme. But Kaplan is also afforded the opportunity to aver her belief in the right of the Jews to a homeland, as long as this doesn't hurt the Palestinians. The notion that Kaplan is less than an unqualified opponent of Israel is quite new.

A minor, but important change concerns Zionist opposition to Hitler in Germany. In the third text, in reply to the inquiry 'Did the Zionists ever fight Hitler' the answer was 'No'. This has now become 'Many did, as individuals, yes, but not the leadership.'

There are several further accretions: the material about Wise's cable, the Kutno ghetto and the quotations from the transcript of the Kastner trial are all new.

Deletions
The phrase in which the Zionist banner flew alongside the Swastika has been removed.

Version three spoke of a 'cover-up' practised by the Zionist leaders, Wise and Weizmann. This has now gone.

Language
In the examination of Orzech by Green, the word 'collaboration', used frequently in earlier drafts, has been replaced significantly by the word 'cooperation'.

The term 'collaboration' is still used by Kaplan although its use is challenged by Lawson. Lawson's argument, close to that of the play's critics, appears to have been partially incorporated into the text.

If the press correspondence about the play is consulted, it will be apparent that many of the points made by critics have been incorporated into subsequent versions of the drama despite the assertions of Jim Allen and Ken Loach that the play had been exhaustively researched and was completely trustworthy as a historical account. In one interview, Loach said of the play's critics that 'they have attacked peripheral points but they have not shaken the play. The evidence is there.' Eighteen thousand lives is hardly peripheral; if the basic thesis of the play has not been shaken, this may be due to the resistance by the author to the incorporation of similar major corrections.

Subsequent to Max Stafford-Clark's decision to withdraw *Perdition*, Jim Allen wrote in *The Stage* that 'Not one line of my play was changed because of the intervention of Gilbert or any other Zionist academic.' The alterations, he asserted, were governed by artistic motives and the need for increased brevity. Yet vital additions have been made which can be traced directly to the evidence put forward by 'Zionist historians'. Jim Allen has even taken to quoting at least one of them in his text.

A final observation has to be made about the general thesis of the play and the role of the bibliography. The list of historical works at the start of the script is intended to give authority to the text. Yet none of the historical works cited, namely those by Ainsztein, Arendt, Dawidowicz, Gilbert, Hilberg, Laqueur, Morse, Trunk, Wymann can be taken to give any support to the central accusation of the play as stated that 'the act of collaboration did not happen all at once, as the Defence will show. Its roots lay in the pre-war efforts of Zionism to effect an alliance with the Nazis' and that 'the interests of Zionism and the Nazis coincided'. It must be remembered that the case of the Defence is vindicated and the arguments of Lawson etc are discredited. The play, therefore, maintains that Zionism and Nazism were compatible

ideologies with shared objectives. This seems to be what *Perdition* is warning against. No respectable historian would accede to this fiction and none of these authorities can be cited to sustain such a fabrication.

It needs also to be noted that the basic structure has remained intact. It is still a drama based on the revelation of a Jewish conspiracy in which stereotypes of cruel Jews and Jewish power abound. The demarche, full of Christian rhetoric of 'absolution, repentance and penitence' presents the humbling and humiliation of a Jew with little attempt to meet the criticism that there is an anti-Jewish 'sub-text' to the play.

A Rejoinder *by Jim Allen*

All plays are subject to the process of editing. The first draft of any play merely provides the bones and raw materials of the finished product. Scripts are revised and changed before and during rehearsal when the work comes alive and problems hitherto hidden and submerged in the text appear. Only an idiot would choose to ignore this necessary creative process.

Cesarani has capitalised on this: he compiles an inventory of changes made from earlier drafts and from this deduces that revisions were made as a direct result of Zionist criticism and intervention. Every man to his trade. To watch Zionism in retreat is to observe the intellectual and moral bankruptcy of its apologists. The orchestrated efforts of the Zionist lobby, its elementary lack of honesty and its attempt to stifle debate, specially in the Jewish community reveals a trait of falsehood and duplicity in every step.

It is not my intention here to debate the merits of Cesarani's note. The play itself and the accompanying letters and contributions should suffice. Although the form and content of this printed text is no different from the rehearsal script banned from the production at the Royal Court in January 1987, some points have been enlarged upon and additional material added to underpin and strengthen areas of the play which drew fire from Zionist critics. I make no apologies for this. Indeed as the author it is my right to do so.

Examples: the rehearsal script correctly states that the Zionist leadership in Palestine knew what was happening in Hungary, yet for six weeks did not publish one single word of protest. In a pamphlet published this March by the Zionist group Bipac *To stage or not to stage: the case of Perdition*, Martin Gilbert claims that this is a lie. To pre-empt his distortion I added new material.

Cesarani says that the reference to the saving of 18,000 was incorporated as a result of an article by Dr Stephen Roth. How could he know? This was written in prior to Roth's piece and before the play was banned. The insertion was made during discussion in rehearsal between the actor Ian Flintoff, the director Ken Loach and myself.

Cesarani notes deletions of references to Herzl's racism. Time, not the carping of critics persuaded me in this. I was loath to do so. In that earlier draft Herzl was described as a racist (which he was) in a section which covers nearly half a page which reads:

> But the most outrageous expression of Herzl's racism was his insane accusation against all non-Jews. "The people among whom the Jews are living are in general overt or covert anti-Semites."

This blanket condemnation which I see as pure racism was adopted by the Zionists and used to combat the growth of assimilation.

Given that the play was running over and that Zionists would or could distance themselves from Herzl's remarks, I thought it more necessary to establish that Israel today is a racist state. I therefore wrote in new dialogue.

So too is the Law of Return which grants automatic citizenship to every Jew who chooses to settle in Israel, yet denies that same right to Palestinian refugees who were born there.

Martin Gilbert was allowed to repeat ad nauseam that the play contains 60 historical inaccuracies and this assertion was widely quoted in the national press. Yet not one newspaper thought of asking Gilbert to produce his list. But the detractors over-looked one small and important detail. One day the text would be published and the play performed. That day has now arrived. Truth will break through when the people have access to the materials and have a chance to decide for themselves.

Press comment in date order

DT = *Daily Telegraph* G = *Guardian* T = *Times* Ind =*Independent* JC = *Jewish Chronicle* NS = *New Statesman* Obs = *Observer*

10.1 DT Peterborough
Jan *New Musical Express* Dealing with the Devil
14.1 G Theatre ready for outcry . . . Nicholas de Jongh
14.1 G Rewriting the Holocaust David Rose
16.1 Ind Private view Stephen Games
16.1 *Jewish Echo* Protests over anti-Zionist play
16.1 G letters B. Shenker; M Hastings; Diane Samuels
17.1 G Holocaust questions . . . Jim Allen
19.1 G letters Eli Ered; David Seymour
21.1 G letters David Cesarani; Alan Sillitoe; Gill Seidel; Uri Davis
21.1 *City Limits* Damned to Perdition
22.1 G Theatre scraps Zionist play Nicholas de Jongh
22.1 T Holocaust play called off . . .
22.1 DT Play cancelled . . . Jenkins & Stringer
22.1 DT Abuse of History leader
22.1 DT Travesty of the facts Martin Gilbert
22.1 Ind Royal Court cancels . . . Anne Spackman
22.1 Ind The dramatic trial . . . Stephen Games
23.1 G Paths to Perdition leader
23.1 T Why we should rue . . . Irving Wardle
23.1 JC Angry Actor Say . . . Friedman et al
23.1 JC Libel! Stephen Roth
23.1 JC Propaganda in the name of art Philip Kleinman
23.1 *London Evening Standard* The brutal insult Lord Goodman
23.1 *Newsline* 'Act of censorship' angers playwright Kathy Hilton
24.1 T Perdition: killed by its blatant lie Barbara Amiel
24.1 G letters Margaret Owen; Hayim Pinner; Elfi Pallis
25.1 Obs Pendennis The Royal Court is caught napping Peter Hillmore
25.1 S Times Focus a Curtain Call . . . Christine Toomey
25.1 S Tele The Royal Court and Red Propaganda Paul Johnson
27.1 G letters Colin Shindler, collective with Steven Berkoff, Andre Deutsch, Elain Feinstein, Rosemary Friedman, Ronald Hayman, Bernard Kops, Emanuel Litvinoff, Bernice Rubens, Alan Sillitoe, Clive Sinclair, Derek Wax, George Weidenfield, & Arnold Wesker; David Hayman; John Rose
27.1 T letters Clemens Nathan; Andrew Sinclair
28.1 *Newsline* Fight State Censorship! leader
28.1 *Time Out* Court Copout? Andrew Bell
28.1 *Time Out* Trial and Tribulation Steve Grant
29.1 G letters Karl Sabbagh; S Levenberg; Mervyn Jones; Chris Barlas
29.1 Ind Anti-semitic drama . . . Stephen Ward
29.1 *The Stage* Director should quit . . . report

21.3 G letters Jon Amiel collective with Roy Battersby, Stephen Bill, Les Blair, Alan Bleasdale, W Stephen Gilbert, Barry Hines, Roland Joffé, Troy Kennedy Martin, Mike Leigh, John Mackenzie, Tony Merchant, G F Newman, Willie Russell, Roger Smith, Kenneth Trudd, Julie Walters
23.3 G letter Derek Paget
24.3 G letter Jack Gold
27.3 G letter M Cohen
27.3 NS letter C Churchill
March Britain/Israel Public Affairs Committee *To stage or not to stage: the case of Perdition*
27.3 JC Perdition row to continue Philip Kleinman
29.3 Obs letter D Cesarani
 2.4 *Listener* Sinister cabals & drama doc Frederic Raphael
 2.4 *London Review of Books* Diary David Lan
 3.4 JC Jew-baiters of the Left Philip Kleinman
 3.4 *Times Higher Educational Supplement* Israel on Trial David Cesarani
April *Jewish Quarterly* The Perdition Affair David Cesarani
April *Common Ground* No 1/2 1987 Comment Perdition and the dilemma of the Holocaust S J Roth
10.4 JC Perdition move by actors deplored . . . David Winner
11.4 *Newsline* 'A venomous, vicious unremitting onslaught' Ken Loach talks . . . Kathy Hilton
 7.5 *Newsline* Perdition – The Actors' view . . . Kathy Hilton
21.5 *London Review of Books* letter Bryan Cheyette, Michael Nelson

Guardian 14.1.87: 'Rewriting the Holocaust' by David Rose

A NEW play about the Jewish Holocaust which opens in London later this month claims that Jews, and specifically Zionist Jews, collaborated with the Nazis. They did so, the play argues, because they regarded the massacre of their co-religionists as a political necessity, which would strengthen their hand at negotiations after the war to achieve the realisation of the state of Israel.

Perdition, which is being put on at the Royal Court, is the first stage play by Jim Allen, a former miner whose previous television work—Days of Hope, The Lump—has made him no stranger to controversy. It argues that the Jewish Zionist leaders in Hungary "allowed themselves to become Eichmann's Trojan horse, the Zionist knife in the Nazi fist." According to one of the play's leading characters, the Jews of Hungary—of whom more than half a million died in Auschwitz—"were murdered not just by the force of German arms, but by calculated treachery of their own Jewish leaders."

The play, directed by Ken Loach, was first presented to the Royal Court two years ago, and its production has been delayed several times. Max Stafford-Clark, the theatre's artistic director, said yesterday that he realised that many people might find it offensive, and some of the Royal Court's governing council have expressed strong reservations—the present opening date of January 27 is almost a year later than originally planned.

Since the Court first mooted the production, Perdition's text has been read critically by at least three historians of the period. They include Martin Gilbert, Churchill's biographer and the author of Holocaust, which was published last month : "When I read it, it bore no relation to historical fact whatsoever," Gilbert says, "and I left the Royal Court in no doubt of my view that it was a vicious travesty of the facts."

According to Max Stafford-Clark, both playwright and theatre have been determined to correct inacuracies in the light of the various critiques, and remaining areas of controversy now concern interpretation, not fact, while in any case the play "is a work of fiction."

But it now seems certain that the Royal Court is about to be engulfed in the deepest

and most bitter controversy in its history. The Institute of Jewish Affairs, an international academic organisation based in London, is demanding that a statement criticising the play be included with the programme—a demand which has so far been resisted.

The Institute's director, Dr Stephen Roth, was present at the events in Budapest described in the play, was tortured by the Gestapo and sent to Auschwitz as a member of the underground Zionist resistance—an organisation whose very existence Jim Allen, in an interview with the Guardian, denied.

Roth says : " In suggesting that the Zionist movement had to cooperate with the Nazis and in other statements about Jewish religious law [in an earlier draft, Allen compared aspects of biblical Judaism to the 1933 Nuremburg laws], the play is clearly anti-semitic. Perdition is a libel against all those who lived through, fought and mostly perished in the Holocaust."

It is understood that other Jewish organisations are considering mounting a picket of the theatre for the duration of its five week run.

Perdition takes the form of a libel trial, set in England in 1967 in the immediate aftermath of the Six-Day War.

Roth, an academic, is being sued by Yaron, a survivor of the Hungarian Holocaust, after publishing a pamphlet alleging that he collaborated with the Nazis in order to save a Zionist few.

Perdition's fictional trial is loosely derived from a real libel case in Israel in 1955. Malkiel Grunwald, an extreme right-wing supporter of the Irgun terrorist group, had published a statement alleging that Rudolf Kasztner, a leading Hungarian Zionist who had become a close associate of the Israeli Labour government — then in power — and one of its parliamentary candidates, collaborated with Adolf Eichmann, the architect of the Holocaust.

Grunwald claimed that in March 1944, when the Germans, along with Eichmann and his SS sonderkommando, occupied the previously independent Hungarian satellite state, Kasztner failed to warn the Hungarian community of its impending fate, despite detailed knowledge of the massacre of five million European Jews which had

already taken place — thus facilitating the organisation of transports to Auschwitz.

Kasztner, he wrote, had close contacts with Eichmann, and in return the Germans allowed a special train to take nearly 1,700 Zionist and other ' prominents ' out of Hungary to safety in Switzerland.

The Israeli government prosecuted Grunwald for criminal libel, and the case dominated Israeli politics for months — eventually leading to the collapse of the cabinet of Moshe Sharrett. But Grunwald engaged the services of a brilliant lawyer, who was also a supporter of the Irgun and the political alternative represented by Menachem Begin, and after days of cross-examination Kasztner came to pieces in the witness box. The judge found most of Grunwald's allegations to be justified, awarding token damages of one Israeli pound.

Three years later, the verdict was overturned on appeal. But before Kasztner could begin to provide answers to some of the questions which remain the subject of intense historical debate, he was assassinated — by another extreme right-winger, who claimed moreover to be a government agent.

The critics of Perdition do not dispute the validity of the issues posed by the Kasztner case, whose continuing importance was shown last year with the performance in Israel of a dramatisation of the real trial by Moti Lerner.

Their concern centres on the use made of it and other material by Jim Allen. They allege that he has wilfully distorted both fact and interpretation, in order to draw conclusions not only about Kasztner but about the entire Zionist movement and the nature of the Israeli state.

Allen himself makes no bones about the overriding purpose of the play : " Israel is a death-trap, a ghetto state," he says, and the conclusions drawn by Perdition provide the full explanation of the present political situation in the Middle East : " I don't want to sound pompous, but I see the play as a small contribution to rescuing the Jews from Zionism. It's a very pro-Jewish play."

Some who have read the play, including Mike Alfreds, who was asked to direct it before Ken Loach, have attacked its overtly polemical nature, and at the weakness

of the case for the other side presented within it : " I don't think Perdition is really a play," Alfreds said in a letter to Max Stafford-Clark. " The writing only catches fire when it is presenting anti-Zionist charges . . . the result is a lack of dramatic sensibility or honesty. Although the play tries to cover its tracks to avoid the indictment, its effect may well be anti-semitic . . . it enforces too many stereotypes : cowardly Jews, Jews who buy their way out of trouble, Jewish terrorists. . . . "

Allen rebuts the charge of racism by speaking of fights in pubs with racist " building workers " as a labour organiser, but remains unashamed of his avowedly polemical purpose. Ultimately, he says, " the Zionists were Hitler's favourite Jews. Their interests coincided, on the basis of opportunism : Hitler wanted the Jews out of Europe and the Jews wanted a state in Palestine. it was almost a volkist thing, blood and land. Hitler was fond of the Zionists, they were the good Jews, they were prepared to fight for land."

To the play's historical critics, one of its most worrying features is its absolute conflation between the Hungarian Zionists and the Judenrat, the Jewish council established by Eichmann to govern the communities and carry out Nazi orders.

As the play, advancing its argument through speeches by Scott, the defence counsel and various (fictional) witnesses, correctly states, the Judenrat at first urged compliance with Nazi edicts, for example the wearing of the yellow star armband. Allen rightly says that the Judenrat did nothing either to inform Jews of the impending deportations to Auschwitz, nor to organise any form of resistance along the lines displayed a year earlier by the ghettos of Warsaw and elsewhere.

However, a witness in Perdition goes on to describe Rudolf Kasztner, to whom frequent reference is made throughout the piece, as " the leader " of the Judenrate, and throughout it is stated and implied that this body was controlled by Zionists.

In fact, Kasztner was not a member of the Judenrat, and the Zionists — who formed a small minority of Hungarian Jews — had virtually no influence upon it. On the same day that Eichmann ar-

rived in Budapest, representatives of Zionist groups met in secret to discuss a four-point plan for resistance based on a " rescue committee."

They resolved to investigate the possibilities for armed struggle, to manufacture forged documentation to " reclassify " Jews as Aryans. to smuggle Jews across the border into Romania. and — crucially — to send envoys to provincial communities in order to warn them of the danger.

Of this, as Allen says, the Zionists were fully aware, owing to their work over the previous two years of smuggling Jews from Poland and other Holocaust communities into what had been the comparative refuge of Hungary.

Interviewed by the Guardian, Allen said he knew that Kasztner had not been a member of the Judenrat. Pressed on the point, he said : " I will accept the criticism that the roles of the Jewish council and the rescue committee are not clearly enough defined in the play."

The Zionist underground's activities included the organisation not only of Kasztner's train. but the successful smuggling of about 7,000 Jews into Romania, a shipment of 18,000 as labourers to Austria and the preservation of 100,000 souls in Budapest itself through forged documentation — events which are to be found recorded in Asher Cohen's recent book, the Hehalutz Resistance in Hungary.

Allen says that he is unaware of the existence either of the book or the movement, and would like to know the sources for such statements. " In terms of salvation," the lawyer Scott says in his closing speech, " the only chosen people left in Budapest were these few Zionists."

Allen admits to having made heavy use of a book by the Jewish anti-Zionist historian and journalist Lenni Brenner, Zionism in the Age of the Dictators — " a goldmine source." It is, however, striking, that in places he has gone far beyond Brenner's own conclusions, and in at least one case, appears to have embellished events described in the book.

Brenner discusses a Jewish British agent who was parachuted into Hungary in an attempt to organise partisan resistance : and her appearance in the play. Allen confirms, was derived from Brenner. But where the his-

torian writes that she was merely arrested by the Hungarian secret police on crossing the border, and therefore made no contact with Hungarian Jews, the play describes a meeting between her and Kasztner. In this, Kasztner is said to have persuaded her to give herself up, in order not to jeopardise his negotiations with Eichmann for the departure of the precious train of " prominents."

Asked about this, Allen said only that he was unsure of what Brenner had written.

More strikingly, Brenner again is the source for what Allen states to be the play's central message that Zionists positively desired the slaughter of Jews in order to achieve the state of Israel.

[excised]

Finally, Allen blames Zionists for two " might have beens " — a fully-fledged armed uprising, and the bombing of the railway lines to Auschwitz by the Allies. This latter, he says, failed to take place because of Zionist pressure in Allied countries. Brenner, for his part, writes that the reason lay in the reluctance of the RAF.

According to another historian who read the script, the charge of anti-semitism is justified by comments in the play about Jewish religious law. His intervention led to the removal of the equation of biblical law with the Nuremburg decrees, but other false statements — that the children of marriages between Jews and non-Jews are legally bastards in Israel, for example — remain. On

119

Judaism, Allen said that the religion " legitimised " Zionism: " Zionism had to wear the trappings of Judaism, it gave them a warrant."

Michael Hastings, the head of the Royal Court's literary department, was a driving force behind the play within the theatre, yet in letters more than a year ago he was expressing reservations. Asking one historian for an opinion, he said that Allen's main problem was that " he has coloured his dramatisation with the language of international socialism not far short of Trotsky, but for the normal theatre-goer, it may look as though this dialectic point of view is the normal one." There was a strong possibility that Allen had " overestimated the intelligence of his audience, expecting them to define a narrow view between anti-semitism and anti-Zionism."

Yesterday Hastings said that " we had intense reservations," adding that the Court had done its utmost to ensure that the criticisms of historians were incorporated in the text. Asked whether some might find Perdition offensive, he said: " I find the State of Israel deeply offensive."

Matthew Evans, chairman of the Faber publishing house, and chairman of the Court's council, said that the play " may be flawed." But, he went on, while it would upset many people " putting forward the question of artistic freedom is very important in this case. As chairman I'm very much in favour of putting it on."

But while the Court's administrators, with the partial exception of Max Stafford-Clark — " I don't think controversy is something the Court has ever avoided " — emphatically denied that they had deliberately sought to generate controversy, Jim Allen may, it seems, have welcomed it.

In a covering letter accompanying a rebuttal of one of the historian's critique, he told the theatre that the criticism was " pathetic, a reflection of how guilty and incapable the Zionists are in defending his dark chapter in Jewish history. " Allegations of anti-semitism would surely be made, he said : " Unable to contest any of the points raised in the script, this will be their main line of attack, and defense (sic) when the play goes out I can't wait."

Guardian 16.1.87: letters

Sir,— It does not surprise me that the Royal Court refuses to avoid controversy (Arts Guardian, January 14) — that is something for which I have always admired it. I am, however, disturbed at the choice of Perdition as its next presentation at the Theatre Upstairs.

Is it valuable to present work to a largely uninformed English public which equates Zionism with not merely racism, but Nazism ? Is it acceptable to base these assertions on limited historical research and fiction which poses as documented fact ?

Is such an approach likely to enlighten or challenge an audience to a greater understanding of the Holocaust or of the relationship between it and Jewish or Zionist awareness ?

It is not good enough to charge any criticism of anti-Semitism as " pathetic, a reflection of how guilty and incapable the Zionists are in defending this dark chapter in Jewish history." All the issues raised by this play are important and emotive and, if the writer and theatre are not prepared to face their own anti-Semitism, their artistic, human, and political values are put seriously into question.— Yours faithfully,
Diane Samuels,
8 Westchester Court,
London, NW4.

Sir,—I did say to David Rose, " I find the state of Israel deeply offensive," but my sentence continued " in its present role as an extension of the American arms machine." What happened to the rest of my sentence ? I understand that David Rose is a sympathetic and equally anguished commentator on Israel, but please don't take a phrase out of its context.— Yours faithfully,
Michael Hastings,
2 Helix Gardens,
London SW 2.

Guardian 17.1.87: letters

Sir, — David Rose's article on my play Perdition (January 14) summarises the Zionist viewpoint, that the play is anti-semitic, a travesty of the facts, and a libel on the Jewish people. He says the play argues that the Zionists " Regarded the massacre of the Jews as a political necessity which would strengthen their hands at negotiations after the war to achieve the realisation of the state of Israel." Not true. The question is posed on page 84 of the script. Scott, counsel for the defence, is examining Ruth, the defendant :

Scott : Are you saying that the German Zionists preferred Hitler and supported him ?

Ruth : No. They were utilising a threat which to them signalled the bankruptcy of assimilation and paved the way for the creation of a Jewish state.

Hitler wanted the Jews out of Germany, and so too did the Zionists. They wanted them in Palestine. For this reason the Zionists became Hitler's favourite Jews. Stephen Wise, leader of American Zionists referred to this in his Congress Bulletin, January 24, 1936 : " Hitlerism is Satan's nationalism. The determination to rid the German national body of the Jewish element, however, led Hitlerism to discover its ' kinship ' with Zionism, the Jewish nationalism of liberation. Therefore, Zionism became the only other party legalised in the Reich, the Zionist flag the only other flag permitted to fly in Naziland. It was a painful distinction for Zionism to be singled out for favours and privileges by its Satanic counterpart." This is quoted in the play.

Hannah Arendt, Zionist activist in Germany before emigrating to the United States, visiting Professor of the University of Princeton, and considered to be one of America's outstanding thinkers, writes in her book Eichmann In Jerusalem : " It was a fact of life that only the Zionists had any chance of negotiating with the German authorities, for the simple reason that their chief Jewish adversary, the Central Association of German Citizens of Jewish Faith, to which 95 per cent of organised Jews in Germany then belonged, specified in its bylaws that its chief task was the ' fight against anti-semitism ' ; it had suddenly become by definition an organisation ' hostile to the state ' . . . Hence the Zionists could, for a time, at least, engage in a certain amount of non-criminal cooperation with the Nazi authorities."

One can drift into corruption with the best of inten-

tions, and the play argues that co-operation turned into collaboration. It says that throughout the Holocaust, the overriding consideration of the Zionist leadership was the building of a Jewish homeland, and that all else — including the rescue of European Jews — became secondary.

A letter sent by David Ben Gurion to the Zionist Executive on December 7, 1938, is quoted. It was written against a background of rising terror against the German Jews, and demands from other countries that asylum be offered to Jewish refugees : " If the Jews will have to choose between the refugees — saving Jews from concentration camps — and assisting a national museum in Palestine, mercy will have the upper hand, and the whole energy of the people will be channelled into saving Jews from various countries. Zionism will be struck off the agenda." As Christopher Sykes wrote in his book Cross Roads to Israel : " It is hard, perhaps impossible, to find a parallel in history to this particular Zionist idea which was at the heart of the Zionist accomplishment during the ten years after 1938. That such was the basic Zionist idea is not a matter of opinion, but a fact abundantly provable by the evidence."

Rose claims that in the interview Allen denied the existence of an underground Zionist organisation. This is a misquotation. Reference is made in the play to Zionist resistance, as I pointed out to Rose. Rose states in his article that I confuse the Zionists in Hungary with the Judenrat (Jewish Council) and that a witness in Perdition described Kastner as " the leader of the Judenrat." This is simply not true.

At no point in the play is Kastner referred to in these terms. With regard to the " confusion " between Zionists and the Judenrat, the language in the play is precise. At every meeting with Eichmann, Jewish leaders are described as council members. I informed Rose that the lines are distinct, but that I would look at it again. With regard to Hannah Senesh, the Jewish British agent who parachuted into Hungary, Rose writes : " And her appearance in the play, Allen confirms, was derived from Brenner." But Hannah Senesh does not appear in the play !

Neither, as Rose says, does the play describe a meeting between her and Kastner, where Kastner persuades her to give herself up. How could it, when-on page 143 of the script, there is a line which reads : " She was captured and shot by a Hungarian firing squad."

Rose writes . " Allen admits to having made heavy ·use of a book by the Jewish anti-Zionist historian and writer, Lenni Brenner." Apart from the fact that being anti-Zionist does not make him any less an historian, Rose fails to mention my reference to 26 other books I had used in my research.

My space is limited, so allow me to make two more points. " Allen rebuts the charge of racism by speaking of fights in pubs with racist building workers." Is Rose trying to portray me as some kind of Northern yob ? I spoke of the need to combat racism at the sharp end. Council estates, dole queues, building sites and pubs. Out of a long conversation comes his reference to fights in pubs, which he isolates and, I suggest, blows out of proportion.

As we waited for a taxi, Rose asked : " Do you enjoy controversy ? " I told him no, but that whatever I wrote seemed to cause controversy. In his piece, he writes : " Jim Allen may, it seems, have welcomed it." My advice to Guardian readers, is to see the play, and then decide for yourselves.
Jim Allen.
1 Parkside,
Alkrington,
Middleton, Manchester.

Guardian 19.1.87: letters

Sir, — It is accepted political wisdom that the further left you go the closer you get to the right. How sad that Jim Allen author of Perdition at the Royal Court theatre has fallen into the trap of a dramatic " overkill " that is historically perverse and gets all its questionable evidence from a combination of right-wing Zionists and right-wing lawyers and judges who tried in the 1950s to reverse the leftward political trend of Israel.

Jim Allen will have none of it. In his determination to rewrite the history of political Zionism he sees neither the distinction nor the difference between Zionist left and

Zionist right. Those of us who went to Israel in the early years (1948) know and knew the difference only too well.

It is a fact that Zionism began and continued as a political movement of the left, challenging the bourgeois and nationalist jingoism of the Zionist right not only in rhetorical exercises of resolutions and conference agendas, but by actually settling on the land (Palestine) in communal/socialist forms of equality. They were a progressive force. No amount of historical hindsight will alter that.

All (European) progressive thinking supported them, with the exception of Jewish converts (Trotsky et al) to the working class movements of Eastern Europe who insisted that Jews must look to their own (Russian) working-class struggle for a better world. This progressive leftward drive of the Zionist movement continued well into the 1950s. World recognition for Israel in 1948 was literally universal. Stalin and the Soviet Union made certain of its physical survival by sending arms. No one else did.

The historical context of the Kaztner trial is a well-established landmark in Israel's political development. Though the verdict was reversed on appeal. a right-wing judge. Benyamin Halevi, and a right-wing populist lawyer (M. Tamir — 20 years later he became Begin's Minister of Justice) between them mounted an anti-Mapai (Labour) mediafeast and pronounced Kaztner guilty of having " sold his soul to the devil ". The judge, too, went on to join Begin's Herut party in the Knesset. For good measure a couple of ex-Irgun members shot and killed Kaztner.

This right-wing attempt at a populist-inspired endeavour to brand and stigmatise the unelected leadership of Jewish communities in Nazi-occupied Europe had its antecedents in the political struggles of the pre-Israel Zionist movement : the right wing habitually accused the left of. either collaborating with the " soft " enemy (Britain) or with the " hard " enemy (Nazi-Germany, Horthy-Hungary, etc.)

By arguing in court, that Kaztner negotiated with the SS and gave evidence in a de-

Nazification trial in behalf of an SS officer. Tamir successfully persuaded the judge that this proved him guilty and by unspoken inference this conferred an equal guilt status on the (Mapai-controlled) Jewish Agency political Department of wartime Palestine, headed by Moshe Sharrett (Shertok).

It was a piece of total perversion. An impartial, yet authoritarian, Advocate-General had forced Kaztner to sue for libel or resign his government post and had landed Sharrett in a position of acute embarrassment about his own wartime activities. In subsequent years the Eichman trial confirmed the essential outlines of Kaztner's version, but opened up another can of worms connected with Joel Brand (who brought a fantastic-sounding Nazi offer — through the Jewish Agency — to the allies : 10,000 trucks for 100,000 Hungarian Jews).

And so back to Jim Allen. His record as a valiant fighter against racism in not in doubt. We take on full trust his version of standing up to many a bar-room anti-semite. He probably very sincerely thinks that standing up to the Nazis in wartime Europe was a matter of handling an argument with a pub-bully.

The Holocaust is a catastrophe unequalled in modern history. Many writers and dramatists and film-makers have tried to, find artistic context-metaphors and somehow come to terms with it. Lanzman's recently seen " Shoah " is certainly a valid and beautifully sustained triumph. Jim Allen is not in that class.

Granted, Israel has not become the Socialist utopia of its early dreamers. Granted, she has arrived at a development which totally subverts Zionism and is on a par with any other colonialist regime. But for Jim Allen to argue on the basis of his rejection of Israel that things were thus in the inferno of wartime Europe and to rely on Zionist right-wingers (whom supposedly he abominates) to prove it, is not only a falsification of history, it is also second-rate art. — Yours etc.
Eli Ered.
67 Queens Road,
London E11.

Guardian 21.1.87: letters

Sir,—Max Stafford-Clark claims (Arts Guardian, January 14) that the criticisms in my report, commissioned by the Royal Court, of Jim Allen's play Perdition were " taken to heart and had caused some revision." This is hardly the case. The unhistorical and grotesque thesis of the play remains unaltered, supported by quotations taken out of context and facts that are frequently invented.

Examples of Jim Allen's dubious methods can be found in his riposte (Letters, January 17) to the article by David Rose. I will cite just a few examples of Allen's dishonest technique.

He denies that the play argues that the Zionist " regarded the massacre of the Jews as a political necessity which would strengthen their hands at negotiations after the war to achieve the realisation of the state of Israel."

Had he looked at page 79 of his own opus, he would have found the chief protagonist saying of the Zionists that " their goal was the creation of the Jewish homeland, and to achieve this they were prepared if necessary to sacrifice the Jews of the diaspora ..." And on page 142 he " quotes " an ultra-orthodox anti-Zionist Jew attributing to the Zionists the belief that " the shedding of Jewish blood in the diaspora is necessary in order for us to demand the establishment of a Jewish state before the peace commission."

The play, Allen says, maintains that for the Zionists the founding of a Jewish state overrode the rescue of Jews from Europe. To support this allegation, he cites a letter from David Ben Gurion.

The letter also has an important role in the play, pages 71-72, and is a useful test case of Allen's ability to understand historical documents : " If the Jews will have to choose between the refugees—saving Jews from concentration camps—and assisting a national museum in Palestine, mercy will have the upper hand, and the whole energy of the people will be channelled into saving Jews from various countries and Zionism will be

struck off the agenda."

This passage, in fact, relates to the effect of British restrictions on Jewish immigration into Palestine, and the British threat to destroy hopes of an independent Jewish homeland there. Ben Gurion is saying that if Jews have to choose between sending aid to the doomed " national museum," that the British were administering, and giving assistance to Jews seeking refuge in other countries, of course Palestine would lose out.

I could continue to give examples of Allen's erroneous use of evidence ; the advice of the academics seems to have been ignored. My own report, in Allen's possession for more than a year, highlighted numerous misstatements which have remained unchanged.

Allen has ignored all warnings that the play contains statements that were offensive to Jews. Israel, he writes, was " coined in the blood and tears of Hungarian Jewry " (page 149). Jewish leaders accused of conniving with the Nazis in the murder of their own people are described as " the Zionist knife in the Nazi fist " (page 156).

Michael Hastings says that the Royal Court " has done its utmost to ensure that the criticisms of historians were incorporated in the text." It is hard to reconcile this comment with the cavalier treatment of history in the play and the consequent distress which it is causing.—Yours sincerely,
(Dr) **David Cesarani.**
Queen mary College,
London E 1.

Sir, — May I add my voice in support of the decision by the Royal Court Theatre to stage Jim Allen's play Perdition as part of its 1987 repertoire.

Judging by David Rose's exposition of the case, Jim Allen's interpretation of Zionist-Nazi collaboration is basically correct. As an anti-zionist Israeli-Jewish academic, I very much welcome the Royal Court decision and the public debate/controversy that it is likely to generate.

Public discussion of this aspect of Zionist history has been evaded or suppressed in many significant quarters. It is important that an open discussion of the subject take place.

I and many others hope that this discussion will contribute to a critical reassess-

ment of the role of the Zionist movement, the World Zionist Organisation, and the state of Israel in the determination of Jewish history at the time of and after the Holocaust as well as today.
—Sincerely,
(Dr) **Uri Davis.**
1A Highbury Grove Court,
London N 5.

Daily Telegraph 22.1.87 leader

Abuse of history

THE news that the Royal Court Theatre will not now be staging "Perdition", Jim Allen's play about the alleged collaboration of Zionists in the extermination of Hungarian Jewry, will bring a sigh of relief to the lips of the vast majority of theatre-goers and others. Not that censorship in the form once administered by the office of the Lord Chamberlain could or should be revived to deal with plays which outrage good taste. But the combination of scholarly objections, the danger of a loss of subsidies (private and public) and—who knows?—perhaps a twinge of conscience at the prospect of distress and disquiet inflicted upon hundreds of thousands of British Jews, not to mention gentiles, evidently sufficed to persuade the Royal Court to cancel the play.

The issue here is not artistic freedom, but the right to travesty the past and to slander a nation. The obvious fact that the Holocaust encouraged Jewish emigration from Europe to, among other places, Palestine appears to have been turned on its head in an attempt, based upon very dubious interpretations of documents and on anti-Zionist publicists, to show that Zionism was no less guilty of promoting genocide for its own purposes than National Socialism.

The letter we published yesterday from Mr Robin Chapman, author of "Blunt", a play that belongs to the same shoddy genre—"faction"—as "Perdition", drew a distinction between historical and dramatic truth. We are inclined to consider truth indivisible and unyielding. The intelligentsia has a special duty to the truth, and to exempt the theatre would be to insult the dramatic art. Historians and dramatists approach the truth by different routes, but it is the same truth which they seek. The true story of the Holocaust is far more tragic than any tawdry conspiracy theory dressed up as art.

Daily Telegraph 22.1.87:
'Travesty of the facts'
by Martin Gilbert

AT THE HEART of "Perdition", the play by Jim Allen called off at the Royal Court's Theatre Upstairs just 48 hours before its first Press preview, was the accusation that wartime Zionist and Jewish leaders in Hungary actively collaborated with the Nazis not to save the mass of Hungarian Jews (more than 500,000) but to destroy them.

The audience were to have been told that this was ordered by the Zionist leaders in Jerusalem in order to win international support for a post-war Jewish state as a result of the shedding of Jewish blood. To this end, it is further stated that the Zionist leadership deliberately inhibited all serious rescue activities.

Jim Allen, a former miner, whose first stage play this is, agrees with this summary. Yesterday he described his play as the "most lethal attack on Zionism ever written, because it touches at the heart of the most abiding myth of modern history, the Holocaust; because it says quite plainly that privileged Jewish leaders collaborated in the extermination of their own kind in order to help bring about a Zionist state . . ."

Typical of the statements made in the play, but never seriously challenged by any of the characters, is the accusation that for six weeks following the start of the deportation of Jews from Hungary on May 15, 1944, "the entire Jewish leadership" in Jerusalem — specifically named being Dr Chaim Weizmann, David Ben Gurion and Dr Yitzhak Gruenbaum — "knew what was happening" but "did not publish or even utter one single word of protest."

In fact the Jewish Agency in Jerusalem, headed by Ben Gurion, warned the Allies on April 6, 1944, five weeks before the actual deportations began,

123

of Germany's plans to kill Hungarian Jews.

Ten days before the deportations started, a Zionist official in Istanbul telegrammed his superiors in Jerusalem that deportations were imminent. Within hours of this telegram reaching Jerusalem the head of the rescue committee of the Jewish Agency, that same Dr Gruenbaum who is specifically named in the play as doing nothing for the next six weeks, telegraphed directly to the British Government in London to urge that "all steps" be taken by the Allies to prevent these deportations.

When I was asked to read this play last May, by the Manchester Library Theatre, who were then contemplating co-production with the Royal Court, I found more than 60 historical errors, each one of which was used, as was the error above, to build what seemed to me to be a vicious case and a false one against the wartime Jewish leadership, both Zionist and non-Zionist, inside Europe and outside.

On Monday night, following a four-hour meeting, the Council of the Royal Court laid down several conditions for the play being performed. First, they wanted to see the script, which despite the controversy about it, which had begun more than eight months ago, they had still not been shown. Nor had the Council been informed of the withdrawal of the Manchester Library Theatre from co-production last May. Yet the Manchester director concerned (he has since died) had withdrawn because he felt the play presented such a serious distortion of the Jewish response to the Holocaust that it would not only be offensive to any Jew or non-Jew who knew something of the subject, but that it grotesquely misinforms those not well versed in the history.

A second condition laid down on Monday night was that the Council of the Royal Court wanted to see the analysis of the play which the artistic director, Max Stafford Clark, had apparently called for and received three to four months ago from the historian Dr David Cesarani. The Council had not even been informed of the existence of this analysis, according to which the basic themes presented by different characters in the play were a travesty of historical fact.

The above conditions proved unacceptable, and late on Monday night the play was abandoned. This decision follows a week of intense activity by those few outsiders who had read the play, and who had been perturbed by many of the accusations in it which no character in the play was allowed to answer.

In an attempt to defuse the criticism late last week, it was made known by one of the most senior members of the Council of the Royal Court that the historical aspects of the play had been approved by two historians, myself, and Norman Stone, Professor of Modern History at Oxford University. Inquiries by members of the Council quickly ascertained, however, that Professor Stone had never read the play, and that I myself had not only submitted my criticisms to the Manchester Library Theatre in May but had also spent last Saturday morning with the artistic director of the Royal Court, pointing out some 30 of the 60 historical inaccuracies which seem to me to need answer on the stage itself, particularly as the play was in the form of a trial.

At least it now seems that what would have been a kangaroo court is not to go ahead.

Paths to Perdition

Jim Allen attempted not so much the undesirable as the impossible. Not without a much wider licence than the merely dramatic can errors, or worse, committed by the Jewish state be conflated with the agony of the Jews in the Holocaust before that state was founded. To go back in time and attribute to Hungarian Jews under Horthy's or Hitler's administration, and to influential Jews then living in safety, motives of the baseness set out in the play Perdition, is a form of post hoc, propter hoc argument which would carry no weight in any other medium. In a theatre it is bound to leave the lingering surmise that, though it may have been terrible for those who suffered, the Holocaust was basically a put-up job and therefore less of a turning-point in Jewish and world history.

In another medium there would be opportunity for rebuttal. In a stage play the only rebuttal comes from the author himself. He can make it as strong or as weak as he chooses. By all accounts the rebuttal of Allen's thesis — that Zionists abetted the horrors of Auschwitz in order to create the state of Israel — is the least part of the dramatic action. Such a tumultuous question cannot automatically and without question be deemed safe in the hands of any playwright who admits little room for doubt, certainly not one who admits he is parti pris.

It is unwise to go on from there and allege anti-semitism. Was Shakespeare, often invoked in these arguments, anti-semitic because Shylock was a Jew? If so, then "hath a Jew not eyes? Hath not a Jew hands . . . senses, affections, passions? . . . If you prick us do we not bleed?" to allege anti-semitism is to attribute motives, the very thing Allen himself has done. It is possible to be strongly critical of extreme Zionism without any anti-semitism whatever, just as it is possible to criticise apartheid without being anti-white. The two emotions are on different planes.

But that consideration did not help the Royal Court's artistic director in deciding to call off the play. He did so because it would "cause distress to sections of the community," a criterion which, though valuable, invites further exploration because it is not always employed in that quarter Since we don't have stage censorship the play itself is not banned and there is nothing to stop the cast from performing it elsewhere. It will have the added soubriquet for whoever puts it on that it's the play the Royal Court thought bad form. Treated as a work of fiction it is doubtless extremely provocative. Treated as history it has all the detachment and objectivity of, say Richard III. What is wrong is that the sensitivities of race are so near the surface of the national life; and that the Royal Court took a long time to realise that, regrettably, that still applies to many Jews, in their hearts and in their perceptions of history, as it does to other minorities. The Royal Court would not entertain a play which put the blame for the slave trade on the Yoruba chiefs of West Africa, however much alleged historical justification an author might say he had found. Sorry, but it categorises people, it pierces too sharp, and, which is what drama should not do, it peddles certitudes.

Evening Standard 23.1.87:
'This brutal insult has
no place in Art'
Lord Goodman

IT was reported in yesterday's London Evening Standard that the author, the cast and others connected with the abandoned production of the play Perdition are seeking an alternative stage on which to present it.

I am persuaded of the sincerity of the belief by the author, Jim Allen, that the play has been unjustly censored and that according to his conviction it constitutes a violation of artistic liberty and on that account there is a high duty to secure presentation.

May I respectfully suggest to readers of the Standard that not only is this great nonsense but, without impugning the honesty of this viewpoint, its achievement would be seen as shameful.

I have no doubt that Mr Jim Allen is convinced of the historical accuracy of his play. In many ways it would be easier to regard him as a villain prepared to exploit vicious untruths for gain or notoriety or, even worse, to promote some political campaign.

But no such accusations can be levelled against him or indeed against any troop of innocents virtuously parading a blind determination to ignore unpalatable facts.

It should suffice for a doubter to read an article published yesterday in The Daily Telegraph by Martin Gilbert, the distinguished author of the massive and definitive life of Winston Churchill, to realise that the play is a total distortion of the truth and a brutal insult to the Jewish community the world

over. It suffices to quote an observation by Mr Jim Allen that his play "touches the heart of the most abiding myth of modern history—the Holocaust."

Only the blind in mind and sight could not question that horrifying observation. I hope that Mr Jim Allen—reported to me as a talented writer—who has several TV plays to his credit will, as wisdom and knowledge dawn, realise the enormity of this assertion.

Memorial

Some six million Jews died in the Holocaust and if Mr Jim Allen will travel to Israel he will find an awesome memorial—where the names are inscribed on the walls and a candle lit daily to preserve the tragic memory.

It may be asked, and I have been asked, "Why all this fuss? It is only a play." The query demonstrates a sad ignorance of the crucial importance of the theatre in social education.

This very day the London theatrical scene boasts, by way of example, Ghosts, King Lear, Breaking the Code and an interesting and wide and exciting miscellany of all kinds of drama which plays an important part in maintaining a civilised world.

But Jews have a more formidable answer to the question and it is the reason why such powerful expressions of disgust and indignation have emanated from Jewish voices.

The Jews have suffered over the centuries from the dissemination of historic lies which have, alas, never been caught up or dispelled by the truth.

Hatred

Once such lies are released Jewish history proves that they have not been recaptured.

I could multiply instances to demonstrate that literature of classic anti-semitism has permitted credulity to feed and foster hatred through the centuries.

Weird libels such as the notorious Protocols of the Learned Elders of Zion appeared in Russia in 1903. It purported to be a record of a meeting held in Basle in 1897 at the time of the first Zionist Congress.

At this meeting, it was alleged, plans were worked out for Jews, in partnership with Freemasons, to disrupt all Christendom and take over the world. It took some years for it to be established that this evil nonsense derived from a piece of fantastic fiction.

However, to this day, fascist groups seek support for their campaign of vilification of the Jews by reference to this legend.

An equally tragic instance of the impossibility of scotching anti-semitic falsehoods is the infamous Dreyfus case. Dreyfus, a Jewish officer in the French Army, was tried in 1894 on a charge of treason, on fabricated evidence, and spent years on Devil's Island before a grudging vindication secured his release. But to this day Jew-haters in France continue to traduce the Jewish community.

Anyone interested in the wicked story of the assiduous spreading of lies about Jews can refer to the long entry in the Encyclopedia Britannica. It will make clear to the most sceptical that Jews have good reason to stop at an early stage any distortion of the truth about their community. Mr Jim Allen's description of the Holocaust can claim a high place in the table of classic anti-semitism.

It is satisfactory to relate that the dropping of this play was not an act of official state censorship.

On Monday of last week I was asked on behalf of the Arts Council to advise what, if any, action should be taken by that body. I advised them, in accordance with the cardinal and hallowed principle of non-intervention, that they should do nothing.

Claim

The Arts Council allots money to selected institutions rightly or wrongly regarded as having an artistic claim. The spending of the money is a matter to be determined by those institutions through their local boards or artistic directors—without any interference from above.

No threat was made to the theatre, no suggestion of a withdrawal of the subsidy. The decision was by no means brought about by the protests of Jewish members of the theatre's boards

I understand that the powerful objection to the play

came from Gentile and Jew alike. I find this very satisfactory.

Lord Goodman is a former chairman of the Arts Council, chairman of the Theatre Trust and other theatrical bodies, president of the Institute of Jewish Affairs and chairman of the trustees of the Jewish Chronicle.

Guardian 24.1.87 letters

Sir, — The critics of Jim Allen's play, Perdition, have been right to emphasise that the — probably few — Zionist Jewish leaders who collaborated with the Nazis in wartime did so in conditions of almost unimaginable horror and powerlessness, but wrong to demand that one must therefore drop the issue.

Given the Holocaust's ongoing consequences, from the Middle East conflict to the traumatisation of the remaining Jews, an informed rather than idealised picture of it matters greatly. This might make us understand, for instance, why Israeli political reality reflects not so much the egalitarian dreams of its pre-first-world-war ideological founders, as an inverted pattern of minority group manipulation, harassment, and persecution.

What is done to Palestinians by Israel today, from the handing-over of their land to Jewish settlers to the shooting of their civilians, ties in directly with past European events.

Jews living outside Israel may like to compensate themselves for past communal suffering by perceiving Israel's founders, soldiers, and politicians as incapable of evil and any criticism of it as anti-Semitic, as some of your correspondents have done; but this is ultimately self-defeating.

It endangers their moral standing as well as furthering a process of moral corruption inside Israel which has led Israel's foremost playwright, Yehosua Sobol — whose play, Ghetto, deals with wartime collaboration — to warn that " when the Nazis sank their weapons and their poisons into the

Jews' bodies, they also carried their spiritual sickness into the Jewish soul. . . .
'' History will judge whether we withstood the'

126

contamination or were spiritually defeated by looking at how we treat those left to our tender mercies. We now rule over a conquered people. If we indeed won a spiritual and moral victory over the Nazis, we should be behaving in ways showing that we have accepted none of their values and have learned nothing from them.

" We should insist that we are not a superior people and not treat the vanquished as inferior. We should not assume that they have inherently lesser rights than we have, rob them of their land or property, destroy their livelihood, or violate their human rights.

" Unfortunately," Sobol concludes, " current Israeli reality makes such ideas sound either naive or satirical, for our actions as a nation say no such thing." — Yours sincerely,
Elfi Pallis.
Israeli Mirror,
London SW5.

Sir,—As a playwright, I am well used to seeing my work trashed in the press and on television, I have yet to suffer, however, the experience of a piece of work being put on public trial, convicted, and shot at dawn before it has even been produced.

The scrapping of " Perdition " (Guardian, January 22) is scandalous. Plays are judged in the first instance in the theatre, not in deliberately inflammatory articles designed to pre-empt the theatrical process. That process has a long and honourable tradition ; certainly longer and more honourable than anything peddled in Fleet Street.

The Guardian's role in the continuing erosion of artistic freedom in Britain is shameful.—Yours sincerely,
Doug Lucie.
Oxford.

Sir, — Much of the recent comment on Jim Allen's play Perdition, which was to have been produced at the Royal Court, has been based on conjecture preconception, or an early draft of the play. What follows is entirely personal comment, but based on an intimate and detailed knowledge of the script, derived from my playing the part of the prosecuting counsel, Lawson, in the play very roughly, the " pro-Zionist " voice

It should first be emphasised that a massive amount

of research and preparation was carried out by Jim Allen as his play evolved ; it was not carelessly chucked together to illustrate the thesis of a made-up mind. The intensity of this preparation was shared by the director, Ken Loach, and involved all members of the acting company In my many years of theatre experience, the earnestness with which this production was undertaken is unsurpassed.

In the role I play, I can vouch that Perdition is not the simple slanging assault that your correspondence — and David Rose's article — suggest. I would not have chosen to perform in a work which was simply an untruthful insult to the Jewish people, many of whom — and the cliche here is personally luminous -- have been friends and acquaintances throughout my life ; including, many years ago, the play's critic, Martin Gilbert.

The play has focussed my attention on the horrors of the Holocaust in a more vivid and concentrated way than I have ever experienced before. It has rekindled in me — if it was ever dead — the sense of deep anger and grief for the atrocities faced by the Jews, and which must never, never be forgotten.

It has also — and this really is my own reaction — convinced me more than ever of the right of the Jewish people to their homeland. In that sense, Perdition has endorsed my Zionism , though I should add that this has not resolved some questions about justice in the Middle East and the Israeli role.

But most of all — and I am persuaded that this was a part of Jim Allen's intention — the play has demonstrated to me with painful clarity the need for people to stand together against oppression, to refuse to create scapegoats. whether in Germany, Hungary, or the United Kingdom — Yours sincerely,
Ian Flintoff.
22 Chaldon Road,
London SW6.

Sir, — With what relief I learned that Perdition has been cancelled.

I attended Kastner's libel case in Jerusalem in 1956 (on which the play purports to be based) ; I sat next to him at lunches during the trial ; I remember every detail of allegations and defences.

Kastner was pathetic, ineffectual, stupid : but in his

dealings with the Nazis he neither represented all Zionists, nor " collaborated " to help the " final solution." Mistakenly, maybe, he saw opportunities to save the community's " leaders " and their families, and took them.

If the Royal Court wants to fill its gap, its standpoint on racism and anti-semitism could well be illustrated by showing Lanzmann's Shoah. This masterpiece, depicting the most terrible crime in history, unfortunately can only be seen in East Finchley.

Royal Court patrons, deprived of Perdition, will clearly understand why the play was withdrawn when this totally compelling documentary is before them instead.
Margaret Owen.
25 Stanley Crescent,
London W11.

Guardian 27.1.87 letters

Sir,—We oppose censorship, but we are impelled to participate in the debate about Jim Allen's play, "Perdition," especially after a number of Holocaust experts have declared that it is riddled with errors and distortions.

Advisers have written countless pages separating fact from fiction in the search for objective truth. Such objections have been ignored by the author, Jim Allen, in a wilful effort to try "Zionism" in a courtroom drama.

The charges made by Scott, Jim Allen's prosecuting mouthpiece, are identical to those which have been appearing in the Soviet press all the way back to the antisemitic Slansky trial of mainly Jewish communists in Czechoslovakia in 1952. Virtually every canard in the play—from Zionist collaboration in the mass murder of European Jewry to hints about the menace of international Jewish finance—have been echoed time and time again in the Soviet press.

Jim Allen has sanitised and polished ancient Jewish stereotypes, even de-Stalinising them to make them more acceptable to a left-wing audience. The socialism of Israel's founding fathers, born out of the Russian social revolutionary tradition, have been edited out and the Marxist-Zionist leadership of

127

the Warsaw ghetto uprising played down.

Effectively, Perdition is an instance of literary McCarthyism where international "Zionism" is even made responsible for the murder of its own Jewish people.

In Pravda and Izvestia, "Zionists" were deemed responsible for the extermination of Jews at Babi Yar; the invasion of Dubcek's Czechoslovakia; the assassination of President Kennedy, even Chairman Mao was turned into a "Zionist."

This would be absurdly humorous, but in a country which has seen millions butchered at the hands of the Nazis, coupled with an antisemitic heritage, such accusations have exacerbated antisemitic tendencies. This is the road which Jim Allen had chosen to tread in this country.

The play ends with an injection of medieval clerical imagery. Yaron the character embodying Zionism, is "crucified" by Scott, the prosecutor. Yaron's shallow defence of Zionism and judicial self-flagellation are in reality a vehicle for his anti-Zionist views.

Yaron: When I sat there in that witness box, it was real. I was on trial. There was no pretence. I suffered.

Ruth: Now the slate is wiped clean.

Yaron: That box became my confessional. I was naked.

Ruth: The worst is yet to come.

Yaron: That Mr Scott, I like him. Merciless! I felt that he was ramming spears into my body.

So Zionists in Mr Allen's world are not simply Nazis, they are also Jews who have lost their way. The road to salvation lies in apostasy.

Perdition is a poisonous and reactionary work. It is an inversion of history. All publicity will undoubtedly serve the play's purpose, but the lessons of Jewish history teach us that to remain silent is far worse.—Yours sincerely,

Colin Shindler, Steven Berkoff, Andre Deutsch, Elaine Feinstein, Rosemary Friedman, Ronald Hayman, Bernard Kops, Emanuel Litvinoff, Bernice Rubens, Alan Sillitoe, Clive Sinclair, Derek Wax, George Weidenfeld, Arnold Wesker.
c/o The Jewish Quarterly, London N3.

Sir, — As someone involved at early script-reading stage with Jim Allen's Perdition, I find it deplorable that the Royal Court Theatre has been forced to cancel the production.

I think it is indicative of our collective guilt about the Holocaust that this piece of drama, which was to have been staged in a tiny 90 seat theatre upstairs at the Royal Court, should unleash such universal damnation without ever having played to an audience.

I am pro-Jew, pro-Israeli, having spent several years of my life in that country where open and heated discussion about this dark period in our recent history is commonplace, and is seen as important therapy in exorcising the evil of that time.

Jim Allen's play may be inaccurate; it may, as some have suggested, be a rewriting of history (even Shakespeare can be accused of that) ;it is certainly not and was never meant to be either anti-semitic or a definitive statement on the subject ; merely the opening statements in what should be a necessary and vital debate that we as a society seem determined never to have.

To open debate is one of the prime functions of theatre , if it doesn't we don't deserve to survive. But a society that doesn't allow theatre its voice, certainly doesn't deserve theatre.— Yours sincerely,
David Hayman.
4 Windmill Street, London W 1

Sir,—Hayim Pinner of the Board of Deputies of British Jews writes (Letters, January 24) that "the libel of Zionist-Nazi collaboration . . . originated in the Soviet Union and was later exported to Britain via the extreme Left and in particular the Trotskyist Socialist Workers Party."

I'm sure that he has seen the Socialist Workers Party pamphlet, Israel : the Hijack State, published last year (which contains not a single Soviet source, a bizarre way indeed to smear a Trotskyist organisation).

It's a pity he has ignored some of the questions the pamphlet raises about Zionist attitudes to the Nazis ; and they are in even more urgent need of answers after the banning of Jim Allen's play. Here are just three :

In 1912 Weizmann, president of the World Zionist Organisation, told a Jewish audience in Berlin : " Each country can only absorb a limited number of Jews. Germany has already too many Jews." Did Weizmann's speech help or hinder the fight against anti-semitism in Germany ?

In December 1938, Ben Gurion told a meeting of Labour Zionists in London why he opposed a British plan to admit thousands of German Jewish children into Britain : " If I knew that it would be possible to save all the children in Germany by bringing them over to England, and only half of them to Eretz Yisrael (ie, Palestine) then I would opt for the second alternative. For we must weigh not only the life of these children but also the history of the people of Israel." Did Ben Gurion's speech help or hinder the prospect of saving German Jewish children from the Nazis ?

In 1933, the Zionist Federation of Germany sent Hitler a memorandum, including the paragraph : " May we . . . be permitted to present . . . a solution in keeping with the principles of the new German state of national awakening and . . . might signify for Jews a new ordering of the conditions of their existence. . . . Zionism has no illusions about the difficulty of the Jewish condition, which consists above all in an abnormal occupational pattern and in the fault of an intellectual and moral posture not rooted in one's own tradition." Did this memorandum help or hinder the struggle against the Nazis ?

I and other Jewish members of the SWP have asked these and similar questions at anti-Zionist meetings over the past few months. We never get answers from the Zionists ; we are just accused of being anti-semitic.

John Rose.
Socialist Workers Party, PO Box 82, London E 2.

Guardian 29.1.87 letters

Sir,—I wonder whether some of your readers, who are neither Zionist nor anti-Zionist are puzzled by the row over the Royal Court's attempt to present Jim Allen's play, Perdition. After all, surely no writer of the calibre of Jim Allen would make up the incidents in the play, and yet the opponents seem to believe he has done so.

Unfortunately, the correctness of the facts is often only one of the relevant factors whenever Israel or Zionism is criticised. Many Jews object to any public criticism of Jewish actions, however legitimate, because it might fuel or give rise to anti-semitism. Some Jews genuinely believe that critics like Allen, and other writers who attack Zionism, are anti-semites. Other Jews know very well that there are many legitimate criticisms to be made of Jewish actions now and in the past, but that for non-Jews to make them is somehow too dangerous.

In fact, the Kastner case was the subject of a book called Perfidy, published in 1961, by Ben Hecht, an American Zionist Jew who did much to rally American opinion against the British in Palestine. Hecht was previously known for his Letter to the (Jewish) Terrorists of Palestine (" Every time . . . you let go with your guns at . . . the British invaders of your homeland . . . the Jews of America make a little holiday in their hearts").

In Perfidy he covered the same 1954 libel case dealt with by Allen in Perdition. For Hecht, too, the Kastner deals with the Nazis were a shameful incident from Jewish history, which the Israeli government at the time of the trial wished to cover up.

In spite of his Zionism he was led to ask : " What happened to the fine heritage (of the Jews) when they finally fashioned a government of their own in Israel ; what happened to a piety, a sense of honour and a brotherly love that 2,500 years of anti-semitism were unable to disturb in the Jewish soul ? My answers are in this book."

The current campaign against the Royal Court shows the characteristics of other recent organised protests against criticism of Israel and Zionism : whatever the content of the criticism, the key accusation is one of anti-semitism ; the major criticism of content comes down to the fact that the writer has not accepted the interpretation that is most favourable to Jews ; and it is often implied that such criticisms only emanate from non-Jews, thus reinforcing the accusations of anti-semitism.

As we've seen, in the Perdition case as in many other similar controversies, there is often internal Jewish or Israeli condemnation which does not get publicised.

We have to remember that the first casualty of war is truth, and Israel and Jews feel themselves to be permanently at war : Israel with the Arabs, and Jews with those who might persecute them, which includes almost everyone, in their eyes. We are reminded this week in the Thames Television programme about the deliberate Israeli attack on the USS Liberty in 1967, which killed 34 " friendly " sailors, that the defence of Israel in the widest sense is more important than truth.

Only when Zionists are prepared to discuss history and policy on the realistic basis that everyone, Jews included, is occasionally fallible, will we get nearer to a sensible and useful discussion of a solution to the antagonisms that exist between Israel and the rest of the world.—Yours sincerely,
Karl Sabbagh,
76 Sheen Park,
Richmond, Surrey.

Sir, — Leon Trotsky was a famous revolutionary with many faults, but no one could accuse him in spreading anti-semitic propaganda ; while an assimilated Jew, he never denied his origin.

It is an irony of history that his followers in the Socialist Workers Party accuse the millions of Zionists who were the victims of Hitler's Final Solution of cooperating with the Nazis ; they are not ashamed in falsifying history and expect the public to read their indecent pamphlet denying Israel's legitimacy.

As to John Rose's concrete question (Letters, January 27) : David Ben Gurion, whom I knew personally, never addressed a Labour Zionist meeting in London during October 1938. He never opposed a " British plan to admit thousands of German Jewish children into Britain " ; he urged the Chamberlain government to allow 10,000 Jewish children from Hitler's Reich to be saved in the Jewish National Home ; this plea had strong backing in Parliament.

The official Jewish Agency's view was defined by the London's Zionist Review of January 19, 1939, as follows : " Zionists are anxious to find any place under the sun which will afford Jewish refugees the prospect of escape."

It is falsification of history to claim that Dr Weizmann — one of the greatest Jewish figures of the 20th-century — or the German Zionist Federation hindered the struggle against the Nazis.

John Rose, who describes himself as a Jew should be ashamed of himself. He should not rely on the truthfulness of pamphlets issued by the Socialist Workers Party. — Yours, etc.,
S. Levenberg,
741 High Road,
London N12.

Sir, — Could you find space for a letter from someone who hasn't read Perdition and doesn't wish to argue for or against it ?

What is wrong, to start at the beginning, is the use of the theatre for productions which present a thesis, and which are to be judged by their factual accuracy or inaccuracy, not by their value as drama.

If Jim Allen has something to say about Zionism, he is free to write a book. In reading it, we can pause for reflection or turn back to compare one passage with another ; we can't do that in the theatre.

In reading, we can't be influenced — as in the theatre — by an actor's talent (or lack of it) which makes the case he presents stronger (or weaker) than it might have been.

No, let's keep our theatres for plays which don't seek the suspect label of " controversial," but which do aspire to be works of art.
Mervyn Jones,
10 Waterside Place,
London, NW 1.

Sir, — I dare say that many of those people who have recently aired their views so forcefully about Perdition would, in other circumstances, vilify those who choose to condemn without reading the text in question. To call for the banning of any work of art without having proper knowledge in a

nasty, not to say, danger-
ously intolerant habit.

I myself was contacted by
Jim Allen's agent shortly be-
fore the withdrawal of the
production at the Royal
Court. I was warned that the
cancellation was about to be
announced and was asked
for support.

As a result of having read
the correspondence in what
is normally a tolerant news-
paper, I told the agent that I
would do what I could, al
though I suspected I would
not like the play. Later, on
considering what I had said,
I realised that I myself had
fallen into the trap of making
judgments on the basis of
speculation and hearsay.

Therefore it is, I am con-
vinced, now vital that Perdi-
tion be staged so that as
many of us who want to, can
make up our minds. It is
obviously vital to the author
who has been condemned
without proper trial, just as
it is vital to the Royal Court.

But above all it is vital to
our public standards of
debate.

Jim Allen has written a
play that deals with a contro-
versial and emotive subject.
That those who oppose what
Allen appears to be saying,
however, wrongheaded it
may turn out to be, should
be able to deny any public
scrutiny of the argument is
to be deeply deplored.
Chris Barlas.
39 Parkholme Road,
London E8.

Guardian 4.2.87 letters

Sir.— The reason given by
the artistic director of the
Royal Court Theatre for
ditching Jim Allen's play
Perdition was, you report,
that he thought it would
" cause distress to sections of
the community." This crite-
rion, your Leader of January
23 says, is " valuable " but
" invites further
exploration."

Nothing that your leader
writer says by way of " fur-
ther exploration " is at all
helpful. Quite the contrary.

" The Royal Court Theatre
would not entertain a play
which put the blame for the
slave trade on the Yoruba
chiefs of West Africa, how-
ever much alleged historical
justification an author might
say he found." Quite right !
But pointing out that some
Yoruba chiefs betrayed their
followers by collaborating
with slave-traders is a long

way from claiming either
that all Yoruba chiefs did so,
or that the treacherous
chiefs were the people really
responsible for slavery.

As Jim Allen neither
claims that all Jewish lead-
ers collaborated — he is look-
ing at the role of Zionist
leaders — nor that it was the
Zionists who were to blame
for the Holocaust, your anal-
ogy is misleading.

Your leader's endorsement
of the " distress " criterion is
extremely dangerous. Far
from this question of " dis-
tress " being a " valuable cri-
terion," it is a licence for
ignorance and prejudice.

Don't you think that plays
about the Holocaust and
about Nazism should be per-
formed in Germany where
unfortunately they may still
" cause distress ?" Don't
antireligious plays " cause
distress " to many ?

I hope the Home Secretary
doesn't decide to use this
" valuable criterion " to ban
pro-republican plays here
lest they " cause distress " to
loyalists or the families of
servicemen.

Whether Mr Allen is right
in every detail, I don't know;
I haven't seen the script and
I can't see the play. But as a
Jew and an anti-Zionist I am
pleased that he has had the
courage to write a play
which throws light on Zion-
ism's true role in the years
of Hitler's domination.

Those of us, Jewish and
non-Jewish socialists alike,
who wish to question that
role do not — as is implied
in much that you have
printed — wish to reduce
Nazism's responsibility for
the Holocaust. If Zionists col-
laborated with the Nazis —
and I think there is evidence
to prove that some did — or
if they failed to fight fascism,
that in no way diminishes
the responsibility of the
Nazis for the Holocaust. Res-
ponsibility, after all, is not a
finite thing which decreases
if shared in any way.

We are not talking about
butter, but blame.—Yours,
Andrew Hornung.
76 Carysfort Road,
London N16.

Sir, — The letter (January
27) against the play Perdition
signed by 14 names, many of
them old friends of mine —
not George Weidenfeld, the
publisher of Franz Josef
Strauss ! — is unjust and
nearly libellous.

The signatories seem to
think that to expose the hid-
eous contradictions of Zion-

ism — as documented on the
same page of the Guardian
by authentic quotes from
Weizmann, Ben Gurion, and
the Zionist Federation — is
" a vehicle for anti-semi-
tism." In fact, the author and
producer of Perdition are
quite right that Zionism, as it
has developed — *not* Martin
Buber's, Baer Borochow's, or
Nahum Goldman's Zionism
— has become a death-trap
for Jews in Israel and a
vehicle for anti-semitism
everywhere.

Jew-haters in Germany,
Austria, Poland, and other
parts of Europe and America
or Saudi Arabia would find
Perdition confusing and full
of disclosures that do not fit
their simplistic bill. But the
actions of today's Zionist
leaders create hatred of Jews
in parts of the third world
where there was never any
anti-semitism.

The lessons of Jewish his-
tory which I have been keen
to learn ever since my rela-
tives died in gas chambers,
are certainly not what the
signatories of that silly and
venomous letter believe. —
Yours faithfully.
Erich Fried.
22 Dartmouth Road.
London NW2.

Sir, — The signers of the
letter (January 27) about the
play Perdition begin: " We
oppose censorship but . . ."

The " but " negates the
rest of the letter. In a democ-
racy, free speech should be
as near absolute as possible.

Oliver Wendell Holmes, Jr,
a US Supreme Court justice,
wrote this in 1919: " I think
that we should be eternally
vigilant against attempts to
check the expression of opin-
ions that we loathe and be-
lieve to be fraught with
death . . ."

And, in the same dissent,
this: " The ultimate good de-
sired is better reached by
free trade in ideas, that the
best test of truth is the
power of the thought to get
itself accepted in the compe-
tition of the market . ."

Several of the signers of
the anti-Perdition letter are
my valued friends. I don't
like disagreeing with them in
public. However, you are ei-
ther for or against censor-
ship: if you are for it, you
can't allow an exception.

Far from proving the rule,
the exception negates it. —
Yours sincerely
Larry Adler
110 Eton Hall,
London NW3.

without analysis, and accusations without substantiation.
Dan Leon, NW6

Myth the Point

Jim Allen (*TO* 857) says his play 'Perdition' 'touches on the most abiding myth of modern history, the Holocaust' on which 'so much had seemed covered up, a cosy set of family secrets, skeletons in the closets'. Elsewhere, he accuses Jewish leaders of collaborating with the Nazis 'in order to help bring about a Zionist State, Israel, which is itself racist'.

As an Israeli and a socialist — and naturally, therefore a supporter of the Palestinian right to self-determination — I am sensitive to the use of words which distort real situations, now or in the past. To speak of the Holocaust as if it were an Agatha Christie novelette shows an almost incredible lack of sensitivity. However, it makes sense if one really sees it as 'the most abiding myth of modern history'. Allen may have read 26 books by Jews on the Holocaust but if this is his conclusion he would be advised, as one critic suggested, to again sit through the film 'Shoah' in order to get nearer the truth.

As for Israel being Zionist and racist, Allen throws out these shop-worn slogans without a word of explanation. In the same way we read of 'the loony left' and 'doctrinaire Socialists', or 'caring capitalism' and 'property-owning democracy'. Zionism indeed created the State of Israel in 1948 on the basis of a wholly legitimate United Nations resolution. So Israel was, and is, a Zionist State — which Allen takes for granted as being something negative, though we are not told why.

The word racist is added as if it is a fact which needs no elaboration. Many of us think that Israel's policies are to be criticised but would totally reject the idea that the State of Israel as such is racist. Steve Grant writes that Allen is a Marxist and a Trotskyist. Surely a Marxist should at all costs avoid the use of slogans

New Society 6.2.87
'Invasion of Reality'
Frederic Raphael

The issue of censorship never quite goes away. What are the limits of what can be presented on the stage, or the screen, and who (if anyone) should set them? You may be glad, or sorry, that I don't propose to waste time saluting the aesthetic finesse of such intellectuals as Mr Winston Churchill or Mrs Whitehouse or Mr Gerald Howarth, the latest lancer for civilised standards. It is a comfort to know that such people are there to protect our children from things that shouldn't happen till after nine o'clock at night. However, if the interests of the immature are paramount with our moral guardians, it's worth wondering who bothers about the interests of grown-ups.

One of the most difficult aspects of what concerns me is how and when a subject becomes a legitimate basis for dramatisation. The history of the theatre makes it clear that the imaginative appropriation of real events has always been part of its tradition. What sort of "responsibility" to fact does an author, or an actor, have? Two recent examples of the invasion of reality are Jim Allen's hitherto unseen (but scarcely unheard of) play, *Perdition,* and John Glenister's film of Robin Chapman's *Blunt.* As an interested party— Glenister is about to direct something of mine—I watched *Blunt* with demanding keenness. There is no more reliable response, on one level, than that of an author in my situation. *Blunt* struck me as almost flawless. Yet it has been assailed for its "inaccuracies." Does it matter that the real Blunt never wore a hat or "wasn't a snob"? The real Henry v never spoke blank verse before a battle, did he? How do the criticisms of *Blunt* differ from the charges against *Perdition?*

Let me begin by retreating to very distant ground. In 494 BC when the theatre was very young indeed, the tragic poet Phrynicos staged a piece called *The Siege of Miletus.* It depicted the condign punishment, by the Great King, the king of Persia, of the famous Greek colony in Asia Minor after it

had attempted to secede from his taxing sovereignty, two years before. Herodotus records that the effect of the production was so devastating that the audience broke down and wept. There was shame in the tears: the Athenians had encouraged a rebellion they had been powerless to assist (shades of Budapest, 1956). If Phrynicos had touched a sore spot, he must have hoped for an ovation at so eloquently siding with his fellow-Ionians. In fact, he was fined and his play was banned. He had reminded the citizens of a "national disgrace."

So what? The belated banning of Phrynicos's drama may well seem rather unfair. How could he be expected to gauge the audience's reaction? The creation of a sensation is part of the acknowledged purpose of the theatre. Who is to tell us what is tolerable, and if we can't say who, why should anyone? As fine a spirit as Mr Michael Winner, rallying liberals against the latest philistine attempts to muzzle the arts, declares that it is ludicrous that we artists should be regulated by what "a reasonable man" might find acceptable. The Athenian instance will probably not embarrass him, but the judgment of "reasonable men" may well have been fundamental to the development of the drama, and also of our freedoms.

When the Athenians punished Phrynicos's opportunism, they were not opting for a theatre without emotional stimulus. All the evidence and all the clichés remind us that they went to the Dionysia to be "purged by pity and terror." But not, it seems, by *any* pity or *any* terror. What appalled them in *The Siege of Miletus* was the proximity of the events depicted. By some rare intuition, the citizens sensed that there were limits to the representation of reality. Drama-doc was not their idea of high art or of rewarding kitsch. The "truth" was not a warrant for the manipulation of an audience's feelings. Yet the god Dionysos was the deity precisely of the interface between the sexes, the elements, man and god, sanity and madness. The drama belongs to an indefinite domain. But because there can be no definitions it does not follow that there can be no decisions.

When, some 20 years after Phrynicos, the greatest tragedian, Aeschylus, came to write the *Persae*—the only ancient tragedy with a non-mythical *donnee* to have come down to us—he proved to have learned the kind of lesson which only masters absorb. Phrynicos's misfortune did not impel him to play safe, but to take an imaginative leap. He treated the 479 BC defeat of the Greeks' greatest enemy, Xerxes, as an occasion for solemn, sympathetic reflection from the Persian point of view. The *Persae* has been scorned as agitprop, but its Athenian patriotism was of an implicit subtlety that makes Henry V seem crude jingoism. Aeschylus's imaginative recognition of the dignity of The Other is at the heart of western culture; it looks like a weakness, this systematic duplicity, and it is our greatest ornament. When, in the Prometheus cycle, he created an antagonist for Zeus, he instituted that debate with the godhead which not even Christianity managed to curtail. By means of drama, the unquestionable is questioned.

The Holocaust, its motives and machinery, is one of the great enigmas, and the greatest crime (or series of crimes), of what used to be civilisation. How can it escape theatrical treatment? Facts do not speak for themselves; they must be given voices. There can be no embargo on subjects. The mistake of the Royal Court and of Jim Allen was more intellectual than aesthetic.

The notion of "aesthetic courage" is an odd one, though Irving Wardle in the *Times* two weeks ago used it as if it were a virtue that certified the production of anything that scandalises or appals. Its paramount authority, in his eyes, leads him to assimilate the shock caused by portraying Queen Victoria as a lesbian with that excited by a play that is said to show that the Jews connived at their own extermination. All good fun, all bold stuff. The zeal for sensation can, on this reckoning, have no limits. Since no certain definitions can be provided, all is permitted. Anyone who stands in the way of aesthetically courageous managements is a sinister representative of reactionary forces.

Am I saying that certain plays should be banned? Do I see myself as a Lord Chamberlain come again? Sorry, but no. Nothing should be banned, but not everything should be permitted. How do we work that? Frankly, just about how the Athenians—and recent pressure on the Royal Court—worked it: by loud resentment of the inadequate and

132

the opportunist. Mr Allen's play and his public announcements seek to make a moral distinction between Jews and Zionists. The good Jews are dead Jews; the bad ones live in, and fought for, Israel. This distinction is ideological. It is an intellectual judgment based on preconceived notions of what people, and Jews in particular, ought to be.

I am no zealous Zionist and no unequivocal supporter of Israel, but the Manichaean morality of Mr Allen is not an encouraging one for those who look to the drama, at the highest level, for imagination rather than distortion. If the outrageous is always to be confused with the unchallengeable, we shall arrive at the theatre of pure scandal, in which only lies can be told, or publicised. When the Athenians veered away from sensationalism they showed an instinct for art as against what, for malicious purpose, we might as well call journalism: the cult of the immediate return. They were not foolish or mealy-mouthed in saying that there had to be limits, just as they were wise in never defining them in statutory terms. The best critics of the theatre, the necessary critics of the theatre, are not professional arbiters but society itself, alert, responsive and, at times, disgusted.

It may be, though I should not like to have to argue it, that the Holocaust is *sui generis* and will never attain that distance which can liberate the subject for imaginative treatment. Meanwhile Mr Allen *et al* might consider whether the story of Anglo-American complicity with it might not make a jolly comedy. Or might that smack too loudly of a "national disgrace"?

New Statesman 6.2.87
'Playing dirty'
_____Victoria Radin

IS JIM ALLEN'S play *Perdition*, which the Royal Court has suddenly cancelled, anti-semitic or racist? Let me quote a passage that was deleted from the script at the last moment:

> *Lawsen:* I assume Counsel for the Defence is not suggesting Jews are cowards in an emergency [the 'emergency' he is referring to is the Holocaust] . . .
> *Scott:* That will be for the jury to decide.

Who is this jury who will decide this, by definition, racist issue? As the stage directions specify, the jury is us, the audience.

Perdition is cast in the form of a courtroom drama, an authoritarian and particularly manipulative genre. Bewigged and begowned barristers parade an assemblage of purported facts before us; a judge, clothed in scarlet, sits above. The momentum derives from the skill of the barristers/hunters in stalking their quarry and the audience's own urge to see justice done, or vengeance. It is exciting and, when applied to the subject of the Holocaust, sensational stuff indeed.

A competent writer of the form will balance the two sides so that each genuinely has a case — otherwise there is no drama. He will also find it necessary to use sound logical principles and to write speeches which conceivably could be uttered in a courtroom. Jim Allen ignores these ground rules. The facts, too, which he presents to his British audience — who are unlikely to be *au fait* with details of Jewish behaviour worldwide during the Holocaust — are apparently, at best, misleading. At worse they are false, as Allen tacitly acknowledged when, very late in the day, he made insertions and deletions, some of them concerning major events, to the rehearsal script. These were apparently based on the reports made over a year ago by two historians, Dr David Cesarani and Martin Gilbert, which were commissioned respectively by the Royal Court and by the Manchester Library Theatre (who withdrew from co-production after the report was compiled). Both condemn the script. The Cesarani report also states that *Perdition* 'does satisfy all criteria by which anti-semitism is normally recognised'.

The play is set in a British court in 1967. The fictitious Doctor Yaron, a Hungarian emigré, is prosecuting the invented Ruth Kaplan, an Israeli emigré, for libel sustained in her pamphlet accusing him of collaboration with the Nazis.

The setting of the play in Britain makes it appear as if the issue of collaboration had never been raised in Israel. But Allen's play is based on the public trial, 12 years before the date of his play, of Dr Rudolph Kastner, a figure in the then Labour government of Israel. On his behalf, the government sued for libel a right-wing supporter of the Irgun terrorist group, who had accused Kastner of collaboration with the Nazis. In this internecine struggle the government lost their case; a few years later they appealed successfully. Kastner's alleged collaboration continues to be be debated in Israel, where a play about it was staged last year. Jim Allen makes his own use of the controversy. Although his work constantly cites Kastner in pursuit of its anti-Zionist thesis, Allen makes no mention of the Israeli trial until the end of the script, when he suddenly brings it in as evidence against Yaron.

But the truly guilty parties in Allen's trial, as he makes relentlessly, repetitiously clear, are Zionists (whom the text, as we have seen, sometimes confuses with 'Jews' or 'Jewish leadership'). Using frequently offensive language (the 'Jewish leadership reacted [to the Nazis] by flopping down on all fours. Grovelling, servile, obedient') he charges his characters to condemn both the people

who believe in Zionism (which he collates into a single monolithic ideology) and the state of Israel (which he perceives only in terms of its present policies).

The script constantly nudges one to see resemblances between the Jews and the Nazis. The Jews of the Holocaust were (in a phrase one associates with the Nazis, which Allen uses several times) 'carrying out German orders'; they were (in the ancient tradition of anti-semitism) 'sacrificing' their fellows' 'blood'; they even 'comprised a Zionist knife in the Nazi fist'.

My last point on the script itself is undoubtedly the strangest. The end of the last version of it discloses that the ostensible opponents Yaron and Kaplan were actually in collusion all along for the purpose of fixing a show trial to indict Israel. Yaron additionally appears revealed as some kind of nut who has seen too much Christian iconography. He perceives the word of his indictment as 'hard as nails'; he talks of 'a tall black crucifix of a woman'.

The subtext of *Perdition* builds shrilly to the suggestion that the Jews not only somehow deserved what they got from the Nazis ('Our Zionist (sic) tradition impels us to save the few out of the many') but that they even, in some analysable way, were responsible for the horror they suffered. The remorseless unveiling of unpalatable events unleashes a kind of rage in the reader, which would be stronger still in a spectator. One searches for an outlet and 'blame' is a word that Allen has continually attached not to the Nazis, but to the Jews/their Jewish leaders/Zionists. It is the venerable psychological mechanism by which the victim stands accused: the rape victim of soliciting violence; the unemployed of foolishly obeying false trades unions.

Perdition is a nasty play. The question to be asked is not why one man wrote it, or even why Stafford-Clark persisted with it against all historical advice and then performed his last-minute *volte face*, but why he ever wanted to stage it at all. The Royal Court, which has been an institution worthy of one's greatest faith, stands against racial prejudice. One cannot imagine that it could produce a work whose theme was slaves colluding with their masters, or one which revealed that the current politics of India or Pakistan somehow fulfilled all one's darkest thoughts about Asians. What made them think the Jews don't need the same kind of respect as other minorities? Could it be a kind of double-think? As one writer who had read the script admitted to me privately: 'British anti-semitism, particularly among the left, is a can of worms. *Perdition* provided the can-opener.' ☐

Guardian 7.2.87
letters

Sir,—The poisonous and reactionary letter (January 27) penned by writers — including Arnold Wesker who should know better — contains an abundance of charges and accusations without offering one shred of proof. "We are impelled to participate in the debate . .. especially after a number of Holocaust experts have declared that it is riddled with errors and distortions."

Here lies the source of the pollution. Among the "experts" are Martin Gilbert, David Cesarani, and the Institute of Jewish Affairs. Eighteen months ago, the Royal Court sent a first draft of Perdition to the institute and Mr Cesarani. Each produced a report attacking the play.

Armed with the added weight of "eminent historians," the Zionist juggernaut was on the road. "Perdition," said Mr Gilbert, "is a travesty of the facts. I found 60 historical inaccuracies."

Why then, after a two and a half hour private meeting with Max Stafford Clark on January 17, did Max emerge with only *two* objections? Why does Mr Gilbert still refuse to put in writing his 60 historical inaccuracies?

Mr Cesarani says in his report: "Several sources used by the author, such as the report of the Kastner trial (which happens to be the official court transcript) and Brand's memoir, Desperate Mission, have to be treated with extreme caution."

So the Zionist Hungarian leader Joel Brand, who negotiated with Eichmann and wrote a book about it, is dismissed.

Then Mr Cesarani produces his hit list: "Ari Bober, Nathan Weinstock, Uri Davies, Nathalie Rein, Lenni Brenner, Noam Chomsky, and Maxine Rodinson are all regarded in academic circles as protagonists against Zionism and Israel. Hannah Arendt and Abram Leon are honoured non-conformists, but they do not stand as credible authorities now."

So now we know. All we are left with is David Cesarani, Martin Gilbert; and Exodus.

As the play makes perfectly clear, it was the Nazis who murdered the Jews, not the Zionists. The latter's

crime was to abandon the Jews of Europe; to block rescue attempts which did not include entry into Palestine; and collaboration.

I do not say that the Zionists welcomed the Holocaust, or that they were equal partners with the Nazis; it would be monstrous to suggest that. But if a person attempting to escape from a burning house finds the doors and windows locked and barred, whoever is responsible becomes an accessory to murder.

Stephen Wise was the most powerful Zionist leader in America during the Holocaust. Mr Cesarani writes: " Wise was a victim of disbelief."

In August 1942, after receiving confirmed reports of the continuing slaughter of European Jews, Wise, at the request of the State Department kept silent. On November 24, he was released. from his promise, and wrote a letter to his friend President Roosevelt: " Dear Boss, I have had cables and underground advice for some months, telling me of these things. I succeeded with the heads of other Jewish organisations in keeping them out of the press."

In 1936 Wise wrote in his Congress Bulletin: " Hitlerism is Satan's nationalism.

The determination to rid the German national body of the Jewish element however, led Hitlerism to discover its ' kinship ' with Zionism . . . it was a painful distinction for Zionism to be singled out for favours and privileges by its Satanic.counterpart."

Perdition runs for two and a.half hours and is riddled not with " errors and distortions," but with well-researched facts. Scott's speech near the end sounds the warning: " If another major economic crisis occurs at some time in the future, can we with confidence assert that fascism will not arise again like a broken sewerage pipe, disgorging its filth and corruption on society? Have we been given not a victory over fascism but a reprieve, a warning, a breathing space ?"
Jim Allen.
Parkside,
Alkrington, Manchester.

Sir,—S. Levenburg writes (Letters, January 29) that Ben Gurion never addressed a meeting of Labour Zionists in October 1938; and that he never opposed a British plan to rescue German Jewish children.

For some reason your correspondent has changed the month from December, which was clearly stated in my original letter, to October. This meeting most certainly took place and Ben Gurion most certainly made those remarks.

They were commented upon in a most interesting article called Zionist Policy and European Jewry, which can be found in Vol XIII of the Yad Vashem Studies, published by the Martyrs and Heroes Remembrance Authority in Jerusalem in 1979 (p199).
John Rose.
Socialist Workers Party,
London E3.

Dear Sir,— The welter of correspondence about Jim Allen's Perdition is in danger of obscuring or distorting basic facts.

Contrary to allegations being made, the play was not " banned," it was withdrawn for reasons that have been clarified by Mac Stafford Clark (Letters, February 2).

He states that a play on the Holocaust must be subject to the " scrupulous canons of history " implying of course that Jim Allen was less than scrupulous in his drama. He has also categorically denied thatany pressure was brought to bear on the theatre.

Nor was the play declared unsound only because of its historical distortions. Michael Hastings has confessed that it " could be looked upon as anti-Jewish, no matter how unintentional this was in the writing."

It is puzzling that anti-racists and correspondents like Erich Fried (Letters, February 4) who lost relatives in the Holocaust, should defend a play that is " anti-Jewish."

The issues raised by Perdition have never been suppressed. Anyone who is genuinely concerned with this ghastly episode can find it dealt with in David Wyman's The Abandonment of the Jews, Yehuda Bauer's Holocaust in Historical Perspective, and Brahams's two-volume The Holocaust in Hungary.

There has been a historical debate on this for two decades; but a debate which treated the past with respect, not to be plundered to provide ammunition for this or that political line.— Yours sincerely,
(Dr) David Cesarani,
Queen Mary College,
University of London.

New Statesman 20.2.87 letters

Tony Greenstein, Brighton
Victoria Radin (*NS* 6 Feb.) is content to rest her case on the opinions of two hardly disinterested historians, David Cesarani and Martin Gilbert. Both are dedicated Zionists and both have axes to grind.

It is clear that the theme of *Perdition* is not a welcome one to Zionists who base the moral legitimacy of the Israeli state on the Holocaust. Allegations of collaboration by the Zionist movement during the war can only undermine that claim. This is why, although a similar play to *Perdition* has been staged in Israel, there is hostility to its being put on in Britain.

Nor is it true, as Ms Radin alleges, that the allegation of Zionist collaboration with the Nazis is the equivalent of blaming the Jews for their own destruction. It was, after all, the survivors of the Holocaust who were instrumental in bringing the original charges in the Kastner case in Israel. It was they who alleged that the survival of the few was bought with the lives of many. Nor does the relevant quote imply that the Jews deserved what they got, that is simply Ms Radin interpreting her own particular subtext; it is a quote from the Israeli Attorney General, Chaim Cohen, in the Kastner case.

It is a fact documented by a number of Zionist historians, such as Lucy Dawidowicz, that during the Hitler period, the priorities of the Zionist movement were on creating a Jewish state, not fighting anti-semitism. It is also a fact that the Zionist movement was singled out by the Hitlerites as a movement that shared its ideology of race and nation. Ms Radin does however avoid the substance of the Kastner case on which *Perdition* is based. But then how could she defend this senior official of the Israeli government who, after the war, went to Nuremburg and personally testified on behalf of Eichmann's superior, Kurt Becher, saving his life.

Far from *Perdition* being anti-semitic, it is a play that Jewish people who wish to learn about their history and the history of a movement that claims to represent them, have a right to see. It is a right that is at present being denied us.

New Statesman 20.2.87
'Censorship & Perdition'
Ken Loach & Andrew Hornung

The vilification . . . has been raucously loud. The clear message is that free enquiry should not be tolerated.

SO PROCLAIMS the leading article (on the spy satellite issue) in the *New Statesman* (6 February). Turn to page 25 of the same issue for some real vilification.

Victoria Radin's 'review' of Jim Allen's banned play *Perdition* is an extraordinary mixture of distortion and misrepresentation. 'The script constantly nudges one to see resemblances between the Jews and the Nazis', writes Ms Radin. The script does no such thing. It does point out that some German Zionists sought a special relationship with Nazis. The Zionists were 'utilising a threat which to them signalled the bankruptcy of assimilation, and paved the way for the creation of the Jewish state'. Joachim Prinz, a Rabbi from Berlin, wrote:

> A state which is constructed on the principle of purity of nation and race can only have respect for those Jews who see themselves in the same way.

Such nice distinctions between anti-Zionist and anti-semitic are of little interest to Ms Radin. Her article is but one of a series of virulent attacks on a play by the most important socialist playwright of his generation.

Jim Allen's work, from *Days of Hope* to *Spongers*, has given a voice to the oppressed and to those who fight injustice. So why did the Royal Court, 'the Playwright's Theatre', withdraw *Perdition* the day before it was due to open?

The context of the play has become familiar, although presented through the distorting lens of a hostile press. Briefly, the narrative shows an Israeli journalist accusing Dr Yaron, a Hungarian survivor from the Holocaust now living in London, of collaboration. Yaron sues for libel. The play's characters are fictitious, but the evidence brought is factual.

The question is asked: how did the Nazis manage to round up and deport half-a-million Jews in Hungary within two months, when Germany was all but defeated? Answer: with the active co-operation of the Jewish leadership in Budapest, in particular a Zionist group led by a man called Rudolf Kastner.

Was this co-operation simply the responsibility of weak or wicked individuals? No; it had its roots in the ideology of Zionism, the movement to create a separate homeland for the Jews. During the Third Reich, Jewish emigration to Palestine became the priority, with rescue to other countries a secondary consideration.

This analysis is supported in the play by reference to events, speeches, documents, and first-hand accounts of what happened. It has widespread support among published historians, and British and Israeli Jews. If you can read it in books, why can you not see it on stage?

Lobby for silence

Of all theatres, the Royal Court is the last one you would expect to apply censorship. It made its reputation as the defender of new writing. And *Perdition* was first bought by the theatre over 18 months ago, a long time in which to assess its worth and likely effect.

It was cut and edited by Jim Allen and myself with the help and advice of Michael Hastings, the literary manager. Yet there was no question of its being withdrawn until 36 hours before its first night. It is simply not credible that the theatre management changed its mind on the script at such a late date without overwhelming and undeclared pressure from the censorship lobby.

So how did political censorship come to the Royal Court?

The first shot was fired by an article in the *Guardian* on 14 January. Full of lines that did not appear in the final text, it quoted abuse from leading Zionists without declaring their political hostility; it raised the spectre of anti-semitism by the old trick of confusing that with anti-Zionism, and it grossly misinterpreted the play.

To take one example, it is claimed that the play's central message is that 'Zionists positively desired the slaughter of the Jews'. Compare that to this quotation from the play:

> Are you suggesting that the Zionist leaders actually welcomed the Holocaust?
>
> No, I'm not saying that. It would be monstrous to even think that.

In the wake of this inflammatory writing, the letters column was flooded with abusive letters. Then a whole series of articles by Zionists or their apologists appeared in one paper after another: Martin Gilbert in the *Telegraph*, Stephen Games in the *Independent*, Lord Goodman in the *Standard*, and Bernard Levin in *The Times*.

It is worth remembering at this stage that no one outside the immediate circle of the production had seen the the the script that was to be presented. We can only assume that Zionist organisations, possibly the Institute for Jewish Affairs, were circulating an early draft of the script, with copies of hostile reviews from historians sympathetic to their cause. Certainly the Institute itself presented its own anonymous report attacking the play.

The method of these articles can be illustrated by Goodman's piece in the *Standard*. He writes that 'the play is a total distortion of the truth and a brutal insult to the Jewish community the world over'. His evidence? None. Not a quotation from the play, not an inaccurate fact exposed, not an argument delineated or discounted, not a document challenged. Instead, this eminent lawyer smears the play by association. He discusses the 'literature of classic anti-semitism'

that has 'permitted credulity to feed and foster hatred through the centuries'.

Levin litters his writing with such phrases as 'peculiar vileness', 'physical stink', 'ignorant, uneducated and brutish, 'horrible lies'. Like Goodman, Levin sees no need to trouble his reader with any facts to support his tirade. In the long article, there is not one quotation or incident recounted from the play. Levin has a particular hypocrisy: he claims to oppose censorship, while, through his venom, encouraging the play's continuing suppression.

One function of these attacks was to indicate that this historical episode was not available for discussion by non-Zionists. In the words of the *New Statesman* (on the spy satellites), 'the message is that free enquiry should not be tolerated'. Another purpose was to create a sense of public anger before the play opened.

At the same time, the play's opponents used their influence to lobby and manipulate behind the scenes. We know, for example, that there was a meeting between some members of the Royal Court Council and Lord Weidenfeld and Martin Gilbert four days before the play was due to open. Its purpose could only be to bring pressure to bear on the Court.

Who organised that meeting? Why was not Jim Allen or any representative from the production given a similar opportunity to defend the play? The tactic seems to have been for the play's opponents to claim that its production would cause outrage, and, as proof, point to the outrage that they themselves had caused.

Zionism and Jews

And so the play was banned, apparently on the sole authority of Max Stafford-Clark, the artistic director, just as we were preparing for our dress rehearsal. Did he fall, or was he pushed?

There have been rumours of threats of withdrawal of funds, which Stafford-Clark has refuted. Certainly the Court is financially vulnerable. It has been suggested that a valuable co-production arrangement with Joe Papp in New York might have been jeopardised. I do not claim to be in a position to evaluate these stories. What is certain is that the stated reason for the ban is quite inadequate: 'going ahead would cause great distress to sections of the community'. Plays about fascism have caused distress in Germany, but does that mean they should be censored?

Stafford-Clark himself staged a play about the Falklands war in Plymouth, despite local objections about 'distress'. Of course, he was not fighting such powerful opposition there. The ultimate 'distress' is that of the Jews who were transported to their deaths from Budapest, while their own leaders, who knew what was happening, failed to warn them. Their voices were suppressed then, and they are suppressed now.

The efforts of the Zionist campaign did not end with the ban at the Royal Court. The lobby has tried to ensure that no theatre will stage the play in London or elsewhere. A number of managements have read the script and been interested in staging it. One producer was told that the theatre he wanted would become unavailable for this play. Not only that, he would not be allowed to rent any theatres belonging to that particular proprietor in the future. Another was telephoned from New York and told that if he produced the play, his future career on Broadway would be in jeopardy.

Legal action has been threatened. We have been advised that it would have little chance of success, but the possibility of legal costs is a severe deterrent to even a sympathetic management.

Gerry Sinott of the Olympia Theatre in Dublin was very enthusiastic, and plans were made to open there almost immediately. Then the propaganda machine went into action. A Labour politician was quoted as saying 'Dublin is not a dustbin place for staging the plays which have been thrown out of every country' (a transparently ludicrous remark) and objecting to 'racialist overtones', which do not exist, in a play he had not read. The Olympia could not stand the pressure.

We have to remind ourselves that we are talking here about censorship, where a political group has used every device to prevent discussion of its own political past. In fact, these people encourage the very anti-semitism they seek to prevent, because it appears that a powerful clique has, through its influence in the press and elsewhere, stopped the play from being performed. But the Zionists do not speak for the Jewish people. They are only a political tendency. Just as the history of communism does not belong to the Stalinists, so Jewish history does not belong to the Zionists, and the history of that terrible War belongs to us all.

Of course, it is not a matter for dispute that historical evidence, if quoted, should be accurate. The charge that *Perdition* is inaccurate has been made principally by Martin Gilbert. Sundry hacks have simply deferred to his authority and then gone on to attack the play.

In Gilbert's article in the *Telegraph*, 22 January, his prime example of 'inaccuracy' is the play's claim that for six weeks after the deportation began the entire Zionist leadership 'did not publish or even utter one single word of protest'. Gilbert responds by referring to several cables sent to Allied governments before the deportations, warning of the impending developments and urging 'all action'. But the play speaks not of private cables, but of *publishing* — that is, broadcasting to masses in print or on the air — and *protesting* to arouse world opinion and action.

If the play is wrong about these forms of action, let Gilbert provide the evidence. In fact, these leaders simply repeated their routine and bourgeois approach: they kept whispering in the ears of the powerful even when they had proved in the past to be deaf. Of course, compared with the World Jewish Congress's suppression of the emerging facts of the Holocaust — something amply documented in histories sympathetic to Zionism — the sending of these cables must indeed seem like a sudden tornado of activity.

The authentic Zionist response was shown by Rabbi Stephen Wise, leader of the American Jewish Congress, who, earlier in the War, when reports of the systematic killing of Jews began to reach him, was able to write to Roosevelt: 'I succeeded, together with the leaders of other Jewish organisations, in keeping them out of the press'.

The charge of racism against the writer, who was a founder of the Anti-fascist Committee in Manchester, is so gross as barely to warrant an answer. Max Stafford-Clark, to his credit, dismissed such allegations as 'vile distortion'.

Fear of fascism

Far from the play attacking Jews, its central idea is precisely the opposite: that Jews under attack were betrayed by Zionist and pro-Zionist leaders. If the play were to attack Jewry as such, it would lose all meaning. It is not Jim Allen who conflates Jews with Zionists. That conflation is a fundamental plank of Zionist disinformation today.

Jim Allen not only exposes, again, the betrayal of Hungarian Jewry by its leaders, but also suggests that Zionism provided the ideological rationale that guided this and other instances of betrayal. It is this political attack on Zionism that outrages the play's opponents. The absurdity is, of course, that this discussion takes place without any public presentation of the play that started it all.

Part of the script deals with the rescue trains that took 1,600 Jews to safety from Budapest in 1944. The Zionist leaders prepared the list of who would be saved — the 'rich', the 'prominents', the 'Functionaries'. Is it not fair to say that those who have campaigned against the presentation of *Perdition* are the contemporary equivalent of those who boarded the rescue trains and got out?

This play that has been so vilified contains a thread that has run through much of the work that I have been privileged to do with Jim Allen: that we should learn from the past so that we can counter the rise of fascism in the years ahead:

> If another major economic crisis occurs at some time in the future, can we with confidence assert that fascism will not arise again like a broken sewerage pipe, disgorging its filth and corruption in society? Have we been given not a victory over fascism, but a reprieve, a warning, a breathing space?

That is the play that has been banned. ☐

New Statesman 27.2.87 'Totalitarian rabbit hole' Victoria Radin

LAST WEEK this paper ran a long and fantastical article on the theme of *Perdition*, the first stage play by the television docu-dramatist Jim Allen. The article was co-authored by Ken Loach, a TV and film director whose first stage production this also was, and by Andrew Hornung. Loach and Hornung's article was a reply to my more modestly-proportioned review of the text humbly buried in the *NS*'s arts pages two weeks before.

I think, first, we need to clear the air. Messrs Allen, Loach and Hornung do not like the state of Israel. Good. To a point I agree with them. So do many people who don't like *Perdition*. Here are some facts.

First fact. These copies of *Perdition* — which Loach and Hornung 'can only assume' were 'circulated' by 'Zionist organisations' — were sent to journalists by the press office of the Royal Court itself — as is its custom with all its plays.

Second fact. The vast chasm which Loach and Hornung claim separates the early draft of *Perdition* from the later version is not very large. I own, as I did when I wrote my review, copies of both an early text and the one designated as the rehearsal script a few days before the play was due to open. There is not much to choose between them. Some fallacies have been deleted: for example, the equation of Rabbinical Law with the Nazi Nuremberg Laws of 1933; but I find the ending of the second version even more dishonest. In the last few pages, *Perdition*'s sole mouthpiece for rebutting charges against Nazi-Zionist collaboration suddenly reveals that he had in fact set up the play's trial in collusion with his purported opponent for the purpose of knocking the views that he was meant to be representing. His entire argument and, since this is a courtroom drama, the play's, is thus rendered null and void.

Third fact. The Royal Court and the Manchester Library Theatre, who early on cancelled their co-production, both independently *chose* two different historians (who had never met), respectively Dr David Cesarani, now of Queen Mary College, London, and Martin Gilbert, of Merton College, Oxford, and *commissioned* them to write reports on the play. I presume that this is what Loach and Hornung mean when they refer to historians' 'hostile reviews' (*sic*: the Cesarani report runs to 22 pages). Both historians found the play filled with serious inaccuracies. It is interesting to remember in this context Allen's two-page interview in *Time Out* (where he labelled the subject of his play, the Holocaust, a 'myth'): here he said that the Court had sent the play to '25 different academics and all we've had has been one scathing but anonymous attack.' I have a copy of a letter Allen wrote to the

Court 18 months ago in which he talks about the Cesarani report.

Fourth and very important fact. The play was not 'banned', 'censored' or 'suppressed', as is the lazy parlance of the press, who picked up the terms from Allen, Loach and Hornung. The Court's artistic director, Max Stafford-Clark — who is now said by his office to be 'bored with the whole thing' and did not return my phone calls — *cancelled* its production at his theatre. The real story is that very late in the day indeed, in fact five days before the scheduled opening, Stafford-Clark rang up Martin Gilbert and asked if he could come to see him in order to go through the text together. Gilbert spent three hours pointing out inaccuracies. The text was constantly being changed by Allen and Loach right up to the moment Stafford-Clark pulled it. How could he 'stand behind it', when it was mutating moment by moment?

Another important fact. The Royal Court's advisory body, the Council, who number four Jewish members out of 19, did not put pressure on the theatre to withdraw the play. Stafford-Clark has said so (in the same *Time Out* interview) and two (non-Jewish) members of the Council have corroborated this to me. What happened was that the Council had seen neither the script nor the historians' reports until three days before the first preview was scheduled, when they were shown the Cesarani report. They immediately convened a meeting at which Stafford-Clark was present. It lasted four hours. 'Max realised that he was putting his reputation on a third-rate play,' according to an important (and non-Jewish) member of the Council, who calls the *Perdition* affair 'an internal cock-up of the highest order'.

The Council voted 11 to 4, with a few abstentions, that the play should nevertheless go on, under the following conditions: 1) that the first preview should be postponed for four days; 2) that the play should be read by a third historian (he was to have been Dr Norman Stone of Oxford); 3) that the play be read for libel (astonishingly, in this *Fawlty Towers* episode of the Court, none of their management had thought to consult their solicitor about a play which named three people currently living in England); and 4) that all members of the Council should be provided with a copy of the script, which they still had not seen.

These conditions were practicable, but Stafford-Clark chose instead to pack in the whole thing. The next day, he cancelled the production.

Allen, Loach and the actors were, justifiably, very angry. They naturally tried to get it on somewhere else. No theatre has taken *Perdition* so far, but not, as Loach and Hornung imaginatively allege, for reasons of a 'censorship lobby', a 'Zionist campaign' or a 'powerful clique'. Says Nicky Pallot, an artistic director of the Bush Theatre: 'What worried me was that the author seemed to take a view without discussion or dialectic.' Pierre Audi, artistic director of the

Almeida, told me: 'They phoned me up and I said, no, and the next thing I knew the 6 O'Clock News was saying we were going to put on *Perdition*. Loach later apologised to me.'

Interesting fact. Gerry Sinott, who runs the Olympia Theatre in Dublin, is the sole management actually named by Loach and Hornung as a post-Royal Court casualty of the massive 'Zionist campaign' they proclaim so zestfully. Sinott did indeed consider staging the play. But he was very surprised to read in the *NS* that a 'political group' had stopped its production at his theatre. 'I certainly did not come in contact with it,' he told me. 'The fact that we decided not to put it on was based on a *legal* problem. Because the actors wanted to be free to make other commitments and also because of our scheduling, I had only two days to make my decision. What we had was a time pressure. This is not censorship. Basically the history of this play is that the Royal Court made a balls-up.'

Stafford-Clark, too, has said that there were no threats from sponsors to withdraw backing. Matthew Evans, Chairman of the Court Council and of Faber and Faber, told me: 'At no stage did anyone suggest that *Perdition* be taken off. There were absolutely no threats. All that people were arguing was that, given the extraordinary complexity of the material, would the Court please ensure that there were no significant inaccuracies in the play.'

The hub of the dilemma. Nobody, inside or outside the Court, has ever made any great artistic claims for *Perdition*. Four directors turned it down before Loach accepted it. Mike Alfreds, now at the National Theatre, was one of them. He told me: 'What I hated about it was that it was terribly over-simplified. From the beginning, we're told what to believe. The author doesn't want us to make up our own minds. It isn't a play — it's a piece of agitprop. Jim Allen should have gone out and hired a hall.' Alfreds sent Stafford-Clark a two-page letter, dated 1 December 1985, where he makes many other points, among which are: 'To take on Zionism, the Holocaust and (in two speeches) Rabbinical Law, needs a much stronger intellectual hold.'

Michael Hastings, the Court's literary manager, is no Zionist. But he had doubts about the play, which he voiced in the covering letter which accompanied the script he sent to Cesarani. He backed the play until he saw a run-through. Then he 'found in the production a relentless resonance. There is a subtext here that the target is Jews (. . .) I realised *Perdition* could be looked upon as an anti-Jewish play, *no matter how much I agreed with the polemic.*'

Sadness. Every person who has written an article or broadcast on *Perdition* — those who had read the script and were unconnected to the production — has said substantially the same thing as Alfreds, Hastings and me. In addition to Loach and Hornung's hit-list of Levin, Goodman, Stephen Games and Martin Gilbert,

they include David Pryce-Jones in the *Times Literary Supplement*, Barbara Amiel in *The Times*, David Rose in the *Guardian*, and on the BBC's *Saturday Review*, Dr Mary Warnock, Dr Jonathan Steinberg and Michael Ignatieff.

Can Loach and Hornung *really* believe that because there was a pretty unanimous verdict on *Perdition* by theatre people and by journalists who probably have never even met — I do not know any of them — that the cause must be a conspiracy? Forget, for a moment, about Jews and racism. This sort of thinking, whatever its application, leads straight down the totalitarian rabbit hole. ☐

Guardian 13.3.87
'Why I axed Perdition'
Max Stafford-Clark

KEN LOACH's open letter to the Royal Court Council suggests undeclared Zionist pressure led to the "banning" of the play Perdition. This is not the case. It should be made clear that as Artistic Director the constitution of the Royal Court entrusts me with responsibility for the selection of the theatre's programme. As Artistic Director, I lost confidence in the play's credibility.

Jim Allen's play Perdition was first sent to the Royal Court in the summer of 1985. Loach comments that 18 months is a long time "to assess the play's worth." He forgets that for many months the play was withdrawn by the writer who wished for a larger theatre.

From the beginning it was clear the play would be provocative but controversy wasn't unknown in Royal Court history. We had deliberately commissioned a report from David Cesarani, a Zionist historian, so as to ensure the facts contained in the play would undergo the most vigorous analysis.

The report was hostile but Jim Allen, a most straightforward and persuasive advocate, had convincingly rebutted some points while accepting others. He had rewritten and edited the play to half its former length. And, in any case, I believed a playwright was free to loot whatever facts from history suited his thesis. As Jim Allen had written in the margin of the Cesarani report when accused of partiality and lack of balance: "This is a play, not an essay ... what do you expect?"

The first time I realised how difficult things could become was in early January when Dr Stephen Roth from the Institute of Jewish Affairs asked to meet me as he had criticisms of the play he wished to present. I met him on Tuesday, January 13 with Simon Curtis, the Royal Court Deputy Director. Jim was not available and the meeting began without Ken as he was delayed. For 20 minutes Simon Curtis, Dr Roth and I discussed Perdition amicably enough.

As I recall, Roth made three main criticisms: firstly that the work of the Zionist Resistance Organisation wasn't mentioned; secondly that efforts of the Jewish leaders had saved not merely the 1,684 mentioned in the play but a further 18,000 who had been sent to work-camps in Austria; and thirdly that the sheer nightmare and agonising confusion in Budapest in 1944 was not represented in the play. He didn't deny that terrible mistakes had been made.

Dr Roth also indicated the powers he could use to remove the play. He could picket. He could contact "the Royal Court's friends" in New York. He could influence funding bodies in London. On Ken's arrival exchanges between the two men became alarmingly heated. Loach was provocative and Dr Roth was intemperate and abusive. He brandished a sheet detailing, he said, 24 major errors. He declined to reveal them as he wished to discredit the play when it was produced.

The meeting had passed the point where it had any useful purpose. His threats could be dismissed but he had an authority in his rage that both Simon Curtis and I found impressive. Ken Loach found him absurd, but it seemed important to pick any relevant points from this torrent of condemnation. If in fact 18,000 had been saved, and if there was an active Zionist Resistance movement then shouldn't that be included in the play too.

I argued that the play would be more dramatically viable if the accused Dr Yaron mounted a more vigorous self-defence.

But this was dangerously close to asking for balance and besides, I couldn't present this as advice on aesthetics if it was really a political point. Ken warned me off: this would be asking for a different play and wasn't the one Jim wished to write. We talked further and agreed on the inclusion of the 18,000 and on some reference to the Zionist Resistance Movement but it was clear that further pressure would lead to a breakdown of trust between us.

Ken Loach asks what pressure was put on the Court. He writes "it is simply not credible that the management changed its mind . . . without overwhelming and undeclared pressure from the censorship lobby". Certainly the pressure on me was intense but Loach himself was present at the only occasion when a direct threat was made.

I spoke to Joe Papp in New York sometime over the following week making it clear that we were presenting a controversial play and that he would probably be contacted about it. He replied that his relationship with me contained no element of control over choice of plays and that if he were to read the play and find it repugnant this would still remain the case.

I understand he was lobbied intensively but in fact we did not speak again until after I had withdrawn the play. It is ironic that throughout its history, the Royal Court has received generous help from a number of Jewish trusts and prominent Jewish families. In the course of this affair, none of them put any pressure on me. As for any other "undeclared pressure", there was none. Much of the pressure put on the play was unacceptable, but because some condemnations could be dismissed as distortions, it didn't mean that all criticism could be dismissed.

In the middle of the same week, Martin Gilbert, the historian, who had claimed

the play was "a travesty" rang saying he would like to meet. Against the wishes of Allen and Loach I agreed. It seemed irresponsible, not to listen. It was at this meeting, on Saturday, January 17, that the claim to a list of "64 errors" was made.

Many of these points were Gilbert's own opinion about what the principal character might have said. He even suggested some alternative lines. He argued that for some months the Jewish Councils must have believed they were negotiating with Eichmann to save one million Jews from the camps. His objective was to prove the Jewish Councils had done as much as possible to preserve lives.

Jim Allen's thesis was the opposite. There was no meeting point. But again, the horrific situation facing Jewish leaders became clearer to me. I grouped Gilbert's major points together and relayed them to Ken and Jim later that day. Jim didn't dispute the facts but didn't wish to expand the play to encompass them. It was very late in the day

On Sunday, January 18, some Council Members were invited to Sonia Melchett's home to hear Dr Gilbert rehearse his criticisms. Having spent the previous morning with him, I did not go. However, Simon Curtis described to me that notwithstanding the emotive representations of a heated Lord Weidenfeld who asserted that the play was anti-Semitic and the measured observations of Rabbi Hugo Gryn, the Council Members remained firm in their resolve to support the theatre's artistic policy.

Over the same weekend I had begun to re-read the books myself and to read others. I became more and more uneasy as I realised the extent to which Jim Allen had selected the evidence for his case and for the first time it didn't seem so clear that a writer making accusations of this gravity led to the artistic licence a playwright could normally depend on.

It became harder and harder to have much enthusiasm about fighting on the side of a piece which was so selective and so certain about such a confused and uncertain period of history. For the first time I saw the possibility that Perdition was a dishonest piece of writing; both because it was so half-hearted in including any mitigating factors, and because its passionate conviction led it to a picture of these horrifying events that seemed less and less authentic.

On Thursday January 20, there was a four hour Council meeting at which the whole issue was discussed. At no time did a single Council member suggest either that the play should be withdrawn or that it was anti-Semitic. At the same time, I was quite unable to give the passionate defence of the play that the occasion demanded.

The Council decided on a two-day postponement of previews so that the question of libel could be assessed, the historical accuracy reviewed by a neutral historian and every Council Member given an opportunity to read the play. The Council were keen to meet Jim Allen to hear his point of view ... and had the proposed scrutiny by a neutral historian taken place a meeting with Allen would have followed.

However I didn't believe the facts contained in the play were any longer the issue. I remain convinced that Jim Allen had sources for any material he has used. But many facts were clearly in dispute and it was the facts omitted that were my principal concern.

I was in what Mary Warnock was later to describe as "a fascinatingly complex moral dilemma". To withdraw the play would be damaging not just to Jim Allen and Ken Loach but also to the fine and committed acting company ... also accusations of censorship would follow ... but to defend a play which I now thought both distorted and distressingly incomplete was impossible. I had thought Perdition fell within a spectrum of work whose views I could support. I now found it did not.

On returning to the Court, I sought Matthew Evans (Chairman) and Anthony Burton (Vice Chairman) and told them I thought I should withdraw the play. They supported this decision fully. As Ken Loach knows, Burton offered to meet the company with me but I thought it better to face them with this awful decision on my own.

Within 24 hours this action had been called both "craven" and "courageous". Without doubt, it was the hardest decision I have ever had to take. The Royal Court's reputation as a champion of new writing is an enviable one. In 99 cases out of 100 of course an Artistic Director must protect the work he has chosen. In the hundredth he must admit he has made a mistake.

Guardian 18.3.87
letters

Sir, — With straight-faced solemnity, Max Stafford-Clark assures us (Arts Guardian, March 13) that there was no pressure put upon him to take off my play, Perdition.

We are asked to believe that five days before the play was to have opened and 18 months after he first read Perdition, he spent the weekend "rereading the books." Then, like Paul on the road to Damascus, came the revelation : " For the first time I saw the possibility that Perdition was a dishonest piece of work."

That is a serious allegation to make against a writer, and I read on hoping to find some evidence that would prove my " dishonesty," but no proofs were offered. Not one single quotation from the play to back up his allegation. Obviously, his courtship with the Zionists has not been entirely unprofitable.

Taking a leaf out of Martin Gilbert's book, he suggests that I rewrote the play as a result of the Cesarani report. Yet he knows that I dismissed it as rubbish.

Some interesting informa-

tion, however, does emerge from his article. We are told how Stephen Roth, president of the Institute of Jewish Affairs, " indicated the powers he could use to remove the play. He could picket. He could contact the Royal Court's friends in New York. He could influence funding bodies in London."

These were no idle threats. We know that one London producer was told : " I own nine theatres, my friend owns six. Put the play on and you're finished." Another producer received a phone call from New York, telling him that his career would be in jeopardy if he produced Perdition.

Mr Stafford-Clark also confirms that four days before he stopped the play, a secret meeting took place at Sonia Melchett's home. In attendance was Martin Gilbert and Lord Weidenfeld.

But Max did not submit to pressure, and all is quiet on the Royal Court front. For now, that is. His performance borders on obscenity
Jim Allen,
1 Parkside,
Middleston, Manchester.

Guardian 19.3.87 letters

Sir,—Max Stafford-Clark's belated defence of his ban on Perdition (Arts Guardian, March 13) begs more questions than it answers :

Why was the decision taken in the author's absence, making it impossible for him to answer the charges against his work ?

Why did Mr Stafford-Clark speak only to Zionist historians and activists about a play to which they were politically hostile ? There are many, academics and others, who support the play.

Why did council members arrange private meetings with the play's opponents but refuse to meet its author ?

Why could we not at least perform the play privately to colleagues and critics to refute the wilder charges of anti-semitism ? The actors knew the play better than anyone. It is hypocritical to pay lip-service to their commitment while disregarding their judgment.

Most important of all, Mr Stafford-Clark does not give

one single example to substantiate his claim that the final script omits " mitigat-

ing factors " that would support the Zionist case.

Here are two examples of the dishonesty that now hangs around the Royal Court management :

I was asked to meet a man who had been in Budapest in 1944. He turned out to be Stephen Roth, Zionist director of the Institute of Jewish Affairs. It is inconceivable that Mr Stafford-Clark did not know his position and political interest, yet Dr Roth was presented to me simply as a survivor from that period.

On the night before the dress rehearsal when Mr Stafford-Clark informed me of his intentions to cancel the production, I asked that no final decision be taken until the following morning. This was agreed between us. When I arrived next day, the press release had already been written.

The plain truth is that Perdition was stopped by public abuse and private manipulation organised by a political tendency, Zionism, that will not acknowledge its past because of the light it sheds on its present.

The eminent poet and author Erich Fried has written of Perdition : " The most telling tribute I can pay it as a writer is this : I am envious I have not written it myself...Dr Yaron is drawn with deep understanding and human sympathy . . . To accuse the play of faking history or of anti-Jewish bias is monstrous. Perdition should be staged and published wherever possible."

It is not the play's credibility which is in question ; it is the Royal Court's.—Yours faithfully,
Ken Loach.
46 Charlotte Street,
London W1.

Sir,— May I add to Max Stafford-Clark's article on Perdition as regards the conversation I had with him and his colleagues on January 13.

I did indeed say that there could be many ways of pressurising the theatre to drop the play. But far from making threats, I emphasised that all those in the Jewish community with whom I discussed this matter unanimously rejected exercising such pressure. I repeated this a second time when Ken Loach joined us later.

In fact, when I mentioned the possibility of pressure and Ken Loach interrupted me saying, " Oh, that is what

you wanted to do," it was MrStafford-Clark who told Mr Loach to wait till the end of the sentence ; which was that we were absolutely against this idea.

Not once did I ask that the play be removed. The purpose of my visit was to ask for a very modest palliative : that the programme include a brief statement that the historical facts as presented in the play are according to the author's personal perception and that many historians and eyewitnesses — of whom I happen to be one — strongly differ from it, and that the same applies to the definition of Zionism in the play.

Ken Loach, without even hearing the proposed words, categorically declared that any such statement was unacceptable. Mr Stafford-Clark was more reasonable and asked me to leave the proposed text of the statement with him to consider it.

Mr Stafford-Clark cited three points I made, but omits my main points ; the so-called " saving of a few Jews," far from meaning that the life of the remaining Jews was to be sacrificed, constituted an " advance " in the negotiations to rescue all the one million Jews still alive in this area ; and while mistakes *may* have been made in the rescue attempts, they had nothing to do with a Zionist " doctrine," as Jim Allen presents it. Doubtful decisions were, in fact, often taken by outspoken non-Zionist bodies, and Mr Allen conveniently confuses them with Zionists.— I am, Yours faithfully,
(Dr) Stephen J. Roth,
Institute of Jewish Affairs,
London W1.

Guardian 21.3.87 letters

Sir,—Jim Allen complains (Letters, March 18) that I give not one single example of my doubts about Perdition. In fact these paragraphs were cut by the Guardian from my article :

". . . There are two accounts of a party given by the leaders of the Skalat Ghetto for the Gestapo on the eve of the trains arriving to take them to Auschwitz. Obviously the party was a reassuring signal to the Jews waiting for the cattle trucks. One account shows this as a deliberately organised and perfidious betrayal. . . while another portrays families

142

shot until a measure of complicity was achieved.

"Jim Allen used the story to discredit Zionist leaders. There was expert evidence to support both views. But which version did I believe? The latter view seemed more likely. It no longer seemed so smart to rely on experts."—

Yours sincerely,

Max Stafford-Clark.

London Review of Books 2.4 87 'Diary' David Lan

The High Court of Justice in London, 1967. Dr Miklos Yaron, a Hungarian gynaecologist, is suing his former assistant Ruth Kaplan for libel. Kaplan has published a pamphlet accusing Yaron of collaboration with Nazi leaders in 1944. As a member of the Central Jewish Council set up by the Nazis, Yaron had known that millions of Jews had already died in extermination camps. Nonetheless he agreed to assist Eichmann with his plan to destroy the Jews of Hungary.

Is there anyone in Britain interested in the theatre, in civil liberties or in Jews who can't identify this as a scene from Jim Allen's play *Perdition*? The successful lobbying by Jews in Britain to have its production cancelled has made it one of the most famous plays of the decade. I have read it and like it very little, but by forcing its cancellation, modern Jewish leaders, Zionists among them, have given credibility to one of the assertions Allen makes about Zionist leaders of the past. A Jewish joke if ever there was one, but not many people are laughing.

As the play is set entirely in the courtroom, I'll start with a confession: I am the only Jew in England who is not an expert on Zionist politics 1939-1945. Have you put on your picketing shoes yet? Hold on, there's more. When I was growing up in South Africa I was totally uninterested in – not to say, embarrassed by – Zionism, or, more accurately, by Zionists. How I felt is captured by Lenni Brenner's account, in *Jews in America Today*,* of the callow youth who are heard to say: 'I wouldn't be seen dead with those creeps.' Reading the correspondence *Perdition* elicited, it came back to me why I felt as I did.

In the play, Ruth Kaplan charges Yaron with gross self-interest. She claims that Yaron's reward for keeping silent about the fate he knew awaited the Hungarian Jews in the

camps was that he, his family and his associates would be allowed to emigrate to Israel. Yaron's defence is twofold. If he had not obeyed Eichmann, he would have been executed. Indeed, many other members of the Central Jewish Council had refused and were killed. More important, he had also been a member of the Zionist Rescue Committee which had achieved some success in smuggling Jews out of the country, even in freeing a number from the camps. He believed his duty lay in bargaining with Eichmann for the lives of doomed Jews. To turn his back was to abandon all of them. To collaborate was to give some, however few, a chance of life.

That collaboration such as Yaron's occurred is not in question. In the course of the play, however, witnesses are wheeled on to bring more complex charges against Zionism and the early Zionist leaders. Allen believes that the roots of Yaron's collaboration 'lay in pre-war efforts of Zionism to effect an alliance with the Nazis'. It is here that the play's accuracy and integrity have been challenged.

Allen's charges are these: Zionists collaborated with Nazis to ensure that the small number of Jews who were allowed to escape would consist of those best-equipped to build up the state of Israel – the young, the strong, the rich. Secondly, believing the Nazi persecution was conclusive evidence that assimilation of Jews by Gentiles would never succeed, they campaigned to prevent Jews emigrating to any country other than Israel on the grounds that it would retard their plans for the establishment of the Jewish homeland. David Ben-Gurion, the first prime minister of Israel, is quoted in the play as saying: 'If I knew that it would be possible to save all the children in Germany by bringing them over to England, and only half of them by transporting them to Eretz Israel, then I would opt for the second alternative. For we must weigh, not only the life of these children, but also the history of the people of Israel.' The third charge is the most grotesque. It is that some Zionists argued that there was only one means by which Jews could ensure that their claims to the land of Palestine would be heard when, after the war, boundaries came to be drawn and territories apportioned. This was by the shedding of their blood: the more the Jews suffered, the greater would be their moral right to the land they claimed as their ancestral

Jews in America Today (Al Saqi, 370 pp., £25 and £7.95, 19 February, 0 86356 124 1).

home.

Allen's charges can be reduced to two assertions: the Zionism of the early leaders was incompatible with basic morality and humanity; the leaders betrayed their people. Many of his claims are disputed, especially those he makes about the relationship between the Central Jewish Council and other Jewish organisations, and the extent to which resistance occurred. As I have said, I don't know enough about the period to contribute to this discussion: but Allen should certainly have got his facts right. On the other hand, among the Zionists and other leading Jews who pressed for the cancellation of *Perdition* were publishers, lawyers, members of theatre boards, even playwrights: they support art, books, free speech – until someone says something offensive to them.

In the end, Allen is interested only in a small group of people, the leaders, and he is interested in presenting them, not within the world in which they lived, with all its hideous complexity and danger, a world of darkness and shadow, but in the cold hard light of the courtroom, the light of 'justice'. The play occasionally allows Yaron to defend himself by sketching the context in which his choices were made, but he is a man on trial – it quickly becomes Yaron rather than Kaplan who is on the defensive – and whatever he says is likely to be a lie. No, Allen has made up his mind that Yaron belongs in a dock and it is only in the dock that he is seen.

It is charged against these Zionists that they held their followers in contempt, not trusting them to find their own best path to salvation. In the face of annihilation they kept their faith in order and hierarchy, in the right of the wise leader to lead; and so they failed to encourage Jews to organise, to take up arms.

Scott: You could have told them to flee, to resist.
Yaron: There was nowhere for them to go. Where could they have fled to?

In a word, the betrayal perpetrated by the Zionist leaders was a betrayal of democracy. This is a crucial point because many of the letters and articles that have been written about *Perdition* claim that it is anti-semitic. To claim that an attack on Zionist leaders – even on non-Zionist Jewish leaders – is an attack on all Jews is absurd. The theme of the betrayal of 'the people' by 'their leaders' is an obsession of Allen's, as of many other Trotskyist writers. It is, for example, a central theme of *Days of Hope*, Allen's outstanding television series about the General Strike. To suggest his attack on union leaders in 1926 is an attack on all working people wouldn't hold water. It is an attack on a system of political representation: so is *Perdition*.

The extraordinary response which the play elicited – a correspondent in the *Stage* called *Perdition* a 'blood libel', whatever that is – shows how determined Zionists in particular still are to see themselves as leaders, as spokesmen for all Jews, to interpret criticism as a slight against centuries of history, to present anti-Zionism as though it were anti-semitism. They are not; it is not. It was precisely this arrogance that made me 'not want to be seen dead' with them when I was a teenager twenty years ago. Surely people expect that their leaders will betray them. Surely it is one of the glories of democracy that when your leaders betray you you can get rid of them. To identify Zionist leaders with the Jewish people as a whole, as critics of the play have done, is to awaken a brand of nationalism the Second World War was fought to put to sleep for good – though it has done no more than settle into a troubled doze.

One of the sharpest objections to Jim Allen was that he referred to the holocaust as a 'myth'. This was interpreted by columns of letter-writers to imply that he did not believe that the killing of the Jews actually took place. How ludicrous this is is made clear when Claude Lantzman, director of *Shoah*, perhaps the most widely-acclaimed record of this particular genocide yet produced, refers to the killings in precisely the same terms. In the *Jewish Quarterly* he is quoted as saying: 'The Holocaust today is legendary in all different sorts of ways. It has all the characteristics of a mythical account; as knowledge of the unknowable, it is blurred, vague and stereotyped.' Lantzman's wish is to oppose the myth of the Jewish holocaust with 'a counter-myth – that is, an investigation of the holocaust's present'. The film, more than nine hours long and ten years in the making, contains no footage from the archive. Nothing is shown that did not happen before the eye of the camera as the film was being shot. The greater part of it is taken up with interviews with people who were there then, survivors, witnesses, Nazi

144

camp officials, peasants who lived in or near the villages where the camps were sited. They talk, sometimes at great length, about what they did or were forced to do, what they saw, what they felt. And yet, although one might expect the weight of these thirty or forty-year-old experiences to thrust one back into the past, everything that we see, or are told, seems to be happening simultaneously in the past and the present, and sometimes in the time in between as well.

The film begins with one of its most moving sequences. Simon Srebnik was 13 when he was sent to the extermination camp at Chelmno. Placed on a 'Jewish work detail', he had as one of his tasks to row up the Narew River under guard to pick alfalfa for the rabbits the SS kept in the camp. As he rowed he sang, and the beauty of his voice made him a favourite. In 1945, two days before Soviet troops liberated the camps, he was shot in the head but survived and emigrated to Israel. Lantzman persuaded him not only to return to Chelmno but to row up the same river in a similar boat and even to sing. He sings with a faint smile on his face as though in a dream. Then Lantzman interviews Polish peasants who heard Srebnik sing as a boy and now hear him again as a fifty-year-old man. The legend of the holocaust is distilled into equal parts of suffering and endurance. The effect is unforgettable – which is the point.

Lantzman takes Srebnik to the site of the camp, now grassed over. Only a low brick wall marks the place where the central buildings stood. Srebnik wanders about: 'It's hard to recognise, but it was here. They burned people here. Yes, this is the place.' The camera tracks back and back and back along the soft grassy paths that lead into the camps: this is the path, this is the railway line that brought in the cattle-trucks . . . For hour after hour, we see only railway lines, meadows, aerial views of forests, paths through the woods, but the screen is full of horror, a horror of transition; to move from one place or one state to another was to move inevitably out of life and into death. How could these trees have grown? When had the grass time to cover the paths? Simon Srebnik is still here singing in his boat on the river. The peasants are still on the river banks, smiling, chatting, hearing him, watching him pass.

Having invented this, to my mind, extremely important technique, Lantzman uses it over and over again. When he interviews Polish peasants who, forty years earlier, had watched trains bearing doomed Jews entering the camps, he places them in front of the same railway lines. Trains shunt up and down in the background. One of the most powerful segments focuses on Abraham Bomba, who survived the camps because he agreed to use his skill as a barber to cut the hair of women before their execution – the hair was then sold to help meet the running costs of these self-financing institutions. He is interviewed in his barber shop in Israel and, while cutting his customers' hair, describes performing his task for the Nazis, sometimes on people from his own village.

In Bomba's replies is the implication that the scene has been set up. It must have been. It's scarcely possible that Lantzman could have arrived unexpectedly and put his uncompromising, relentless questions to the unprepared barber. The scene is a kind of performance, a partial reconstruction, and Lantzman insists that it be carried through even when Bomba is close to breaking down.

> 'But I asked you and you didn't answer.'
> 'I can't. It's too horrible. Please.'
> 'You have to do it. I know it's very hard. I know and apologise.'
> 'Don't make me go on, please.'
> 'Please. We must go on.'

What is the justification for that 'must'? Because it's good cinema? Partly. Because it's good for Bomba? That would be intolerable. Because it's good history? It is extraordinary history, but the real point, I would guess, is that Lantzman feels compelled to record this distress because it is evidence, otherwise easily overlooked, that these lives have passed through death. It is as much a sign of the existence of the past in the present as the nameplate on the truck speeding along an autobahn: Siemens, suppliers of trucks to the Nazis.

Lenni Brenner's new book is a lament for the failure of so many American Jews ('the best-educated and richest minority in America') to hold onto their memories of distress, to broaden the horizons of their compassion, to give support to oppressed minorities of the present day. It is a raucous over- and underview of where American Jews have got to over the past forty years. The first half deals with

the financial and political power Jews have acquired. The second deals with what Brenner sees as the misuse of this power. The chapter on blacks and Jews concludes that 'the Jewish Establishment have been waging a ferocious economic war against the Blacks, with their never-ending attacks on affirmative action '

The most passionate chapter, 'Six Million Skeletons in the Closet', is a return to the themes of Brenner's earlier book *Zionism in the Age of the Dictators*, one of the key sources for *Perdition*. Here Brenner reviews the efforts of the Jewish establishment of the war years to play down, even to conceal, reports of the camps in Europe for fear of inciting anti-semitism at home. One of his prize quotations is also used by Jim Allen. It is from a letter sent by Rabbi Steven Wise, leader of the American Jewish Congress, to Roosevelt in 1942, the first year of the Final Solution: 'I have had cables and underground advices for some months, telling of these things. I succeeded, together with the heads of other Jewish organisations, in keeping them out of the press.'

'I wouldn't be seen dead with these creeps.' As I watched *Shoah*, it came to me that of course in certain circumstances, whether I wished to or not, I would.

Jewish Quarterly
'The Perdition Affair'
David Cesarani

BY the time the last article on *Perdition* has been written and the last letter published, it is quite likely that the controversy over Jim Allen's play will have outlasted the run it was supposed to have had at the Royal Court Theatre. It has been an affair that has raised a bewildering complex of issues.

What kind of a play is *Perdition*? Is it a version of anti-Zionist propaganda which sets about the denial of the Holocaust? Is it antisemitic...or anti-Jewish? Why was the play cancelled twenty-four hours before the preview? Was there censorship or Jewish pressure? What is to be made of claims to this effect by Allen and Ken Loach, the play's director?

There are still more questions on the agenda and others may arise. In fact, since the play has not been suppressed and may well be produced in the future, there is bound to be yet more debate. However, in the interim, it might be worthwhile reviewing the state of the play so far.

Perdition is anti-Zionist propaganda. Jim Allen has proudly called his drama "the most lethal attack on Zionism ever written". Michael Hastings, the head of the Literary Department at

the Royal Court, made no bones about this when he said "it does provide a subtext acutely aimed at discrediting Zionism". But whereas Hastings followed this up by adding that "the fictional account must be honestly declared, right from the start", Allen and Loach have defended the play's facticity to the bitter end. The question of accuracy became central to the debate since the author claims to represent actual events and arguments in the past while its critics have accused it of bending history in the service of ideology.

The play is a court-room drama based on an actual libel case brought by Rudolf Kasztner against Malkiel Grunwald in Israel in 1953-54. Kasztner had been a member of the wartime Rescue Committee in Budapest which sought ways of aiding Jews from Slovakia and, after the German occupation of Hungary in March 1944, managed efforts to save Hungarian Jewry.

Grunwald accused Kasztner of collaborating with the Nazis and saving himself, his family and certain Zionist leaders while deserting the Jewish community. The case was complicated when it was turned into an attack on the Mapai (Israeli Labour Party) government and its leader Moshe Shertok. Kasztner had close links with Mapai; Shertok had been at the Palestine end of his unsuccessful rescue schemes. Kasztner faced a hostile anti-Mapai lawyer and a similarly antipathetic judge. Although he won the case technically, the court awarded derogatory damages and Kasztner was forced to appeal, without success. He was assassinated before a higher court finally cleared his name four years later.

There is a rough consensus amongst historians as to what happened in Hungary during those awful weeks. Kasztner had originally been a rebel against the quiescent official community leadership but he became increasingly authoritarian and overconfident when he established contact with the Nazis in Budapest and began bargaining for the lives of Hungarian Jewry. He was exploited and out-manoeuvred by Eichmann who first took money from the Jews in return for promises of salvation and then used Jewish channels as a way of sowing discord between the Allies. After demanding cash for Jews, the Nazis offered to let thousands go if the western Allies would supply them with trucks for use against the Russians. This was the plan conveyed to the West by Joel Brand on his famous mission. The deal was quashed by the Allies, despite pleas by Jewish leaders in Palestine and the West that it should at least be spun out to delay the slaughter. All that Kasztner achieved was a "goodwill gesture"—a train load of around 1,800 Jews which was first deposited in Belsen before being released in two groups, in August and December 1944, destined for Switzerland.

Jim Allen's version is very different. Kasztner, in the fictional guise of Dr Yaron, is accused of deliberately misleading and pacifying Hungarian Jewry. In return for this he is allowed to save selected prominent Jews who will go on to help build the Zionist State. Yaron's main object is not to save lives but to see to the success of Zionism. He is prepared to "sacrifice the Jews of the

Diaspora" to this end since the massacre will strengthen Jewish claims to a homeland. This outlook is shared by other Zionist world leaders who decline to make any intervention to prevent the mass killings. This ruthlessness and willingness to save a chosen few is attributed to the "cruel criteria" of Zionism which is portrayed as a political philosophy that shares with Nazism the ideas of racial exclusivity and the worship of the soil. It is this common outlook which facilitates Nazi-Zionist collaboration, a phenomenon which the play traces back to the first years of Hitler's ascendency. Yaron's collaboration is thus the outcome of Zionism. *En passant*, Israel, the embodiment of Zionist ideals, is characterized as a racist state and this underlines the account of the wartime events.

T O construct this version, Allen gives to the Defence Counsel a series of quotations from various sources. Many of the quotations he uses have been taken out of context to distort their meaning; much of the narrative of events is sheer invention. The predominant view amongst historians—as varied as Martin Gilbert and Dr Jonathen Steinberg of Cambridge University—is that the play traduces history. But the correction of the facts needs also to be placed within an analysis of the particular world-view, the line of propaganda, which necessitated this travesty. Perhaps, even more importantly, Allen's reconstruction of the past and his characterization of its Jewish victims has to be examined for the projection of certain stereotypes of the Jews and their history.

Allen's play belongs to a strand of left-wing anti-Zionism which regards the accepted history of the Holocaust as an ideological prop for Israel's survival. Israel and Zionism are thought to derive strength and legitimacy from the torment of the Jews in 1933-1945 and from the West's guilt that it was allowed to go on unhindered. Zionism is perceived here as an entirely modern movement without roots in Jewish religion or culture. In the script, Scott, the Defence lawyer, says that the "early Zionists were atheists and non-believers" who used Judaism to legitimize its seizure of Arab Palestine; Zionism "annexed the Jewish religious tradition". Such an analysis is simplistic and ignores the role of rabbinical figures like Mohliver and Kook who were ardent Zionists, not to mention the whole stream of Mizrachi, the religious Zionists. It is necessary, however, because left-wing anti-Zionism is based on the assumption that Zionism is purely a negative response to Jewish persecution; if *that* could be ended, Zionism would have no function. In the same way, if the story of the Holocaust can be qualified, it is assumed that Israel loses a major part of its *raison d'etre*.

Anti-Zionists bent on undermining the Holocaust do not deny that it occurred, in the manner of the extreme right. But they utilize certain historical events like the Kasztner case to argue that the Jews were accomplices in their own destruction. In particular, they argue that Jews and Nazis worked together during the war, even to the point of assisting in the killing process. Allen made this intention clear when he said his play was

the most lethal attack on Zionism ever written, because it touches on the heart of the most abiding myth of modern history, the Holocaust. Because it says quite plainly that privileged Jewish leaders collaborated in the extermination of their own kind in order to help bring about a Zionist state, Israel, a state which is itself racist.

This form of anti-Zionist propaganda has existed for many years in the Soviet Union and has recently been popularized in the West in polemics like *Zionism in the Age of the Dictators* by the American Trotskyist Lenni Brenner. Allen draws his thesis and most of his quotations from this book which he calls a "goldmine source". Commentators have noted that this style of Soviet anti-Zionism has drawn widely on anti-Jewish stereotypes and Allen does so too. But *Perdition* is singular for the range of anti-Jewish imagery and for the Jewish conspiracy theory which lies at its heart.

T HE revelation of the conspiracy begins with the reading of the indictment. The fictional author of a pamphlet entitled "I Accuse", Ruth Kaplan, is quoted as writing that "I accuse certain Jewish leaders of collaborating with the Nazis in 1944. Among them was Doctor Yaron. He knew what was happening in the extermination camps, and bought his own life and the lives of others with the price of silence." It is claimed by Scott that Yaron "lied" to the Jews of Budapest: "You did everything in your power to mislead your people in order to save your own neck."

The network of conspiracy spreads wider. It is stated that, after the Nazis came to power, the Zionists in Germany had "secret meetings" with them. When the American Jewish leadership learned of the extermination of the Jews, it is alleged that they remained "silent". Their leader Rabbi Stephen Wise "agreed to remain silent... acting as an accomplice of...antisemites in the State Department". Weizmann is also part of the conspiracy; the Prosecution summarizes part of the testimony of Ruth Kaplan: "Are you seriously suggesting that Chaim Weizmann...was...part of a cover up?" Ruth answers "Yes".

This conspiracy is juxtaposed with the power attributed to the Jews. Had they wanted to, they could have resisted the Nazis, in Berlin, Budapest or in Washington. Wise is accused of refusing to mobilize "all-powerful American Jewry". Jewish leaders in Germany refused to lead "Jewish workers [who] went out on to the streets" to fight the Brownshirts. Yaron refused to mobilize "one million Jews who had nothing to lose. A formidable force". Instead, the Zionists betrayed the Jews of Europe.

As the play progresses, the act of betrayal becomes the black centre of the conspiracy and the cover-up. Scott makes the accusation that Yaron and the Zionists in Budapest were "hired functionaries who secretly crept out of Hungary at the height of the Deportations....First you placed a noose around the neck of every Jew in Hungary, then you tightened the knot and legged it to Palestine." "To save your hides you practically led them to the gas chambers of Auschwitz. You offered them soothing assurances while the

147

gas ovens were made ready". "A curtain of silence, prompted by shame, has shielded this dark page of Jewish history", but the trial has now exposed this conspiracy to betray.

THE theme of a covert plot and betrayal resonates with the story of Judas. This is reinforced by ascriptions of Jewish cruelty, callousness, expediency and ruthlessness. The purpose of this is personal gain or the achievement of a greater good—Zionism. Explaining Zionist behaviour, Ruth alleges that "in return for keeping the peace in the camps, they would be allowed to select certain Jews for rescue". She says that "their goal was the creation of the Jewish Homeland, and to achieve this they were prepared if necessary to sacrifice the Jews of the Diaspora". This was the "cruel criteria" of Zionism.

Zionists are driven by the desire for personal gain and are willing to justify any means, no matter how terrible, by their ends—the goal of Jewish Statehood. They are characterized as heartless dealers in lives: "Israel was coined in the blood and tears of Hungarian Jewry." These references to blood connect with a plethora of christological references in the last twenty pages of the play. Yaron mentions Pontius Pilate and Golgotha: he describes the trial, which it turns out was his devising, as a "confessional" in which he was hoping for "absolution". There are also several metaphors relating to the crucifixion. The junior counsel for the Defence gleefully exclaims to Scott: "You crucified him." Yaron congratulates Ruth on her pamphlet, for its "words hard as nails". He approves of Scott too: "I like him. Merciless. I felt that he was ramming spears into my body."

The play virtually ends with references to "polluted wells" and, again, crucifixion, both major thematica in Christian antisemitism. There are also parallels between Allen's writing and the antisemitic image of the Jew found in *The Merchant of Venice*. Yaron and his accomplices are compared to "the Zionist knife in the Nazi fist". The *Merchant* abounds in cutting imagery; it also builds a picture of the Jews as a cold people without sentiment, willing to sacrifice life for abstract higher principles. If Yaron delights in the "spears" which Scott thrusts into him, Shylock in the *Merchant* exclaims "Thou sticks't a dagger in me . . ." and like Yaron ends up grovelling for absolution.

TO alleviate Western guilt for the Holocaust and to subvert its utility to Zionism, Allen reconstructs it as a conspiracy in which the Jews were themselves complicit. Allen also overcomes the problem of Jewish powerlessness which the events of 1933-1945 appeared to exemplify and which is often held to justify the existence of a Jewish State. Instead of being powerless and doomed to extermination, the Jews are implicated in a vast conspiracy with the mighty Nazi Empire. The claim of Zionists and others that the Holocaust revealed the helplessness of Jews in the era preceding the creation of Israel can be dismissed.

If Allen's play was simply a piece of anti-Zionist propaganda it would be unexceptionable, but Allen goes further and crosses the frontier into antisemitism. *Perdition* incorporates the myth of the Jewish conspiracy, the myth of Jewish power as well as numerous anti-Jewish stereotypes to do with betrayal, cruelty, dealing and a host of emblems resonating with imagery from the death of Christ. Nor is there any defence in the fact that the play is about the suffering of the Jews and portrays some of them in a heroic mode. The only Jews to appear in a positive light are left-wing Jews, anti-Zionist Jews or assimilated Jews—none of whom would find ready acceptance in the established Jewish community and who have no obvious commitment to Jewish continuity.

Perdition was withdrawn by the Royal Court the day before it was due to be previewed. The final decision was taken by the theatre's Artistic Director Max Stafford-Clark, after the Theatre's Council had voted by twenty-seven to three to postpone the production until, amongst other conditions, it could be vetted by independent historians. Despite this, Allen and Loach have asserted that the play was "banned" as a result of "pressure" on the Royal Court by prominent Jews and "the Zionist lobby". Loach has alleged that a "clique" comprising Lord Weidenfield, Lord Goodman and Stephen Roth—men who can "buy their own way"—were responsible for the suppression of the play.

Yet Stafford-Clark has gone on record to the effect that absolutely no financial pressure was brought to bear on the Theatre. Although he originally defended the veracity of the play he has since admitted indirectly that the play did not meet the "scrupulous canons of history" and that a subject like the Holocaust "cannot be allowed the license customarily afforded to playwrights". Despite this, Loach has insisted that "there was a heavy and effective piece of lobbying by a very small group" which forced the cancellation of the play. Allen has suggested that theatres which show an interest, even school halls, are leaned on to prevent performances of his work. The allegation that there is a Jewish-Zionist conspiracy against the play and the assumption that Jews have the power necessary to stop it, indicates that the line presented in the play is not just a historical account but the expression of a current world-view.

Allen and Loach could easily have been disabused of this idea if they had been privy to the ramshackle way in which the organized Jewish community actually did respond to the problem which *Perdition* presented. Individuals protested to the Theatre and wrote letters to the Press. Journalists naturally used the story and both the protagonists and the antagonists supplied them with copy. A spectrum of Jewish groups planned demonstrations outside the Theatre. Only at the last moment did the Board of Deputies set up a coordinating committee which attempted to concert plans for a protest. The Board's Press conference, called at the eleventh hour to present a so-called communal viewpoint, was rendered irrelevent by the Theatre's decision, yet the Board's leadership appeared eager to give the impression it had acted and careless words were uttered implying that "pressure" had been brought to bear.

148

This claim was repeated by the *Jewish Chronicle* and was soon being quoted by Jim Allen.

Jewish organizations might have acted legitimately and in the open at an earlier stage, as an ethnic group threatened by a play that dealt categorically with Jews in negative terms. While official communal leadership did little about the play until very late, it nevertheless managed to create the damaging idea that it had exerted influence via the backstairs. Subsequently, the Board's leaders resolved to re-write history and claim that it had, indeed, acted to suppress the play. It is ironic that only Jim Allen and the Board of Deputies have a shared interest in perpetuating this fabrication.

Michael Hastings, once a champion of Jim Allen's cause, has confessed in a letter to the *Jewish Chronicle* that "*Perdition* could be looked upon as an anti-Jewish play, no matter how unintentional this was in the writing...". These are the grounds on which Allen's writing can be contested most strongly. It might be argued that it is wrong to protest against the production of a play which is merely inaccurate, like *Richard III*, or nasty about Jews, like *The Merchant of Venice.* But Shakespeare's plays were Tudor propaganda and it is hardly a defence of a play to say that it is hackery in the service of some cause, least of all if it lacks even a mite of the Bard's brilliant writing. And if there had been a Race Relations Act in 1596, and Jews in England willing to contest their negative depiction on the stage, perhaps the eternally dangerous stereotype of the cruel, wheedling Jew would not have entered Western culture.

In a society that is struggling towards ethnic pluralism, there is an obligation to challenge stereotypes everywhere, especially in the cultural sphere. This is not undue touchiness as the *Guardian* implied, in an editorial criticizing *Perdition* which explained that "what is wrong is that the sensitivities of race are so near the surface of the national life; and that the Royal Court took a long time to realize that, regrettably, that still applies to many Jews, in their hearts and in their perceptions of history, as it does to other minorities." There is nothing regrettable about the desire to cherish national memories or to dispute cultural stereotypes; in a multi-ethnic society it is an act of citizenship.

For Jews and non-Jews who are engaged in the dilemma of Israel and the Palestinians there is a similar obligation to end the process of demonization and to seek dialogue. Allen's play has not helped the Palestinians one bit. It has inflamed feelings about Jews and given renewed currency to the myth of the Jewish conspiracy and the myth of Jewish power. No play and no *cause célèbre* ever had a more appropriate title than *Perdition.*

Newsline
'Perdition- the actors view'
Kathy Hilton

SOME four months ago nine actors came together to work on a play – 'Perdition' – written by Jim Allen and directed by Ken Loach.

It was to be put on at the Royal Court theatre in London – a theatre with a strong reputation for promoting new and often controversial work.

After three weeks of rehearsal and just 36 hours before the curtain was due to go up, the Royal Court's artistic director Max Stafford Clark called the cast together and anounced that he was cancelling the production.

He claimed the play, which shows the collaboration between the Zionists and the Nazis in World War II Hungary, would cause much suffering in the 'community'. It was later said that the play could incite racial hatred.

The cast, which included four Jewish actors, together with backstage staff, completely opposed the decision and stood 100 per cent behind the play.

An intense public discussion ensued, including a prolonged 'debate' in the 'Guardian' newspaper.

Many people aired their views and took sides on this play which had been read by few and seen by no one.

Even the writer Jim Allen and director Ken Loach managed to fire a few shots across the bows of their critics.

But up until now, the actors and the backstage staff have had little opportunity to say why they stood so firmly by the play.

Last week five of the actors, Judith Sharp, Caroline Gruber, Ania Marson, John Gabriel and Zbigniew Siciechowitz, plus two of the backstage staff, Lindy Hemming and Bob Starrett

told News Line why today they are more firmly in support of the play.

Their statements are a tribute to a brave and principled stand and an indictment of those who have opposed 'Perdition'.

Because of the play's subject matter all took on their jobs with some commitment to the piece. It was a serious play, they were to work with a writer and director they respected and at a theatre they held in the highest regard.

Caroline: With a play like this I don't think any actor could have done it if they hadn't been at least been interested. There's no way if you'd been shocked and horrified at what was being said you could have accepted the part. So we all went in there with a commitment to the piece.

We all felt if the Royal Court is putting this on it must be alright. It must have been researched. We were under the aegis of the Royal Court.

Zbigniew: When I had read the script I was a little surprised that the play wasn't causing waves already. When it was taken off I thought — this is what was supposed to happen.

Lindy: If you write a play that touches the nerve of established situations in this country, you will immediately see that censorship is fully in operation. There is power everywhere to stop things being said that certain people don't want to hear.

The unfortunate thing about the theatre is that there are hardly any plays written or produced that do touch on really strong or fundamental issues at all. That's why I suspected that 'Perdition' would either not get on or would cause a huge controversy.

Judith: I knew there would be trouble but I couldn't imagine the Royal Court taking an enormous step backwards like that.

And what of the feelings once the play was taken off?

Lindy: Before we started doing the play we hadn't really thought of what the play was about and what the implications were.

What unfolded after the play had been taken off was more than we had understood would happen. If it's done any good it's informed a lot of people about that side of censorship.

John: At first we viewed it as a play. We didn't view it in any way as a political document. We saw it as a piece of drama in which we were asked to appear.

As the months went by — after all the hassle, all the controversy, the various views and all the reports, mostly biased — then gradually we started to think of the play in an entirely different way.

Caroline: We all felt quite strongly when it was taken off. If the final word on 'Perdition' is that the play will incite racial hatred, then what does that say about the people that were involved in it? We were all determined to disassociate ourselves from that opinion.

From my own point of view, when we were working on it my own commitment to the piece developed every day. I believe totally that this play should be seen.

When it came off and we had been struggling for several weeks to put it on, there were times when the pressure was very intense. There were times when I felt — and I didn't stay with this opinion — that I couldn't go through with it.

So many people were being offended, so many people who I cared about were being made very upset by it. At one point I said, I think I'm going to pull out, but I didn't. But I think it was made very difficult for us.

To a point, we were taking things on trust. We believed in Jim and we believed in Ken, which is why we've all stuck with it. But there were moments when we thought: 'My God. What have I let myself in for? Is this play inaccurate? Have I let myself in for something which is bigger than I thought it was?'

The blame for feeling like that rests with the Royal Court, which withdrew its support from us. We were left anchorless.

We were left without any protection and we were having directly to face the onslaught of, 'You are an anti-Semite', which was something very hard for anyone to face and particularly hard for a Jew.

John: It was obviously a decision by the board or the council of the Royal Court. Surely it would have been more honest and fair if somebody representing them had had the courtesy to tell the company 'It is a policy decision to take this play off. It's not an artistic decision'.

It's a dangerous precedent when they can ban things without people having seen them. Papers take up one side or another and there's been plenty written about 'Perdition'. Yet nobody has seen the thing.

What about the charges of anti-Semitism?

Caroline: The vast majority of Jewish people couldn't believe what was in the play was true. They thought it was a pack of lies and anti-Semitic.

Jewish people and non-Jewish people do connect anti-Zionism with anti-Semitism. It's very difficult to persuade people that if someone is anti-Zionist, they are not anti-Semitic.

If you say 'I think what the Jews are doing in Israel is wrong', they immediately think you're anti-Semitic.

Experts

John: Whenever we were wavering, Ken brought in informed Jewish experts. One was an Israeli filmmaker, an ex-Israeli diplomat. He came in and sup-

ported the play totally and endorsed all the facts and said it was the truth.

From the word go, not one member of the cast spotted anything anti-Semitic. As a Jew, I would no more be in an anti-Semitic play than grow wings and fly.

Every Jew who's seen it says there's nothing anti-Semitic in the play. There were people from Hungary who'd been in concentration camps who came to rehearsals and said the same.

To say it is anti-Semitic is a myth. That is one of the reasons why the play should go on so that people can see for themselves.

Ania: The play makes Doctor Yaron (the Zionist in the play who collaborated with the Nazis) very sympathetic towards the end. The end of the play is saying, what would you have done? Put yourself in their position at that time. What would you have done?

Judith: That's what's so good about the play. Whatever Jim Allen thinks, and however much you think you know what Jim thinks, when you actually read the play or watch it you find yourself switching ideas. You get very troubled and very disturbed and have to think really hard about what you're being presented with. It doesn't make easy judgement at all.

Caroline: Jim tried to make the character of Yaron sympathetic. He wasn't a villain. It wasn't 'a tirade of anti-Semitism'.

Bob: It's such an insult to be branded an anti-Semite. It's a terrible thing because in the folklore of the business some whizz kid in a newspaper in the future will go back to what happened in 1987. They'll say, 'Oh yes, "Perdition", who was for and who was against?' – and the original debate and the original play will be lost.

And why should the play go on?

Zbigniew: I think simply that this is the first attempt at portraying Jewish affairs during the last war which are not well known to the public at all.

Judith: Even speaking from our own experience, it's the kind of play that takes a while to sink in. It takes ages to think through it. It's not the sort of play you could just read and have an immediate: 'Right, I know what I think about this thing'.

I'd read it ages before and I'd gone through incredible fluctuations of feeling about it. At one stage I really thought I couldn't do it. I thought, 'I'm not sure because it does deal with such really difficult things'. But that is its strength and why it is so important.

Bob: I would like to say I don't think we've heard the last word on 'Perdition'. I think it will eventually be staged and there'll be a more aware audience because people will have gone to the textbooks and have looked things up.

What about the role of the press?

Caroline: The initial problem was the article by David Rose in the 'Guardian'. His article was not only biased, it was also grossly inaccurate. That was when all the trouble started because people started to respond to the inaccuracies.

Judith: What shocked me about the reporting in the press was this banding around of these famous historical inaccuracies. Yet, when people were questioned about the inaccuracies on TV, they suddenly disappeared.

Every single newspaper said there was inaccuracies in this play. None had checked what they were and none ever said what they were.

Lindy: I can't think all the misinformation comes about by accident. Otherwise

you'd have an equal amount of true information. There has to be a reason why they took that line.

If I had the time or the balls I would try to find out what that was. But I can't just go down the river believing that it happened by accident.

What kind of support did the play receive?

Ania: There was support from the Directors' Guild. They supported Ken Loach.

Bob: It was sad to see letters in the 'Guardian' from people like Arnold Wesker and Alan Sillitoe, writers that I've always admired.

Larry Adler summed it up. He said: 'The minute you say I'm opposed to censorship, BUT . . . you're on dangerous ground'. I agree with him absolutely.

What do you think should be done to protect actors and playwrights against such an attack?

Lindy: Unless we behave like we're behaving now, then censorship is the name of the game. What should be done to protect actors is that actors should protect themselves.

They should involve themselves in affairs and not live in a rarefied atmosphere, which is the tendency of everybody in the arts. They think what they're doing is so important that they don't have to involve themselves in anything else.

Caroline: Unfortunately the name of the game with actors is fear, the fear of unemployment – if I'm involved in this play nobody will ever ask me to work for them again. They get very frightened and don't want to rock the boat.

I think it shows our commitment to the play and our strength of feeling about it that people who would have given their high teeth to work at the Royal Court all sat there

151

and shouted down Max
Stafford Clark.

I was amazed at myself
because I wanted to work
there and was putting my-
self in a position where the
chances were that I would
never work there again.

We all fought him and
that was because of what
the play did. It was not
about actors losing their
jobs.

Bob: It was about taking a
principled position.

[excised]

New Statesman 13.3.87
'How the row started'
David Rose

No one was more surprised than I when a week
after my article in the *Guardian* opened the
Great *Perdition* Row on 14 January, the Royal
Court theatre announced the cancellation of the
play. Somewhat guardedly in the *NS* (13 Feb.).
Ken Loach has accused me of being part of a
'Zionist front', campaigning for the censorship
of the play by dishonest means.

My article, according to the piece by Loach
and Andrew Hornung was 'full of lines that did
not appear in the final text' and 'grossly
misinterpreted the play'. Loach and Hornung
wrote: 'We can only assume that Zionist
organisations, possibly the Institute of Jewish
Affairs, were circulating an early draft of the
script, with copies of hostile reviews from
historians sympathetic to their cause. Certainly
the Institute presented its own anonymous
report attacking the play.' Thus, they claim, I
fired the opening shot in the undeclared war
against the play from the (Zionist) 'censorship
lobby'.

In fact, I got my copy from the Royal Court
press office, which sent out the script with a
press release to national newspaper arts editors.
The day before I wrote the article, the same
organisation gave me a thin sheaf of
amendments, and assured me that I had the final
text that was to be performed. I went through all
the points I raised in my article during a
90-minute interview with Jim Allen, referring
constantly to my copy of the script, which lay on
the table in front of us. At no stage did he
suggest it was anything other than the text which
would be performed.

Alas, for Ken Loach's emerging conspiracy
theory: I have never seen the critique submitted
by the Institute of Jewish Affairs.

Loach quotes a line from the play refuting my
central allegation that the play claims that Jews
welcomed the slaughter as a way of establishing
the State of Israel. I based my statement both on
my interview with Allen and on other passages
from the script.

[excised]

What I objected to in first reading the play
was not its message, or its purpose — to carry
out 'the most lethal attack on the State of Israel'
according to an interview with Allen in *Time Out*
— but the way it was put across. The script,
considered, was shot through with an odious
and slippery intellectual dishonesty. In mounti
his attacks like that in the *NS*, Loach has
perpetuated and deepened that dishonesty.

New Statesman
13.3 87 letters

Tony Garnett, Kestrel Films, Burbank,
California, USA
The pathetic flurry over *Perdition* is familiar.
Jim Allen is used to public rows. The odd fact,
at least to me, is its location. Few people go to
the theatre, fewer take it seriously. The Royal
Court, however, living off its radical past, take
itself very seriously. Yet when tested it caves in.

Stafford-Clark and Hastings are set up to tak
the rap. And cravenly do so. Some members of
the Board are nobbled and they all keep their
heads down. No one wants to stand up and
defend a committed writer. They all want the
cachet and prestige which attend an association
with the Court. But no one, when tested, will
earn the right to the job. This is moral
corruption.

We are used to it in television and movies.
Hollywood, in this as in other things, is a
professional among amateurs. I congratulate th
Royal Court on its nimble skill in disposing of
mandate and betraying its history. After all,
patronage and a few deals on Broadway are
what count, aren't they? We all have to be
realists these days.

Meanwhile, a writer with rare political
integrity, who has not an ounce of anti-semitism
in him, is censored and vilified. It's not Jim
Allen I worry about. He has always been able t
ake care of himself. It's the shape of things to
come. And the villains of this Act could be the
victims of the next. But not to worry. They will
be surprised and grateful to find Jim Allen
fighting at their side, combative and principled
to the last.